THE COLLABORATIVE ARTIST'S BOOK

*Contemporary
North American
Poetry Series*

SERIES EDITORS

Alan Golding

Lynn Keller

Adalaide Morris

THE
COLLABORATIVE
ARTIST'S
BOOK

Evolving Ideas
in Contemporary
Poetry and Art

ALEXANDRA J. GOLD

University of Iowa Press | *Iowa City*

University of Iowa Press, Iowa City 52242

Copyright © 2023 by University of Iowa Press

uipress.uiowa.edu

Printed in the United States of America

Design and typesetting by April Leidig

Printed on acid-free paper

Library of Congress Cataloging-in-Publication Data
Names: Gold, Alexandra J., 1988– author.
Title: The Collaborative Artist's Book: Evolving Ideas in
 Contemporary Poetry and Art / Alexandra J. Gold.
Description: Iowa City: University of Iowa, [2023] |
 Series: Contemporary North American Poetry Series | Includes
 bibliographical references and index.
Identifiers: LCCN 2022040209 (print) | LCCN 2022040210
 (ebook) | ISBN 9781609388898 (paperback) |
 ISBN 9781609388904 (ebook)
Subjects: LCSH: Artists' books—United States. | American poetry—
 20th century—History and criticism.
Classification: LCC N7433.35.U6 G65 2023 (print) |
 LCC N7433.35.U6 (ebook) | DDC 700.973—dc23/eng/20221117
LC record available at https://lccn.loc.gov/2022040209
LC ebook record available at https://lccn.loc.gov/2022040210

For my parents, Harvey and Marianne Gold

CONTENTS

ACKNOWLEDGMENTS

It is perhaps an inevitable cliché to note here that the art of making a book is, above all, a thoroughly collaborative affair. Like the many poets and visual artists whose works occupy these pages, I have never been alone in my pursuit. So many people, in their distinct ways, have supported this project from its inception and have conducted it through numerous revisions. Among them, I am particularly grateful to the Contemporary North American Poetry Series editors Lynn Keller, Alan Golding, and Dee Morris for seeing the value in this book's interdisciplinary vision and offering keen suggestions about its direction early on, as well as to the two anonymous peer reviewers whose attentive comments on the manuscript were formative for revision. I am likewise grateful for the expert guidance of Meredith T. Stabel, Margaret Yapp, Susan Hill Newton, Susan Boulanger, and other critical hands at the University of Iowa Press who have shepherded this book to its final form.

In an important way, this book's origins extend back to my undergraduate years at Penn, where Charles Bernstein's incomparable knowledge and teaching first sparked my interest in post-1945 experimental poetry, visual art, and the connections between them—an interest that I have pursued ever since. As a doctoral student at Boston University, this interest deepened under the guidance of Bonnie Costello and Elizabeth Loizeaux, whose indispensable dissertation mentorship not only allowed the earliest versions of this project to flourish but helped give shape to what it would become. It has been an honor to learn from these incredibly generous scholars, and the many more at the University

of Pennsylvania, Drexel University, and Boston University who have molded me into the writer and teacher that I am today.

This project has benefitted greatly from several additional sources of material and immaterial support. Funding for this book's archival research was furnished by the Modernist Studies Association, which enabled a visit to Robert Creeley's archives at Stanford University, and by the Smithsonian's Baird Resident Scholar Program, which provided access to the Smithsonian Libraries' extensive artist's book collection and the Archives of American Art. The staff at Harvard University's Houghton Library not only made my research on the Tiber Press possible but were instrumental in providing photographic reproductions of several of the works discussed in this study. Special collections librarians at Stanford, Brown, and the University of Iowa provided additional support in this vein. I also especially appreciate the wonderful, encouraging colleagues I have been able to connect with through the broader Network for New York School Studies; this network and its many enthusiastic members, from whose own work I have learned so much, have been lifelines for me as a contingent scholar working outside a traditional English department—perhaps more than they know.

I have substantially written and revised this book while teaching as a preceptor in the Harvard College Writing Program (Expos). I owe broad thanks to the dedicated colleagues and departmental staff who allow our program to thrive. Thomas Jehn and Karen Heath, our intrepid program directors, have been tremendously encouraging to me in all my teaching endeavors and have provided vital counsel along the way. My colleagues and friends in the program, especially Lusia Zaitseva, Katie Baca, Jessie Schwab, Matt Cole, Elliott Turley, and Sparsha Saha, have been essential sources of support and excellent sounding boards; their creative pedagogical ideas and insights have been a constant inspiration. The exceptional non-ladder faculty I've had the privilege to work with in Expos, and the many more university-wide, are the educators who truly sustain and enrich Harvard's pedagogical mission each day. Not least, I am a better teacher for the many outstanding, extraordinarily thoughtful students I've had the great fortune to encounter in my first-year writing course on feminism and media; in their capable hands, our intersectional feminist future is indeed a bright one.

Finally, I would like to thank all my family and friends, and to briefly acknowledge a few. Amanda Bakowski, Dacy Knight, Jenna Schultz, Emily Selvin, Shannon Draucker, and Pia Heilmann have been especially cherished friends, always ready to lend a listening ear, some much-needed levity, or a healthy dose of reassurance. My unfailingly kind husband, Ben Roberts, has been with me through every step of this project; he has been a steadfast and patient partner as I've exalted, and more often fretted, through my work. His own kindness well reflects that of the extended Roberts family, who have readily and warmly embraced me. Sonny Gold has never failed to keep me humble or to make me laugh, as younger brothers are wont to do; I am fortunate that he had the good sense to choose a wife, Allie Gold, who has become a true friend and sister. Last, no mere words are sufficient to express my gratitude to my parents, Harvey and Marianne Gold, who have been unwavering sources of love and support in this endeavor and throughout my life. This book is chiefly for them and for my Nonna, Anna Schoffel, whom I dearly miss.

Between Subjects

Poetry, Visual Art, and the

Collaborative Artist's Book Form

C ollaborative artists' books are challenging forms. At once visual, textual, spatial, and tactile forms, collaborative artists' books provocatively connect concept to material, and word to image, challenging audiences to draw connections between them. Functioning simultaneously as works of visual art and as literature, artists' books reside uneasily between artistic categories and academic disciplines, challenging straightforward classification and conventional hermeneutics. Entreating a methodical, tactile engagement that often violates the norms of the museum exhibits and special collections libraries where they reside, collaborative artists' books also challenge curators, archivists, and researchers to negotiate the aims of user availability and conservation. Given these several challenges and the many others that they encode both in their forms and in their reception, it is little mystery that artists' books have become something of a secreted form in cultural institutions and academic spaces alike— collected, filed, and then, all too often, forgotten. And indeed, it is our incomplete response to their challenging nature that has obscured the majority of artists' books from broader recognition despite their long-standing place in the art world and their status, in bookmaker

and scholar Johanna Drucker's inimitable terms, as the "quintessential 20th-century artform . . . appear[ing] in every major movement in art and literature" and "all of the many avant-garde, experimental, and independent groups whose contributions have define the shape of 20th century artistic activity."[1]

Still, the relative neglect of artists' books is not unexpected. That many artists' books were created in limited edition or else are long out of print has made them difficult to locate. Moreover, interested parties must typically arrange costly or time-consuming visits to special collections or rare book libraries where access to these works is highly regulated. Even when artists' books are granted broader audience in the form of academic scholarship or museum catalogues, written description or photographic duplication of the works inevitably fails to capture their multidimensional beauty and material import. Exhibitions scarcely do better. When artists' books are exhibited, they are usually confined behind museum glass both to allow patrons to see the book from all sides at once and to ensure that they are accessibly displayed for wheelchair users, and they are typically on view only for short periods to avoid light damage to the work.[2] While preservation and accessibility are indisputable priorities, museum displays inevitably offer their audiences a different, distant version of the artist's book than a close physical encounter. Like photographic duplications and written descriptions, exhibitions entail a nagging insufficiency.

The complexities and challenges that plague these works are not just regrettable but ironic, since the artist's book's institutional life cycle has undermined one of its primary objectives: widespread but intimate access to art. It was a fate foretold by the artist Ulises Carrión, who observed, in a 1976 *ArtRite* issue dedicated to the form, that "Nowadays the only trouble with artists' books [is] that they have gained the attention of museums and the collector. The [works'] sabbath dance . . . has beg[u]n. . . ." Today, the "sabbath dance" has reached its maturity, as too many artists' books languish in archival boxes never to be touched again. "On any given day," Krystyna Wasserman notes of the National Museum of Women in the Arts' vast book collection, the works "si[t] silently on shelves and in vitrines. But it's not enough to merely house books; books must meet their readers, their viewers,

their lovers."[3] Despite their long history and by now cemented place in institutional collections, artists' books, and especially collaborative ones, are persistently viewed as minor forms, sometimes dismissed as whimsical but trivial experiments. Whether for reasons of interest or access, they have been less prone to sustained attention than other artistic genres (doubly so, if their creators are neither white nor male).[4] On one hand, this contributes to their charm: the artist's book rewards its invested readers with a thrill akin to discovering a rare time capsule, like a portal to a secret world. On the other hand, the artist's book was not a secret meant to be kept. "A closed book is a treasure trove of wild possibility," book artist Kurt Allerslev affirms,

> The bookmaker creates something that is meant to endure. The insides—text and/or images—stay lit up forever [. . .]. A book is fed by every pair of eyes that fall on it; in turn, the insides of that book pay homage to the creators—the authors, the artists who make it—by providing the reader with a passage to a secret life that can only be accessed by opening it—as if dreaming.[5]

If artists' books "stay lit up forever," they at last demand an audience to witness their light.

Alongside recent work that has either championed particularly prolific book artists and schools or surveyed the broader field of artists' books, this study aims to carry the torch, shining light on and granting new passage to the words, images, and worlds that these works contain.[6] Focusing on a discrete subset of artists' books created collaboratively by poets and painters between the late 1950s and the early 2000s, this study offers close analysis of five central works: Frank O'Hara and Michael Goldberg's *Odes* (Chapter 1), Robert Creeley and Robert Indiana's *Numbers* (Chapter 2), Anne Waldman and George Schneeman's *Homage to Allen G.* (Chapter 3), Mei-mei Berssenbrugge and Kiki Smith's *Concordance* (Chapter 4), and Erica Hunt and Alison Saar's *Arcade* (Chapter 5). Moving mostly chronologically through this small but heterogeneous sample of contemporary American works, which mimic the wide variation in size, layout, and word-image configuration found across artists' books writ large, this study not only animates similarities and differences that emerge across nearly three generations of

poetry, art, and bookmaking but begins to develop a generic sense of the collaborative artist's book form itself.[7]

Though they remain largely overlooked in critical accounts both of poetry and of visual art, collaborative artists' books are essential forms for humanistic inquiry. Remarkably intermedial, intersubjective, and interactive, they allow us to develop new ways of thinking about connections between creators, arts, and audiences. Testing, and often superseding, the limits of individual media, of artistic and aesthetic autonomy, of authorship, and of the codex's conceptual and/or formal parameters, collaborative artists' books are excessive artforms, and subversive ones. Shaped by the academic, aesthetic, interpersonal, and even sociopolitical currents that bear them, they are thoroughly material forms. Not only is each collaborative artist's book an exquisite art production in its own right, crafted with detailed attention to typesetting, binding, paper, and other material considerations, but each is also a product of the reproductive and communicative technologies — serigraph, Xerox, mimeograph, computer, telephone, email — that facilitated their production and sustained their artists' connections in the first place.[8] They are, as such, exceptionally social forms, reflecting the formal and informal networks (interpersonal, professional, or communal) to which their artists belonged. Just as the "group manifestos, alternate canons, little magazines, and anthologies have organized much post-1945 literary history," as Anne Dewey and Libbie Rifkin propose, collaborative artists' books surface a "poetics of community" and, often, of friendship that is not only central to the works' conception and reception but has been central to artistic and poetic innovation in the twentieth and twenty-first centuries.[9] As highly interactive and intersubjective forms, both for their creators and their audiences alike, collaborative artists' books are, at last, intrinsically human forms. In them, Anca Cristofovici attests, "a poetics of human relationships surfaces as a constant pattern, involving such qualities as self-effacement, humility, forms of sociability, attention to the other, acceptance, curiosity, admiration, generosity, reciprocation, risk, and even compromise."[10]

Foregrounding "a poetics of human relationships," collaborative artists' books offer an instinctive locus for artists and poets keen to reimagine models of artistic subjectivity and self-expression that have

traditionally glorified "the individual," including the modern conception of lyric poetry. For the experimental American poets who were especially drawn to the collaborative artist's book form in the twentieth and twenty-first centuries, like those considered here and the many others broadly associated with the "New American Poetry" and its immediate descendants, including Language Poetry, these works offered rich sites for engaging with and dismantling received ideas about lyric subjectivity and its concomitant sense of address. Locating subjects in relation, collaborative artists' books reject the heroic or insular individualism often aligned with post-Romantic lyric poetry and post–Abstract Expressionist visual art, allowing the poets and artists who embraced the form at and after midcentury to imagine lyric and artistic subjectivity anew. When the poets and artists address themselves and their art to each other and, ultimately, to their audiences in their collaborative artists' books, the resulting works assert an intersubjective reciprocity that cannot be denied.

The Artist's Book: Definitions and Questions

Before venturing further into this terrain, however, we must take a short but important detour, since one cannot get far in any artist's book discussion without confronting the perpetually unsettled questions the form provokes. To begin: What is an artist's book? The most basic definition is this: an *artist's book* is a work of art in book form. On its own, however, this facile description shrouds both the breadth of activity that the term *artist's book* encompasses—ranging from intermedia collaborations to singly authored or single-medium works, and from traditional codex forms to sculptural and accordion ones—and the long-standing debates about what works "count" within its purview (not to mention the placement of the apostrophe in *artist's book* itself).

One still prominent but narrow view holds that the artist's book, a term coined by curator Dianne Vanderlip in 1973, is a postmodern, American form invented in the 1960s and '70s.[11] As Conceptualists like Sol LeWitt, Dieter Roth, and Ed Ruscha (whose 1963 *Twentysix Gasoline Stations* is often cited as the first artist's book) adopted the book form as a major vehicle for their work, the "artist's book" became closely

affiliated with the "democratic multiple": a form that any artist could produce and distribute quickly and cheaply using reproductive technologies like offset and mimeograph printing.[12] Paralleling the small press literary movement spawned by the "Mimeo Revolution," the democratic multiple stood to defy the hegemony of the elitist, slow-moving fine art economy and to reach a proletarian audience. As Lucy Lippard infamously mused: "One day I'd like to see artists' books ensconced in supermarkets, drugstores, and airports, and, not incidentally, to see artists able to profit economically from broad communication rather than from lack of it."[13] Glorifying reproductive technology, speed, and widespread access, the postmodern artist's book was cast as a form diametrically opposed to the *livres d'artistes* and other fine press works (*livres (de) luxe, livres de peintres*, "illustrated books") that avant-garde European artists like the Surrealists, French Symbolists, and Russian Futurists created in the early twentieth century. Because livres d'artistes were typically handmade, frequently collaborative (usually created by a painter and a poet), produced in limited editions, and commissioned by a press, they appeared antithetical to the "democratic" ethos their newer American counterparts claimed to embody.

Yet the use of "artist's book" to denote only works in the democratic multiple vein and to exclude livres d'artistes and other "fine press" works (including, as some would insist, this study's five works)[14] has important limitations — not least the obvious irony that *livre d'artiste* itself translates to "artist's book."[15] First, however "democratic" the multiple was in theory, it was in practice still exclusionary; while any artist could ostensibly create a book beholden only to their vision, they could not do so without access to the expensive technology needed to bring it to fruition.[16] Second, the elision of the artist's book with the democratic multiple is underwritten by distinctly American values — democracy, individualism, technological progress, and, by implication, exceptionalism — that obscures the long history of global printmaking practices rightly subsumed under the broader "artist's book" rubric. Finally, the artist's book / livre d'artiste distinction is too categorical to accommodate the many works that blur the line between them, including many discussed in this study.

A better definition of the "artist's book," then, is one that Drucker for-

mulates in her touchstone survey, *The Century of Artists' Books*. Though she initially distinguishes between the livre d'artiste and the artist's book on the basis of form, noting that "it is rare to find a livre d'artiste which interrogates the conceptual or material form of the book as part of its intention, thematic interests, or production activities,"[17] while "artists' books are almost always self-conscious about the structure and meaning of the book as a form," she ultimately concedes that "Any attempt to describe a heterogeneous field of activities through particular criteria breaks down in the face of specific books or artists," making it "counterproductive to try to make a single point of demarcation for this complex history."[18] This study's examples corroborate Drucker's important caveat. For though *Odes*, *Numbers*, and *Arcade* maintain "the [*livre d'artiste*'s] standard distinction between image and text, generally on facing pages," they also prioritize the "conceptual or formal or metaphysical potential of form" essential to the artist's book.[19] While Creeley's and Indiana's 1968 *Numbers*, for instance, preserves the "standard distinction" between print and poem, the book's formal alternation between them also complements its thematic musings on seriality and time, as we'll see in Chapter 2; it is therefore difficult to claim that the "structure and meaning of the book as a form" is not integral to *Numbers'* endeavor and that it, as a result, categorically differs from other period artists' books. Moreover, many early livres d'artistes were themselves exceptionally attentive to "the book as a form." The prodigious French poet and book artist Mallarmé, Susi R. Bloch suggests, "insisted upon a recognition of the meaning of format [in his livres d'artistes]. He demanded a precisely reckoned and designed volume in which . . . typography and even the foldings of the pages achieve an ideational, analytic, and expressive significance."[20] As such, Drucker's more capacious use of the term "artist's book" to encompass a wide "zone of activity . . . made at the intersections of a number of different disciplines, fields, and ideas—rather than at their limits,"[21] not only allows us to see livres d'artistes, democratic multiples, fine press work, independent printing projects, broadsides, performance art, and even concrete poetry as part of a larger experimental continuum but empowers readers to develop their own understanding of these works since the "final criteria for definition resides in the informed viewer."[22]

In this light, as book artist and Primrose Press founder Tia Blassingame avers, the form is "endlessly expansive. There is space within the discipline for every iteration, format, and version of an artist's book."[23]

Subscribing to the ascendant view that "fine press books, livres d'artistes, and other creative book forms that once stood alone and sometimes above artists' books in the genre hierarchy have [become] subsets of the artists' books genre, now the dominant term,"[24] this study situates its collaborative artists' books both as successors to a centuries-long, transnational practice of innovative print work and as part of an emergent American bookmaking movement that took off at midcentury and exploded in subsequent decades with the rise of book art schools and presses, culminating in what Karen Eliot calls the "contemporary popular renaissance of the artists' book" in the twenty-first century.[25] Focusing here on five examples that prioritize gestural art, drawing, and print work—sketching, stencil-work, serigraphy, letterpress printing, and woodcutting—instead of the photography central to many "democratic multiples" indeed strengthens these works' connection to a longer bookmaking tradition that both predates and succeeds photography's ascent. More than that, situating the five collaborative works within both the broader "zone of activity" that Drucker carves out reminds us not just that the artist's book has been a continually evolving form, but that it has always been vested within a "larger circuit of cultural history,"[26] transformed as much by changing aesthetic values as by technological advances and even the sociopolitical context.

Nevertheless, rehearsing the debate surrounding the artist's book terminology usefully highlights the real sense of uncertainty that these forms occasion. Beyond definitions, collaborative artists' books elicit yet another crucial, unsettled question: are they literature or visual art? A short answer: neither and both. Often combining text and imagery (whether poetry or prose, print, photography, or drawing), artists' books challenge medium-specificity and academic disciplinarity. The interdisciplinary approach that these works require, bridging literary, art, and even book history, can be tricky, at best, and scorned, at worst. As T. J. Hines humorously describes: "There is no fury like that of an art historian watching a literary critic discuss art history unless it be of a musicologist listening to an art historian analyze a piece of music."[27]

Their visual-verbal hybridity does not simply stymie academic disciplinarity, it also complicates archival classification; whether artists' books belong in special collection libraries or in museum repositories is an ongoing question and one not easily resolved.[28] Nor is it a superficial question since, as curator Cornelia Lauf points out, "Where they are shelved determines what they say."[29] Cross-institutional cataloguing inconsistencies that consign the same work either to a special collections library or to a museum's print and drawings archive can essentially determine whether it is deemed "literature" or "art." Artists' books, Eva Athanasiu notes, "travers[e] institutional boundaries—slipping between galleries, libraries, archives, and museums—in a way that other art objects have never quite achieved."[30] That they are infrequently discussed, taught, and canonized should therefore come as no surprise.

Yet for the many unresolved questions they raise, artists' books, and particularly collaborative ones, "deserve to be welcomed into the academy for their potential to reconfigure fields of knowledge . . . [and] narratives of literary and art history from a relational perspective," as Anca Cristofovici maintains.[31] Making a case for the interdependence of several fields, collaborative artists' books act both as a conceptual guide and as a material impetus to interdisciplinary thinking. These forms may consequently encourage us to shift our professional and pedagogical praxes to match, training our vision on a thoroughly interdisciplinary, humanistic enterprise at an especially exigent moment when individual humanities disciplines face severe enrollment declines and deep budgetary cuts. As artists' books and their creators engage in sustained interdisciplinary and interpersonal collaboration, they model ways forward, illustrating not just that reciprocity between disciplines is possible but that beautiful forms emerge in its achievement.

Subjectivity, Lyric Poetry, and the Art of Collaboration

Above all, collaborative artists' books are relational forms. Founded on interaction, dialogue, and mutuality not just between the books' immediate creative partners but also between the network of binders, typesetters, editors, printers, and others who typically play a hand in their design, collaborative artists' books highlight both the acts of exchange

through which they are created (the collaborative *practice*) and their finished products (the collaborative *form*) as social constructs.[32] Because the "collaborative medium goes so against the heroic isolated macho image of what an artist is in American culture,"[33] as artist Archie Rand maintains, it modulates the idea of art as a vehicle for individual self-expression and rejects the trope of solitary artistic "genius."[34] This is not to suggest that the result is uniform; while some collaborations arbitrate between "individual" and "collective" artistic identity, making each contributor's specific involvement in the work clearly known, others embrace a more integrated or "composite subjectivity"[35] from the start. In either case, however, collaborations predictably draw attention to, or at least stoke curiosity about, the work's extradiegetic trappings: What is the creators' relationship? What were the terms of their exchange? As David Shapiro notes, collaboration "makes us exactly aware of the process itself and context; and the context is relatedness."[36]

As a result, collaborations also ask audiences to relate to and interact with them differently than do other artforms, entreating us to attend not just to texts but to contexts. In collaborative artists' books, this includes drawing readers' attention to both the work's generative process—Who decided where certain elements go? Were the collaborators in agreement?—and to the status of the book as an object itself. Artists' books amplify reader-viewers' awareness of "normal" book features that they might otherwise take for granted. If, Alexa Hazel suggests, "A poem in an anthology often seems to the reader as something stable: fixed, legible, and easily consumed," then the poetry and artwork found in collaborative artists' books "willfully resist this extractivist model of reading. . . . The acts of institutional curation typically hidden in commercial texts are brought to the surface" as the works "call attention to their own bookishness."[37] In collaborative artists' books, to adapt Brian Reed, "page numbers, line numbers, annotations, illustrations, choice of font" traditionally "deemed to be extrinsic to the 'real' poem" or to a book or anthology—the "concretely visual" elements "which the eye takes in"—can no longer be "effaced or displaced" but become *intrinsic* to the work.[38] Intermedia collaborations engage audiences in yet another way, enlisting reader-viewers as active contributors to or, indeed, collaborators in the work as they

consider connections between disparate art forms, sometimes bearing no self-evident relation. In short: to best understand collaborations, audiences must account for the form's intrinsic materiality and contextual relationality, including, at times, their own relation to it.

By inscribing relationality between artistic practices, creators, and audiences in their very forms, collaborative artists' books destabilize (singular) authorship and aesthetic autonomy from the start, making it difficult, if not foolish, for any poetry and art contained in them to sustain the impression of a unified subjectivity, artistic or lyric. The especial allure of collaboration, generally, and of collaborative artists' books, particularly, for the late twentieth- and twentieth-first-century poets associated with the various New American Poetry groups and their affiliated antecedents—the New York School (and its so-called Second Generation), Black Mountain, Beat, Umbra, San Francisco Renaissance, and Language poets—thus comes into greater focus. Of course, poets' interest in collaborating and in creating innovative, multimedia print works was not new.[39] Nevertheless, the collaborative work flourishing among interwar European avant-gardes, the influx of European print-makers who fled to America during World War II and founded fine presses eager to fashion works in the modernist vein,[40] and the poets' own intermedial interests all conspired to help collaborative bookmaking and adjacent verbal-visual forms, including broadsides and little magazines, flourish among the New American Poets and subsequent generations of experimental poets directly influenced by them. Among contemporaries of O'Hara and Creeley, for instance, one finds numerous examples of visual-verbal collaboration by James Schuyler, John Ashbery, Kenneth Koch, Barbara Guest, Amiri Baraka, Jack Spicer, Robert Duncan, and others. In Waldman, Berssenbrugge, and Hunt's subsequent generations, one finds still more wide-ranging examples by Ted Berrigan, Ron Padgett, Alice Notley, Susan Howe, Charles Bernstein, and more. A cursory glance through independent presses' and booksellers' catalogues from companies like Granary Books, the Arion Press, Printed Matter, Abrams Books, and Kelsey Street Press only produces further evidence. Though few collaborative works produced by these poets and their artistic partners look like any other, the sheer magnitude of them confirms that poets across coteries and generations have

found a creative outlet in the visual arts. Most significant, collaborating with each other and with visual artists likely seemed an intuitive pursuit for these poets, intent as they were, after Charles Olson, on "the getting rid of the lyric interference of the individual as ego, of the 'subject' and his soul" and (projectively) locating "the artist's act in the larger field of objects"—in nature or in the city, in other people, and perhaps even in collaboration itself.[41]

Refusing to sustain the assumed insularity of the "individual as ego, of the 'subject' and his soul" that had come to be associated with the expressive lyric poem after Romanticism, collaborations disenable lasting claims to subjective unity or transcendent individualism in the first place. Even if the individual lyric subject can be temporarily located in a collaboration, the presence of another—another work, another voice, or another medium—denies its claims to absolutism. As poet Kenneth Koch put it in the New York School's *Locus Solus II: A Special Issue on Collaborations*: "The act of collaborating on a literary work is inspiring, I think, because it gives objective form to a usually concealed subjective phenomenon and therefore it jars the mind into strange new positions,"[42] often yielding, in the process, "strange new" forms of subjective, or intersubjective, lyric positionality. Seeking to redress the Romantic lyric at the very moment when New Critical curricula and attendant "lyric reading" practices increasingly codified it— institutionalizing the "isolated lyric subject" and, by extension, the lyric poem as a "social, even an historical and cultural abstraction"[43]—the New American poets, Donald Allen remarks in his eponymous anthology, "show[ed] one common characteristic: a total rejection of all those qualities typical of academic verse."[44] Leading the charge among Allen's disparate but commonly committed artists were the two best represented poets in his volume: Frank O'Hara and Robert Creeley. Formatively helping shape what would become known as "the New American Poetry," it was Creeley and O'Hara, who, as Charles Altieri notes, "Despite their very different emotional agendas . . . refused to give their texts the look and feel of well-made poems"—refused to indulge New Criticism's autotelic vision of the expressive lyric—"since knowledge based on abstract meditation left the poet trapped in a culture of vague idealizations and insufficiently examined psychological

constructs."[45] It is perhaps unsurprising, then, that Creeley and O'Hara were also among the period's most prolific collaborators, between them completing over fifty collaborative projects with visual artists and many more with artists in other disciplines. Situated at the forefront of an era in which artistic reciprocity was increasingly the norm, O'Hara and Creeley's artists' books not only "map out a journey into the art of the second half of the twentieth century,"[46] but their collaborative and lyric innovations also set an influential precedent for younger poets like those included here: Anne Waldman, Mei-mei Berssenbrugge, and Erica Hunt.

I do not mean to claim, however, that Waldman's, Berssenbrugge's, and Hunt's collaborative artists' books or their later engagements with the Romantic lyric seek merely to emulate those of O'Hara, Creeley, and their peers. In addition to the salutary acknowledgment that these women, the latter two of whom are Chinese American and Black, respectively, created work under vastly different circumstances and constraints than their elder male counterparts, the results of their collaborative and lyric experiments also look no more like O'Hara's or Creeley's than they do each other's, even if we can locate some discernible resonance among them. Giving the lie to an ahistorical view of lyric poetry, the five collaborative artists' books examined here exaggerate our sense that the poetic and artistic differences found in them are not merely idiosyncratic but thoroughly material—testaments to the specific confluence of historical, aesthetic, technological, and social factors that shaped each artist's and their generation's work. Consider that "the self" was a persistent concern for the immediate postwar generation to which Frank O'Hara, Robert Creeley, and their visual artistic collaborators Michael Goldberg and Robert Indiana (all born in the 1920s) belonged. These artists came of age in the 1940s and '50s when Abstract Expressionism, Freudian psychoanalysis, and Confessional poetry, each venerating the idea of individual self-expression, dominated the scene. If "the self" that materialized in the public imaginary was an abstract rather than a coherent figure or an unconscious rather than an overt one, it nonetheless remained an outsized, ordering principle. The apocryphal declaration attributed to Jackson Pollock, "I am nature," is perhaps emblematic. For many postwar artists and experimental poets,

Abstract Expressionism's legacy—with its oversized canvases conveying the subject's enormous presence—was one to contend with. As expressionist gesture gave way to mechanical reproduction and the unique canvas work yielded to multiples, sculptural work, and book forms with the advent of Pop and its ironizing or repudiating of subjective interiority, O'Hara, Creeley, Goldberg, Indiana, and other artists and poets of their generation sought to strike a delicate balance between indulging and resisting self-expression, ultimately making it an intractable, but not all-consuming, part of their work, and locating "the subject" within the field: in society, in the world, and among others. If their artistic or lyric subjects would not purport to *be* nature, then they might, at least, be found in it.

Born a decade or two later, in the 1940s and '50s, Anne Waldman, Mei-mei Berssenbrugge, Erica Hunt, and their respective collaborative partners, visual artists George Schneeman, Kiki Smith, and Alison Saar, came of age in the late '60s and '70s: a time when art, culture, and politics increasingly reflected social or collective, rather than individual, questions: feminism, racism, multiculturalism, the body, the environment. Their youth, marked by identity politics and political protest, saw opportunities expand for women and people of color both within the art world and outside it. Reflecting the period's cultural and political ethos, the art world gradually shifted away from the 1960s obsession with concept and dematerialization and back toward physical media and materiality, precipitating a rise in easily reproducible paper-based and other tactile forms—"multiples, posters, books, broadsides, flyers, newspapers, and other more democratic forms of artwork"[47]—and an appeal to narrative, biographical, and populist themes. Younger artists like Berssenbrugge, Smith, Hunt, and Saar capitalized on these shifts. Pursuing personal and political themes and assuming the personal to be political from the start, these artists brought embodied (gendered, raced) experience to bear on their works and frequently turned to tactile materials and forms of art-making—sculpture, books, prints, and more. They also increasingly found creative traction in—or themselves founded—tight-knit alternative artistic organizations that not only stood in opposition to the "mainstream" art world but perhaps enabled

the artists to navigate the complexities of lived experience by finding affiliation in aesthetic and social community.

In view of these sociocultural currents and aesthetic trends, it seems clearer why collaborative artists' books created in the immediate postwar period often take pains to formally and/or titularly delineate each artist's contribution, alternating between media, while works from a few decades later merge print and poem in ways that downplay it. While first-generation artists' books like *Odes* and *Numbers* maintain vestiges of artistic autonomy or of the individual artwork / creative subject and "ten[d]," as Daniel Kane writes, "to mythologize individual practitioners, as opposed to demythologizing and depersonalizing the participating subjects,"[48] second- and third-generation works like *Homage, Concordance,* and *Arcade* conceptually and/or formally forward a more integrated sense of artistic subjectivity from the start, "threatening privileged authorship and the fetishization of the book as organically connected to a single person in favor of a more collective vision."[49] Later artist bookmakers followed suit, also frequently highlighting in their works complex social issues as well as political and ethical (collective) crises like the raging culture wars, the AIDS epidemic, Reaganism, and the Gulf War. "Mov[ing] away from both the conceptually-based artist's book and the didactic artist's polemic [of the '60s]," Brian Wallis explains, "the new form that developed—particularly among artists of color—was closer to storytelling" and sought to "empower groups that [were] alienated by their own marginalization in society."[50] Perhaps further emboldened by the 1970s expansion of women-run art presses like Women's Studio, Mills College, and Kelsey Street Press (responsible for both *Concordance*'s trade edition and *Arcade*), non-white, non-male creators transformed lived experience into a critical paradigm for artists' books. In these works, deeply invested in subjectivity and, more, in intersubjectivity, there is no mistaking a socially situated subject for a universal one.

Such generational distinctions are finally reflected in the poets' respective approaches to the expressivist lyric. While O'Hara's poems in *Odes* and Creeley's in *Numbers* retain some allegiance to the individual lyric subject even as they work to deconstruct its more self-absorptive

or transcendent Romantic tendencies, Waldman's poems in *Homage*, Berssenbrugge's in *Concordance,* and Hunt's in *Arcade* more readily abandon it as an artistic premise, embracing from the start a nonrepresentational, social (or socialized) lyric subject that is less egocentric than community oriented. Though these later, more foundational lyric reconfigurations may owe a particular debt to Waldman's and Berssenbrugge's shared interest in Buddhist philosophy, they also more broadly reflect all three women's investment in gender, race, and social justice issues—ones which put pressure on the singular or universal (masculine) subject. For many contemporary experimental women poets, such reinvention was virtually programmatic, as traditional lyricism seemed a fraught ideal due to its historical misogyny.[51] And for Berssenbrugge and Hunt, as Chinese American and Black women poets, the "whiteness of the lyric subject"[52] likely posed a residual difficulty that demanded further reckoning, as we'll see in their works.

To be clear, I am not suggesting that these collaborative artists' books or the poetry found in them are explicitly *anti*-lyric or *anti*-subjective—at least not in the way "democratic multiple" creators conceived it in the 1960s when Lucy Lippard proclaimed that "the new artists' books . . . have disavowed surrealism's lyrical and romantic heritage and have been deadpan, anti-literary, often almost-anti-art"[53] or as Language poets would later have it in their calls for "artifice" and "intellect" over "nature and sentiment."[54] The poetry under consideration takes a more measured approach, and one that perhaps unexpectedly anticipates the recent emergence of the "conceptualist lyric": a technocentric poetry whose lyric negotiation works, as Brian Reed, following Werner Wolf, argues, "to thicken language, that is, to 'slow down the process of reception' and encourage readers to attend to the materiality and specificity of 'all the components of oral and written language.'"[55] These contemporary poets, like the five featured here, showcase how lyric poetry might prioritize "not so much the [Romantic] plumbing of interior depths," but an understanding that although

> the self might be irrevocably caught up in social networks, technological circuits, and economic forces that are beyond its control, writers
> can still . . . compose poetry that resonates for readers and that gives

them access to qualities and experiences that exceed or transcend what markets can provide.[56]

That is: the five central collaborative artists' books here highlight how lyric poetry can remain intensely subjective, evocative, and emotionally resonant—even sentimental—for creators and readers alike without assuming, "even as a fiction, the stance of 'withdrawal,' 'self-absorption,' and 'detachment from the social surface'" that has been made central to it.[57] Inasmuch as collaborative artists' books attach their poetry, and their poets, to "the social surface" from the start, they help affirmatively answer Gillian White's critical question of whether "poems [can] register resistances to lyricizing readings of them without taking on the premises of avant-garde antilyricism?"[58]—a particularly striking question for Berssenbrugge and Hunt, often associated with the "anti-lyric" Language circle. Alongside White, I would suggest that what we find in the five collaborative artists' books are the poets' various efforts to "exceed and test the limits of the New Critical [and Romantic lyric] conventions" in order to "foreground canonical attachments to 'personal' utterance as a critical problem full of possibility."[59] I argue further that there is no more apt conduit for this endeavor than the collaborative artist's book itself.

A Form of Lyric: Address, Audience, Materiality

The key to collaborative artists' books' negotiation, resisting isolated "lyricizing readings," on one hand, without fully adopting "anti-lyricism," on the other, lies in their sense of address—a fundamental feature of lyric poetry. In his comprehensive tome, Jonathan Culler identifies four generic lyric tenets. First and arguably most important is lyric address, which, he argues, is always indirect. Because, as Culler argues, "to address someone directly—an individual or an audience—one would not write a poem," lyric poetry always addresses its reader *indirectly*, via triangulation, through an apostrophic call to another (e.g., nature, a muse) or through the speaker's self-address.[60] Rooted in what he calls the lyric's special "here-and-now" temporality, Culler's second and third tenets hold that the poem is both a repeatable and therefore

ongoing "event" (rather than a mimetic representation of an event) and a ritualistic form, a "text composed for *reperformance*" wherein readers come to stand in for the poetic speaker and thus give voice to, or perform, the text.[61] The fourth, finally, states that lyric poetry is hyperbolic; when lyric poems "seek transformations of experience — the favor of the goddess, amorous success, acceptance by the world . . . [they] hyperbolically risk animating the world, investing mundane objects or occurrence with meaning."[62]

That several of these tenets map exceedingly well onto collaborative artists' books not only belies the idea that they are foundationally *anti-lyric* forms but suggests again why they have been especially magnetic sites for lyric experimentation. Like lyric poems, artists' books have an insistently present "here-and-now" quality that cannot be denied; "if it is mass-produced," Keith Smith writes, "the book can reach a greater audience than an exhibit. It is not relegated to a one month spread of time or a single event. A book can be seen anywhere, at any time, in any situation, and can be returned to time and again."[63] Notwithstanding the archival restrictions often placed on these works today, artists' books, whether they are mass-produced or editioned, afford their audiences a real sense of an ongoing artistic event "here-and-now" rather than a mimetic representation of an event each time they are re-opened. Existing in many places at once and capable of being returned to multiple times, artists' books exude a continuous presence; indeed the "main focus" of the artist's book, Dick Higgins writes, is an "experience."[64] Moreover, because the reader-viewer is highly involved in animating the work — because, bookmaker Gervais Jassaud notes, the artist's book "is a living object that solicits the reader's participation," making them "not just a detached participant . . . an observer watching from a distance, but a direct and active collaborator who participates with her or his hands, and even both, to the reading process . . . [in] both a physical and psychological experience"[65] — it is also a ritualistic form, both imaginatively and physically performed (and reperformed) by reader-viewers. Finally, insofar as the artist's book's "meaning resides not simply in the text itself or in the subject matter but in the human transmission of experience," as Brian Wallis contends, reader-

viewers too, to recall Culler, "invest mundane objects with meaning" and "hyperbolically risk animating the world."[66]

If, however, collaborative artists' books complement Culler's three later tenets, augmenting the temporal, ritualistic, and hyperbolic qualities of the lyric poems found in them, then they also stand to complicate his first, challenging the "characteristic indirection"[67] of lyric address. Culler suggests that lyric poetry is "optative; articulating desire, it allows itself to imagine a response to its call or address and works to constitute an active relationship to what might be a resistant other, even if that relation brings destruction, as happens in later lyrics."[68] Artists' books are "optative"; they have, as Lynn Lester Hershman, uncannily echoing Culler, notes, "the salient qualities of individual and intimate objects that can be touched, owned, loved, handled, and even destroyed. The action of the book brings about a response in the reader."[69] Both lyric poems and artists' books entreat a response, even if that response proves resistant or destructive. The difference, however, is that where Culler's understanding of address assumes "triangulation" and "indirection," as the poem speaks to an "audience"—"the presumed beneficiaries of lyric communication, most often listeners or readers"—through an "addressee"—"whomever or whatever is designated by the pronouns of address"—the modes of address found in collaborative artists' books assume direction and dialogic exchange.[70] In the collaborative book form, lyric poetry speaks directly both to the visual art (and by extension the visual artist) to which it is tethered and to its reader-viewers. When lyric poetry speaks in collaborative artists' books, it always speaks directly to an audience.

In collaborative artists' books, lyric poems are not insulated or isolated, self-contained works but intermedial and dialogic ones; they not only speak directly to but garner direct response from the visual art they encounter, whether that response comes in the form of echo, interruption, juxtaposition, or, indeed, resistance.[71] Because the visual artwork effectively becomes an immediate "beneficiary of [the poems'] lyric communication" and, moreover, one that speaks back to it in the collaborative artist's book context, the book form makes visible the presence of an otherwise merely imagined or implied audience for the

lyric poems and thereby denudes them of a certain "vatic" quality that Culler ascribes to them, one predicated on a sense of "improbable" or impossible response.[72] This directness seems to hold true even when the individual poems initially consecrate Culler's sense of "triangulation" in addressing themselves to extrinsic figures, as in O'Hara's *Odes*. Although O'Hara addresses several real people (Michael Goldberg, Joe LeSueur, the French Negro Poets) and inanimate concepts (Joy, Necrophilia) in his individual odes, the poems themselves are also placed in direct conversation with Goldberg and his prints in the collaborative artist's book form. Whatever theoretical indirection the lyric poems may initially purport is thus tempered by or even made supplementary to the book form's senses of direct, material relationality and conversational exchange—the incontrovertible presence of an immediate respondent. In this case, the titular addressees named in O'Hara's odes serve not as intermediaries for the audiences or beneficiaries of the work with whom the lyric poems are always already in conversation but as other, potential interlocutors who exist alongside them; accordingly, the poems seem less to uphold a limited sense of the triangulated lyric address Culler imagines than to function as inclusive sites of social gathering and correspondence. Unwittingly or not, the lyric poetry found in collaborative artists' books comes to adopt the form's direct models of communication and exchange—its inherent sociality.

Such directness also extends to the collaborative artists' books' reader-viewers. In Culler's view, readers relate to lyric poems in a merely representative or figurative way; not only do lyric poems address readers by proxy, through triangulated address, but readers also participate in lyric poems by proxy through vocalization. Lyric poetry's ritualistic capacity means that the reader becomes a "performer of the [poems'] lines—that he or she come[s] to occupy, at least temporarily, the position of the speaker and audibly or inaudibly voice the language of the poem, which can expand the possibilities of his or her discourse."[73] This again introduces a sense of indirectness to the relation between readers and lyric poems. By vocalizing what is essentially a pre-made script set out by the author and/or the poem's speaker, the reader serves only as a temporary substitute for the poetic subject or the speaking "I"; their relation to the poem is somehow constrained rather than agential.

Because readers' relation to lyric poetry, as both temporary performers and triangulated addressees, is mediated by or takes place through another in Culler's schema, they are neither really direct participants in nor direct recipients of it, effectively consecrating the lyric poem as an autotelic textual entity, complete in and of itself, impervious to external intrusion or response.

In the context of the collaborative artist's book, however, lyric poems are not autotelic or autonomous entities; they occur within and draw attention to the channels of production, circulation, and reception—the extratextual forces—that dictate their existence. As collaborative artists' books exaggerate their own objecthood, purporting a three-dimensional "weight, object and texture" that must be "touched to be experienced,"[74] and entreat their audiences to activate the conversation between their poetry and visual art, they transform reader-viewers' relation to the work, including to any lyric poetry they contain. In collaborative artists' books, reader-viewers do not merely vocalize or rehearse the lyric poetry (or artwork) that they encounter in them, but they actively respond to it. Collaborative artists' books solicit not just reader-viewers' direct, embodied participation in the work but their intellectual and emotional responses, contributions, and perhaps even interventions—ones that are not necessarily pre-scripted or fixed. Of course, this is always true; even in "ordinary" books or in poetic anthologies, readers always have a haptic as well as emotional relation to the text at hand that makes their participation in these texts physical, actual, and thus direct. Artists' books, however, heighten this sense by making reader-viewers more acutely aware of their own interactive positionality vis-à-vis the work. In artists' books, as Anton Würth observes, "the book becomes the subject of artistic expression—a self-referential medium "that not only represents reality but that also presents itself as reality.The book is taken over by artistic freedom and the reader becomes part of a discourse that forces him to act and to judge."[75] Collaborative artists' books make readers-viewers both direct participants in and direct recipients of their artforms, rather than merely belated addressees or representative actors within them. As poet Bill Berkson notes, "Addressing an audience—conceiving an addressee, a reader or viewer, for the work—you collaborate with that

shifting phantasmagoria. Such sociability is what puts the work in the world."[76]

Precisely because collaborative artists' books exploit many of the fundamental features of lyric poetry that Culler distills in his influential generic study while confounding his first—indirect address—they both resist "lyricizing readings" of the poetry found in them and extend scholarly appeals to lyric poetry's essential materiality. Contra ahistorical readings like Culler's, critics who take a materialist view of lyric poetry—Marjorie Perloff, Virginia Jackson, Yopie Prins, Brent Hayes Edwards, Brian Reed, Seth Perlow, and others—have persuasively argued for its status as a historical, social, and technological artifact, attending to the poems' modes of production, reception, and circulation.[77] This book extends their thinking. Occasioning readers' interest in and often making concretely visible their "developmental history—of social relations, of print, of edition, reception, and criticism"[78] in ways that encountering the same work in anthologies, collected volumes, or museum displays does not, a collaborative artist's book, in Jackson's terms, "strenuously resists substituting the alienated lyric image of the human—the very image the modern reading of the lyric has created—for the exchange between historical persons between whom the barriers of space and time had not fallen."[79] Indeed, the necessity and more, the great joy of reading poetry or viewing visual art in the collaborative book context for which it was often first created or in which it was first printed lies in the way it forestalls "the common practice of reading lyric poems in isolation—what we might call anthology syndrome," that not only "presents a rather skewed view of the poetic process,"[80] as Perloff and Dworkin argue, but that presents lyric poems, as T. J. Hines notes, "without [the] illustrations, music, or choreography that originally may have made up the whole context of the work."[81]

Finally, attending to the "whole context of the work" not only illuminates collaborative artists' books embedded senses of sociability and materiality, it also foregrounds the generative connections or productive dissonances between the poetry and visual art they contain, enlivening the forms' foundational play with word-image relations. While scholars and thinkers have, for millennia, presented the word-image relation

as one of direct comparison, making competing cases for visual-verbal parity (*ut pictura poesis*, the "sister arts"), antagonism (*paragone*) or one-to-one semblance (ekphrasis), "this straightforward relationship, this norm" is, as Shelley Rice contends, "imitated, parodied, altered, undermined, and sometimes completely revamped in artists' books."[82] "Sometimes," she continues, the visual art found in artists' books "relate[s] directly, either in subject matter or mood, to the text," but sometimes it "serve[s] as metaphoric allusions to the emotional states described; at other times [it] ha[s] little if anything to do with the text, and act[s] as visual counterpoints."[83] The five works central to this study lend credence to Rice's charge, conveying a similar range of word-image relations in employing direct or indirect visual-verbal counterpoint (*Odes, Numbers, Arcade*) and/or ekphrastic leanings (*Concordance, Homage*) to varying degrees. Like many postmodern and contemporary visual-verbal collaborations more generally, all five works fundamentally rebuke the limiting, one-dimensional models of word-image relation and instead forward new extensions and revisions of them.

Chapter Overviews

Restoring to view "the whole context" of the five collaborative artists' books engaged here and thus privileging, in Stephen Fredman's recent framing, a "transactional view of poetry,"[84] this study (re)places the poets' lyric work—or more accurately, their lyric interventions—in conversation with the visual art that it extends, complements, confronts, and engages. In Chapter 1, Frank O'Hara and Michael Goldberg's 1960 *Odes* confronts the midcentury's dominant mode of artistic subjectivity, Abstract Expressionism, as its artists strive to reconcile their admiration for their expressionist idols with their competing desire to forge their own artistic signatures. Denying the heroic but isolated sense of selfhood associated with both Abstract Expressionism and the Romantic lyric, O'Hara and Goldberg situate the individual subject within the context of others, elucidating and negotiating the complexities of artistic and intersubjective attachment, affiliation, and disloyalty that conduct our intersubjective lives. Robert Creeley and Robert Indiana's 1968 *Numbers*, explored in Chapter 2, extends this

premise, seeking to reincorporate the individual subject within the collective. Exploiting its numeric, serial conceits in both form and theme, *Numbers* moves away from the solipsistic condition of the lyric I—the number one—and into the company of the many, as the poet and artist increasingly draw each other and their audiences into their works' ever-expanding empathic and subjective presence.

Progressing into a subsequent generation of bookmaking in Chapter 3, Anne Waldman and George Schneeman's 1997 *Homage to Allen G.* conveys the younger artists' intent to honor their forebears' poetic and artistic innovations while reimagining them anew. Revisiting lingering first-generation assumptions about artistic patrimony and egocentric subjectivity as they offer a visual and textual palimpsest of several photographs left behind by the book's dedicatee, poet Allen Ginsberg, Schneeman and Waldman dispense with the lyric "I" and the ideal of art as self-expression. Transforming their book from a private Beat tribute into an ongoing public performance, their artist's book not only elicits the audience's involvement in the work but situates the book itself as an instrument of community-building. Mei-mei Berssenbrugge and Kiki Smith's 2006 *Concordance,* covered in Chapter 4, deepens this sensibility, conceiving of the artist's book as an inclusive, feminist space that inscribes reader-viewers within its capacious landscape. Crossing continually between artistic media and epistemological premises—word/image, human/animal, "I" and "you"—the artists navigate the contingent and often fraught nature of embodied experience, especially for those who occupy gendered and racial bodies, as they work to cultivate intersubjective reciprocity. Taking an even more protracted view of race and gender issues, Erica Hunt and Alison Saar's 1996 *Arcade,* considered in Chapter 5, finally seeks to rewrite Black womanhood and attendant concerns of the body and sexuality. Challenging both the existing structures of hegemonic power and domination (patriarchy, racism, capitalism) that threaten to deprive their figures of full subjectivity and self-governance and revealing the audience's complicity in them, Hunt and Saar aim less to reify individual autonomy than to redistribute authority. Locating creative potential in community and social (re)organization, their artist's book reimagines a more hospitable public sphere by inscribing new modes of social relationality within it.

Widening out from these five case studies and reassessing the collaborative artist's book as a generic form, the coda takes up the question of its place in the twenty-first century, considering the books' complicated relationship to both our digital age and the reading practices that contemporary technologies have engendered. It considers how and why we might continue to attend to and to expand the representational reach of these forms in the present, indicating how artists' books can be valuable assets to both pedagogical practices and community-building efforts. Most important, however, this book ultimately extends itself as an invitation to others: an invitation to seek out the thousands of artists' books—collaborative, American, and otherwise—stashed away in archives worldwide so that new readers and scholars may deepen our knowledge of the genre and its many subcategories, and so that they may experience the tangible delight of these curious works. After all, as book artist Stephen Dupont once colorfully put it: "[Artists'] books are like lost dogs. They want to be found, picked up, touched, and smelt."[85]

"to refuse to be added up or divided"

Frank O'Hara and Michael Goldberg's *Odes*

Sometime in 1952, a twenty-six-year-old Frank O'Hara, fresh off the publication of his first volume, *A City Winter* (1951), met the painter Michael Goldberg, then twenty-eight, at the Eighth Street artists' hangout "The Club." According to their mutual friend, the artist Larry Rivers, O'Hara and Goldberg's was a fast friendship and an advantageous one. "Frank," Rivers relays, "practically made Michael Goldberg into an artist in the sense that he talked Mike Goldberg into the fact that he was a good painter," and it was O'Hara who subsequently "persuaded [Tibor de Nagy's John Bernard] Myers to give Goldberg's de Kooning-esque paintings their first show in October 1953."[1] But their acquaintance was surely as important to O'Hara, for it was in Goldberg and the other painters with whom they consorted at the Club and the nearby Cedar Tavern that he found the "only generous audience" for his "non-academic and indeed non-literary" verse, suggesting that it was, in some important sense, Michael Goldberg who "practically made" O'Hara into a poet.[2] Their early meeting was no doubt an auspicious one, occasioning a close friendship and professional relationship that would be memorialized for posterity in several well-known O'Hara poems, including the now infamous, much anthologized "Why I Am Not a Painter."[3] A short poem that witnesses O'Hara visiting Goldberg's studio as he painted (a not infrequent occurrence, since

"the days go by" and O'Hara is continually "drop[ping] in again" (*CP* 262)) and that offers, in course, an incisive meditation on visual-verbal relations and artistic process, "Why I Am Not a Painter" captures well the casual, collaborative sociability that defined O'Hara and Goldberg's relationship. It is a poem that presents two friends not only enthralled with making their own art but with making each other artists: a "real poet" (262) and a gallery painter whose most important audience was always one another. It is a poem, in this sense, that anticipates the most formal collaboration O'Hara and Goldberg would ever produce together: a five-print, nine-poem artist's book titled *Odes*.

Published in 1960 but begun around late 1957, *Odes* had been commissioned by the independent Tiber Press as part of a four-volume boxed set of artists' books that included three other collaborations by several of O'Hara and Goldberg's closest friends: John Ashbery and Joan Mitchell's *The Poems*, James Schuyler and Grace Hartigan's *Salute*, and Kenneth Koch and Alfred Leslie's *Permanently*.[4] Founded by the Italian serigraph master Florian Vecchi and the American printers Richard Miller and Daisy Aldan, Tiber Press had previously published a small journal *Folder*, which featured work by young artists and poets associated with the New York School, Black Mountain, and Beat circles, including Robert Creeley (Chapter 2) and Allen Ginsberg (Chapter 3). Though hardly unique among the period's many little magazines and journals in highlighting emerging artists, *Folder* was, Terence Diggory notes, exceptional for its "aesthetic emphasis," distinguishing it from "the pragmatism that drove the small-press movement of the 1960s."[5] It is unsurprising, then, that the Press should venture into even more elaborate aesthetic terrain with its collaborative artists' books. Drawing inspiration from Daisy Aldan's master's thesis on "The Influence of French Surrealism on American Literature," Tiber fashioned its 200-copy run, limited-edition artists' books after the European, modernist livres d'artistes that had been created in the 1920s and '30s by the likes of Apollinaire, Mallarmé, Picasso, and Matisse (among O'Hara and Goldberg's important shared influences).[6] Conceived as stunning art objects, "the generous size of the pages (17-by-14½ inches), the fine quality of the handmade paper, and the richness of color in the prints," Diggory observes, all served to "enhance the [Tiber books'] visual pre-

sentation."[7] More striking than these visual features, however, was the artists' books' subversive materiality, signaling a departure from the day's aesthetic norms, which were then still largely beholden to Abstract Expressionism. First, the books' use of serigraph (silkscreen) printing—an art technique through which paint or ink is squeegeed through a screen onto paper—not only proved a "significant exception" to the Abstract Expressionists' general reluctance to embrace print-making, as Donna Stein notes, but it also challenged the sense of pure, unadulterated gesture on canvas by then synonymous with the movement.[8] The Tiber books' use of screen printing augured a new relation between art and print technologies that would not only come to dominate Conceptualism and Pop in the next few years, as Andy Warhol popularized the method, but that would also precipitate the "democratic multiple" artist's book frenzy that took off as a result, discussed in the introduction. Second, although the "abstract expressionist movement [was] basically antimuseum in spirit,"[9] as O'Hara once mused, the museum had, by the late 1950s, become its rightful domain. The Tiber artists' books, by contrast, still belonged to the domain of independent galleries, booksellers, personal collectors, and private friends, residing at the margins of the central fine art economy and museum system. Finally, unlike the giant Abstract Expressionist murals hung on museum walls, which required of viewers a certain reverent distance, the Tiber books demanded of their audience close, tactile engagement. Like the interactive "happenings" and other innovative forms of poetry and art at midcentury, the Tiber artists' books blurred the boundaries between the aesthetic and social space—between art and everyday life.[10] Relegating fine art to the status of an ordinary object (a book), on one hand, and amplifying their aestheticism through their exaggerated dimensions, high-cost, limited-edition status, and non-representational prints, on the other, Tiber's collaborative artists' books could resist the sense of aesthetic autonomy associated with Abstract Expressionism, but they could also resist becoming "mass art."

Of the four collaborative artists' books in the Tiber Press set, none seems to probe these ideas more explicitly in form and theme than *Odes* itself—a volume that marries aesthetic concern to social reality in poem, print, and form. Created just between Abstract Expressionism's

nadir and Pop's explosion, *Odes* broaches for O'Hara, Goldberg, and their cohort of young New York School artists a pressing question: where does art go next? In answer, O'Hara's poems and Goldberg's prints strive to reconcile a dutiful allegiance to their artistic idols, centrally including first-generation Abstract Expressionists like Jackson Pollock, Willem de Kooning, and Franz Kline, with a competing desire to make proprietary art, effecting in O'Hara's poetry a revitalized lyric subjectivity and, in Goldberg's, an invigorated, non-derivative line that could be responsive to their own and others' lives in the world. Mediating between the individual's desire for freedom and the irrepressible presence of the social and artistic world, *Odes* elucidates the complicated forms of allegiance that people—artists, friends, lovers—bear to each other, refusing the conflation of any two artists while denying their complete separation. Taking Abstract Expressionism as its central test case, O'Hara and Goldberg undertake in *Odes* a complex negotiation between affiliation and, in equal measure, disaffiliation that positions art-making, and indeed life itself, as a thoroughly intersubjective affair.

That their collaborative artist's book alternates at uneven intervals between Goldberg's five screen prints and O'Hara's nine poems, that the artists did not necessarily complete the work together (with the exception of "Ode on Necrophilia"), and that it downplays any overt correspondence between the poems and prints has left *Odes* vulnerable to the suggestion that the work is an "illustrated book" rather than an artist's book or a "real" collaboration: a charge that insinuates both that the book is not a formally or conceptually integrated endeavor and that Goldberg's prints perform a merely ornamental role in it. Such assumptions might also explain why *Odes* is often overlooked in accounts of O'Hara's collaborations, despite being created just between his two most famous ventures: the 1957 *Stones* with Larry Rivers and the 1960 *Poem-Paintings* with Norman Bluhm. Yet while it would be inaccurate to suggest that the prints and poems purport any direct one-to-one semblance or ekphrastic relationship, one continually finds in *Odes*, to appropriate Harold Rosenberg's fitting description of the "Action Painters" themselves, that "What [the artists] think in common is only represented by what they do separately."[11] Or to adapt Goldberg him-

self: while the "poetry [doesn't] complete [the] visual material," it does "complete [our] understanding of visual material," and vice versa.[12] Announcing on its cover "Poems by Frank O'Hara," and "Prints by Michael Goldberg," *Odes* insists on the uniqueness of each man's artistic contribution even as it insists on their essential relation; in the artist's book form, after all, they are quite literally bound to each other. Any initial encounter with the book thus underscores what Andrew Epstein has called in O'Hara's work "the tension between individuality and union inherent in any collaboration or indeed, in friendship itself."[13] More than that, the measured formal relation between O'Hara's and Goldberg's art in *Odes* parallels exactly that with which they approach their Abstract Expressionist forebears in their individual poems and prints, crystallizing for the artist's book at large an intersubjective ethos best expressed in the opening poem for Pollock himself: "it is noble to refuse to be added up or divided" (*CP* 302).[14]

From the outset, *Odes* is deliberate in its positioning of O'Hara and Goldberg vis-à-vis Abstract Expressionism. The book's external and internal cover pages, bearing the first and second of Goldberg's five prints for the volume, are revealing. Featuring black and white calligraphic screen prints, both cover images readily evoke the signature work of first-generation Abstract Expressionist Franz Kline. This initial identification, however, soon gives way to a sense of defamiliarization, as the softness and imprecision of Goldberg's lines in both cover prints belies the relatively sharper, more exacting geometry often on display in Kline's canvases. If, as is often suggested, Kline's lines recall a stark urban environment of fire escapes, rail tracks, or skyscrapers, Goldberg's elicit a more fluid, natural landscape. In the second Goldberg print, in fact, the black and white paint strokes seem to evoke a vaguely human figure standing alone under a yellow sun, graphing not the (urban) environment itself but the place of the artistic subject within it. Goldberg's yellow paint strokes are striking for another reason too. Like the dramatic neon pink and green streaks Goldberg includes in *Odes'* external cover print, the internal cover print's bright yellow ones add a vivid color component to an otherwise black and white palette that further distinguishes Goldberg's prints from Kline's largely monochromatic ones, occasioning in the younger painter's work

what Paul Schimmel calls a "more dynamic, exuberant, and activated surface" than that found in earlier abstraction.[15] From its cover pages, then, *Odes* signals that although Goldberg remains indebted to the gestural innovations of first-generation expressionism, including to Kline himself, he also intends to forge his own approach to it.

O'Hara's first poem, "Ode on Causality," strikes much the same chord, taking the recently deceased Jackson Pollock, rather than Franz Kline, as its chief inspiration. Oscillating between a real reverence for Pollock and a marked ambivalence toward the painter's pervasive influence, the poem's equivocation is evident from the start. "There is a sense of neurotic coherence," it opens,

> you think maybe poetry is too important and you like that
>
> suddenly everyone's supposed to be veined, like marble
>
> it isn't that simple but it's simple enough
>
> the rock is least living of the forms man has fucked
>
> and it isn't pathetic and it's lasting, one towering tree
>
> in the vast smile of bronze and vertiginous grasses (*CP* 302)

Accentuating the "neurotic coherence" that O'Hara describes, the lines' double syntax cheekily indulges the poet's sense of his own artistic importance ("you think that poetry is too important and you like that") and that of Pollock ("You like that / suddenly everyone's supposed to be veined") while casting doubt on the same position through its grammatical ambiguity: *do you* like that, after all? The ode's long enjambed or "veined" poetic lines further enhance this effect, simultaneously granting Pollock's influence by emulating his drip paintings and qualifying the same position in turn, for as soon as the "veined" lines become "like marble," both O'Hara's poetry and Pollock's drips calcify. John Wilkinson contends:

> The marmoreal becomes associated with poetry (or any art) conceived as "important" and "Suddenly everyone's supposed to be veined, like marble"—marble whose veins then run into the main body of the poem along the parallel lines of "fucked" and "your grave," veined like an erect penis and at the same time signifying the grave.[16]

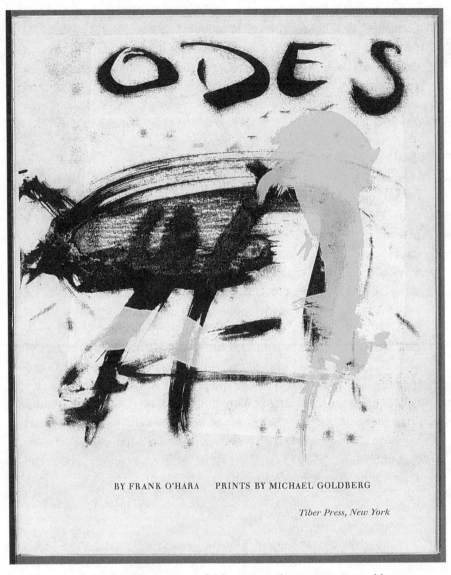

ODES

BY FRANK O'HARA PRINTS BY MICHAEL GOLDBERG

Tiber Press, New York

Figure 1. Michael Goldberg, cover of *Odes*, 1960, color screen print and letter-press on paper, 17¾ × 14⁵⁄₁₆ × ½ in. Artwork © Estate of Michael Goldberg; courtesy of Michael Rosenfeld Gallery LLC, New York, NY. Images of *Odes* furnished by Houghton Library and Library Imaging Services, Harvard University.

To extend Wilkinson's erectile reading, O'Hara suggests in "Ode on Causality" that being "veined" is no longer a viable nor a virile pose. As soon as "everyone's supposed to be veined," art becomes impotent or turns to "rock"—the "least living of the forms man has fucked." In replicating Pollock's (marmoreal) line, circulation is impeded: art and body turn to stone. After all, as the poem's original title, "Ode on the Grave of Jackson Pollock," makes clear, the elder artist is already quite dead with his grave marked by a large boulder ("the rock"). Thus, any desire to reproduce, sexually or artistically—to "fuck" Pollock or to create in his "vein"—is not only deadly but perverse, as the later "Ode on Necrophilia" will perhaps confirm.

In "Ode on Causality," O'Hara makes mockery of those, including himself, who would take Pollock's influence too seriously. Breaking with the poem's plain language, O'Hara parodies the obsequious monumentalizing of Pollock by adopting the sensationalized tone of historical elegies and odes, mocking the "sweet scripts" of "Old Romance . . . draping dolors on a scarlet mound, each face / a country of valorous decay, heath-helmet or casque, *mollement, moellusement*" that "obfuscate the tender subjects of their future lays" (*CP* 302). The subjects of such overblown "lays," as the bawdy pun suggests, must be put to bed (perhaps a lethal enterprise). As the poem continues, O'Hara figures Pollock as an outsized force of nature in a send-up of the vaulted modes of apostrophic address central to the great Romantic odes—or what Marjorie Perloff has called a "Shelley-cum-Dada" burlesque.[17] Reminiscent of Shelley's "Ode to the West Wind," O'Hara positions Pollock as a kind of Aeolian wind, furnishing artistic inspiration:

> over the pillar of our deaths a cloud
> heaves
> pushed, steaming and blasted
> love-propelled and tangled
> glitteringly
> has earned himself the title *Bird in Flight*
> (*CP* 303)

Here again, however, the poem reveals the risks of reproduction, for as soon as Pollock becomes an artistic progenitor—his procreative or

ejaculative capacity evinced in language of "heaves," "pushed," and "love-propelled"—he himself solidifies into a memorial painting or statue—another form of "rock."[18] There is, O'Hara warns, an implicit hazard in Pollock's iconicity: the bird here is, ironically, frozen in flight, and forward movement is impeded.

Inasmuch as O'Hara considers the stultifying consequences of reproducing (with) Pollock, however, "Ode on Causality" does not disavow his influence outright, striking a balance akin to that which Goldberg achieves in his earlier Kline-inspired prints. Like Cordelia's vow to King Lear, who is referenced earlier in the ode—"I love your majesty according to my bond, no more nor less" (I.i.93)—O'Hara vows to Pollock, artistic *paterfamilias*, "not much to be less, not much to be more" (*CP* 303), negotiating a measured approach toward his aesthetic bequeathal.[19] O'Hara longs to remain charged by Pollock without resorting to stale imitation of him:

> and like that child at your grave make me be distant and imaginative
> make my lines thin as ice, then swell like pythons
> the color of Aurora when she first brought fire to the Arctic in a sled
> a sexual bliss inscribe upon the page of whatever energy I burn for art
> and do not watch over my life, but read and read through copper earth
> (*CP* 302)

Calling out to Pollock-as-muse, O'Hara desires a (pro)creative "fire" and a "sexual bliss" that can inhibit "veined" impotence, conferring on the poet "lines" that are not "like marble," but swollen "like pythons"— engorged, virile, alive (the poem's earlier sexual-artistic innuendo carries through). David Sweet has noted that O'Hara derives "important lessons from Pollock's method especially in the painter's "sense of free bodily movement, exhilaration, and even violence."[20] Yet if, as Sweet continues, "this movement implies a kind of macho vigor apropos of Pollock's work," then O'Hara instead aims to "captur[e] [in his work] the more nervous, sprightly energy of his own verbal restlessness."[21] "Ode on Causality" stresses the point, conveying O'Hara's desire to emulate Pollock's uninhibited, bodily method without succumbing to his now defunct machismo, striving to preserve the "metamorphic vitality"[22] of the painter's lines in spirit, not letter. Where Pollock might

achieve in his art, "a state of spiritual clarity [. . .] a limitless space of air and light in which the spirit can act freely and with unpremeditated knowledge,"[23] as O'Hara describes in his book on the painter, the poet instead strives in "Ode on Causality" for "the look of earth, its ambiguity of light and sound / the thickness in a look of lust, the air within the eye" (*CP* 302). If, in other words, Pollock achieves a "spiritual clarity" in his work, then O'Hara is after "the look of earth" in his own: a poetry vested not in transcendent perspicuity but in tangible phenomena (light, sound, air) and human desire ("a look of lust"), attuned to the contours of his own material life. It is a mode of poetry that O'Hara will, in fact, unearth in the final "Ode to Michael Goldberg ('s Birth and Other Births)" where the lyric speaker reveals:

> . . . a foreign land
> toward whom I have been selected to bear
> > the gift of fire
> > the temporary place of light, the land of air
>
> down where a flame illumines gravity and means warmth and insight,
> > where air is flesh, where speed is darkness
> and
> > things can suddenly be reached, held, dropped, and known
> > > (*CP* 293)

Completing *Odes*' trajectory from Pollock's death to Goldberg's birth —which Wilkinson has called a "reverse biography,"[24] but which appears, in this view, more like a requisite art-historical progression— O'Hara finally locates in and through Goldberg's work what he sets out to discover in Pollock's wake: a responsive, fleshly, material art that he can bring, Promethean-like, back to earth where "things can suddenly be reached, held, dropped, and known."

That the poet ultimately discovers this in his final dedication to Goldberg is no accident, since Goldberg's art itself provided O'Hara a clear example of innovative art that could capitalize on Action Painting's "method" without being beholden to its result. How to achieve such an art—or what it might look like—was indeed a central concern for Goldberg and many of their fellow Tiber artists who made up the

"second-generation Abstract Expressionists" like Joan Mitchell, Grace Hartigan, Helen Frankenthaler, Al Leslie, and others. As these artists recognized early on, the art world was quickly becoming stagnant, flooded with painters who rushed to emulate abstraction's "endless tangle, the great scale, the new materials," which had, as Happenings originator Allen Kaprow laments in a 1958 essay on "The Legacy of Jackson Pollock," petrified into "clichés of college art departments."[25] "In the late 50s," Goldberg recalled in a 1979 interview, "there was more bad, permissive abstract expressionist work being done than you could shake a stick at—and most of it was done seriously but with complete mindlessness."[26] O'Hara himself broached a similar point when, in his 1963 "Art Chronicle III," he reflected: "What hath Pollock wrought? you don't even have to put the thing on the floor anymore and you can even get someone else to finish it, as a boyfriend helps his girlfriend win a panda at Palisades Park."[27] By 1963 and certainly by 1979, such "mindless" derivativeness was self-evident. In the late 1950s, when O'Hara and Goldberg were first working on *Odes,* however, the question of Action Painting's continued influence had not yet been so firmly resolved, as a playful poem addressed to Tiber Press's Richard Miller makes clear. Admonishing Goldberg for being so intoxicated by the contemporary art scene (figuratively and too often literally) that he was neglecting his collaborative duties, "To Richard Miller" begins:

> Where is Michael Goldberg? I don't know,
> he may be in the Village far below
> or lounging on Tenth Street with the gang
> of early-morning painters (before noon)
> as they discuss the geste or jest
> of action painting.

"Maybe," O'Hara speculates,

> he is living sketches of an ODE
> ON SEX which I do not intend to write
> in his abode or drinking bourbon in the light. (*CP* 301)[28]

Still, O'Hara promises to "goad him into Tibering and hope all's for the best" (*CP* 301). O'Hara's characteristically droll tone notwithstanding,

the poem's description of "action painting" both as "geste" and as "jest"—worthy of real admiration but also at risk of becoming a real spoof—foreshadows the ambivalence toward Abstract Expressionism that underscores *Odes* itself.

For Goldberg and O'Hara, the task in *Odes* is to capitalize on earlier artistic experiments, centrally including Action Painting, while finding their own individual interpretations of them: interpretations that could avoid both the (faux) self-seriousness of "geste" and the farce of "jest." As Goldberg would later emphasize in a 2001 interview, "I've always felt that art comes out of art. . . . Art requires looking, and a little bit of selective thievery, too."[29] To Goldberg, the artist's task is to balance "selective thievery" with a commitment to personal development, casting the artistic past—both others' and one's own—as a structural foundation out of which to reinvent the artistic present. Ironically, this idea, which he elsewhere calls an "architectonic concept,"[30] is likely one that he adopted from Willem de Kooning himself, since Goldberg esteemed "the way de Kooning had deflected the grand tradition of Western art in a new direction while acknowledging his debt to the 'fathers' of modernism. As de Kooning said, 'I have this point of reference—my environment—that I have to do something about. But the Metropolitan Museum is also part of my environment. . . . I change the past.'"[31] It is therefore fitting that the Goldberg print in *Odes* that offers the clearest feat of this de Kooning-esque revision is also the one that most directly invokes the elder artist's work itself. Arrestingly done in mustard yellow, cobalt blue, gray-black, and candy red, *Odes'* third print bears a familial resemblance both to de Kooning's 1955 *Gotham News* and to Goldberg's proximate 1955 *Sardines* (the subject, perhaps not incidentally, of O'Hara's "Why I Am Not a Painter") in its reprisal of those works' primary color palettes. As in his Kline-inspired cover prints, however, Goldberg's vibrantly colored print suggests a slight departure from these earlier works, which are comparatively muted in tone. Additionally, in moving further away from the sketch-like nature of both *Gotham News* and *Sardines*, which call attention to their manual generation, Goldberg's *Odes'* silkscreen seems to portray a more dynamic, almost brash, approach to color and line that not only sharpens our sense of his medium—the active push or pull of forcefully "flood-

ing" and "stroking" the paint onto the silkscreen—but that solidifies Robert Rosenblum's assessment of Goldberg as a "painter who dared to embrace and to master the wildest fringe of Abstract Expressionist spontaneity."[32] Not least, the print exemplifies Goldberg's "architectonic" strategy, highlighting what *ArtNews* critic Thomas Hess called in an early review of Second-Generation Expressionism the marriage of "Manner"—"the 'look' of a picture as it relates to other pictures"—and "Style"—"the 'look' in a picture that is distinctly the artist's own [. . .] his signature of form, his unique perception, modification, and reflection, his color, and light."[33] "Manner," Hess elaborated, "helps bringing maturity more quickly and with maturity a different kind of liberty. They cannot simply smear a *tache,* but Goldberg can find room . . . in the velocity of colors that he has found in de Kooning."[34] *Odes'* third print works to this end, allowing Goldberg to "find room" or a "kind of liberty" in de Kooning's colors ("Manner") while showcasing his own artistic impulsivity and maturation ("Style").

Following in Goldberg's stead, O'Hara increasingly conveys in his odes a process of aesthetic development forged both in response to and in defiance of other artists, among whom few loom larger than de Kooning himself. Positioned just after "Ode on Causality" (despite being written before it), "Ode to Willem de Kooning" schematically continues the artistic quest begun in the first poem. Continuing the Pollock ode's pattern, "Ode to Willem de Kooning" vacillates between deference to and subversion of its titular addressee in what constitutes O'Hara's own attempt to bridge some poetic equivalent of "Manner" and "Style." The poem declares:

> I try to seize upon greatness
> which is available to me
>
> > through generosity and
> > lavishness of spirit, yours
>
> not to be inimitably weak
> and picturesque, my self
>
> > but to be standing clearly
> > alone in the orange wind (*CP* 284)

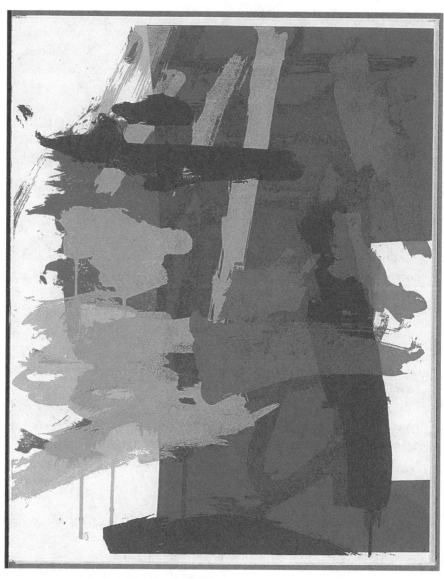

Figure 2. Michael Goldberg, untitled print from *Odes* 1960, color screen print and letterpress on paper, 17¾ × 14⁵⁄₁₆ × ½ in. Artwork © Estate of Michael Goldberg; courtesy of Michael Rosenfeld Gallery LLC, New York, NY. Images of *Odes* furnished by Houghton Library and Library Imaging Services, Harvard University.

Recalling his vow to Pollock, "not much to be less, not much to be more," O'Hara here, as Epstein notes, "longs for some of de Kooning's 'greatness' and genius to rub off on him and his own work, a possibility which seems tantalizingly 'available' because of the beloved painter's 'generosity / and lavishness of spirit.'"[35] At the same time, Lytle Shaw adds, de Kooning's "exemplarity" also "carries with it the prohibition against imitation: the painter does not imitate nature and (therefore) the poet should not imitate the painter."[36] Without giving over to "weak" imitation, O'Hara seeks inspiration from de Kooning's "greatness" in order that he might better discover "my self." That he should particularly locate himself in the "orange wind" is further revealing since, John Wilkinson notes, "orange" is "the colour O'Hara associates especially with de Kooning because it dominates the small de Kooning he possesses."[37] But it is also a color that has become indelibly linked to O'Hara's own collaborative and artistic imaginary, figuring prominently in both "Why I Am Not a Painter" (and thus further associating it with Goldberg) and in his work with Grace Hartigan, *Oranges: 12 Pastorals*. In "Standing clearly / alone in the orange wind," then, O'Hara seems poised to discover a new "kind of liberty" in the "velocity of colors that he has found in de Kooning," marrying manner to style in the same way Goldberg achieves in his prints.

What nonetheless distinguishes "Ode to Willem de Kooning" from the earlier "Ode on Causality" and from Goldberg's prints is that the aesthetic freedom O'Hara locates in the former is not exclusively reserved for the individual artist. In the de Kooning ode, the lyric speaker's solitary posture, "standing clearly / alone," is only a temporary ruse, especially since he has located that freedom via another: de Kooning, most immediately, and Goldberg by extension. As the poem's dominant pronoun conspicuously shifts from "I" to "we," O'Hara situates aesthetic freedom less as an individual achievement than a collective prerogative. In fact, no sooner does the poetic speaker pledge his quasi-patriotic allegiance and loyalty to de Kooning—saluting his *Easter Morning* and *Gotham News* hung on the "enormous" museum walls—than the poem undercuts this devotion a mere couplet later, devolving into a violent act of collective betrayal:

and I look to the flags
in your eyes as they go up

 on the enormous walls
 as the brave must always ascend
into the air, always the musts
like banderillas dangling

and jingling jewellike amidst the red drops on the shoulders of men
who lead us not forward or backward, but on as we must go on

 out into the mesmerized world
 of inanimate voices like traffic
noises, hewing a clearing
in the crowded abyss of the West (CP 284)

To be sure, this is not an uncomplicated or a painless revolt even if it is a necessary one, as O'Hara makes clear when the banderilla-inflicted wounds, "red drops on the shoulders of men / who lead us not forward or backward," are thrown into ambivalent relief at the poem's end: "'Maybe they're wounds, but maybe they are rubies' / each painful as a sun"—perhaps insinuating the foolishness of the "brave" insurgents' Icarus-like ascent (CP 285). Still, he does recognize this departure as a collective necessity ("always the musts"), bolstering the de Kooning (in)subordinates ("we") who "must go on" beyond the museum's "enormous walls" and "out into the mesmerized world," where they will pursue their artistic manifest destiny and carve out their own place in the oversaturated European art tradition, "hewing a clearing in the crowded abyss of the West." The poem's pioneer imagery would have been salient for O'Hara and his friends who, Daniel Kane notes, fancied themselves "cowboys going beyond the frontier . . . both in terms of the experimental nature of . . . the [art]work and in their role as bohemian 'colonizers' of the Lower East Side."[38] That this imagery also evokes Americana so clearly solidifies America's role as the postwar Western art world's "new frontier," completing the shift from the European and Parisian to the New York avant-garde that had, of course, begun with European émigrés like de Kooning.

In "Ode to Willem de Kooning," O'Hara suggests that he and Goldberg can best show their allegiance to the first-generation Abstract Expressionists' legacy by becoming themselves the next avant-garde, even if that means partially rebelling against their idols. Cataloging an epic journey, "Beyond the sunrise / where the black begins" (*CP* 283) to a "Dawn" that "must always recur / to blot out stars and the terrible systems / of belief" (*CP* 285)—from darkness to light, ignorance to Promethean knowledge—the de Kooning ode presages the emergence of a new artistic generation buoyed by the "imperishable courage and the gentle will / which is the individual dawn of genius rising from its bed" (*CP* 285), rehearsing a tension elsewhere implied in *Odes* between a striving for "individual genius" and a necessary, inevitable sense of social and aesthetic collectivity and affiliation ("our lives"). More striking, O'Hara's description also resonates closely with Thomas Hess's *ArtNews* review of second-generation expressionism (which the poet surely would have seen), wherein the critic finds in Goldberg's and his peers' work a "'new light'" that "reflects from Pollock, Gorky, de Kooning, Still, Kline, and other older artists—and the artists borrow light from each other. It is not a new dawn but a continuation of a day that may last as long as the one the Impressionists, almost a century ago, saw filling their landscapes with sun."[39]

Nonetheless, this sensibility entails the critical caveat that the second-generation artists' "new light," in Hess's terms, or the "new dawn," in O'Hara's, is not unequivocally "new," since both O'Hara and Goldberg disparage novelty as an aesthetic goal. Asked in a 1965 interview whether O'Hara thought it was "important to be new," he replied, "No, I think it's very important not to be bored though."[40] Goldberg himself similarly derided the contemporary "worship of the New," questioning why "Hot-off-the-griddle art is usually hot off somebody else's griddle?"[41] A rejoinder, in part, to the Poundian/modernist injunction to "Make it New," O'Hara and Goldberg are less concerned with aesthetic novelty for its own sake than for circumventing the tedium of derivativeness or cliché. Indeed, "Ode to Michael Goldberg" itself sanctifies this position when O'Hara dismisses the facile equation of "newness" with innovation:

"the exquisite prayer
to be new each day
brings to the artist
only a certain kneeness" (*CP* 297)

Mutlu K. Blasing has wondered whether the malapropism "kneeness" offers a "parody of Poundian newness" or a "sign of the subjugation of the artist, brought to his knees in spiritual abjection or physical incapacitation."[42] O'Hara seems to mean both. The term "kneeness" not only rejects the high modernist imperative to novelty but also proposes that pursuing "newness" for its own sake results, if not in a "spiritual abjection or physical incapacitation," then in a humbling recognition that no art is ever truly "new"—that all art, to recall Goldberg's own words, always comes out of other art. In rejecting "*knee*ness," O'Hara embraces its opposite: *keen*ness. As the de Kooning ode makes plain:

. . . the light we seek
is broad and pure . . .
[. . .]
while we walk on to a horizon
line that's beautifully keen,
precarious and doesn't sag
beneath our variable weight (*CP* 284)

Reinforcing both their common project and the "variable" potential of its individual realization, the artists' search not for a "new" light but for a "broad and pure" light circumvents aesthetic inertia, allowing them to discover a "horizon / line" both in painting and in verse, "that's beautifully keen." Seeking to liberate art from the twin pressures of banal imitation and absolute novelty—both forms of "useless aspiration towards artifice" (*CP* 296) as O'Hara writes in "Ode to Michael Goldberg"—*Odes*' stance toward "newness" bears its closest resemblance not to Pound's but to their friend James Schuyler's: "not Make it new, but See it, hear it, freshly."[43]

Making this Poundian adjustment central to its aesthetic philosophy, *Odes* both eschews novelty as an aesthetic value and refuses perfunctory reproduction, especially since the former, as Goldberg once

suggested, often precipitates the latter. In his 1958 essay "The Canvas Plane," Goldberg writes: "The demand and economy of the 'new' makes bastardization our accepted norm: packaging attractively the feeling of others, in the cry for the something immediately up-to-date in look, not necessarily something honest and felt."[44] Not content with something simply "up-to-date," O'Hara and Goldberg reject both high modernism's glib "newness" and the sense of rote imitation that not only threatened Abstract Expressionism in its late stages but that would soon assume its place as one of Pop's defining values, situating *Odes* at a crucial juncture between them. Perceptively noting a key difference between Frank O'Hara and Pop icon Andy Warhol, Brian Glavey maintains that O'Hara, unlike Warhol, "remains invested in a modernist logic of the exceptional, in the unique voice of the poem, and in the possibility that art might put us into contact with 'some marvelous experience.'"[45] That is: even if O'Hara and Goldberg reject "newness" for its own sake, they nonetheless remain attached to the "modernist logic of the exceptional," intent to produce art that is, in Goldberg's terms, "honest and felt" in order to stave off Pop's rote impersonality or art's predictable banality. The result in Goldberg's screen prints, to adapt Paul Schimmel, is a "shift from an epic, heroic art primarily concerned with the self to a lyric art interested in reality or nature and its emotional, spiritual, and perceptual effects on the artists."[46] In O'Hara's odes, similarly, it is a lyric subjectivity that denudes both abstraction's and the earlier Romantic odes' stale tendency toward sublime, transcendent, or "heroic" selfhood while still foregrounding, and insisting upon, its material inimitability: the marvelousness of its own experience. In retaining the "unique voice of the poem" or as analog, the artist's unique line but denying its claims to absolute autonomy, O'Hara and Goldberg can avoid transforming their artistic or lyric subjects—the "self"—into a Romantic or Abstract Expressionist cliché, but they can also avoid ironizing or reclaiming the self *as* cliché, as would increasingly happen in Pop. At a determining juncture in twentieth-century art history, O'Hara and Goldberg locate in *Odes* a new way "to relate to abstraction," to borrow from Glavey, that "blur[s] the line between abstraction and figuration itself."[47] The result, as David Shapiro might suggest, is a "collaborative contemporary work" that

"takes the idea of the marvelous . . . and makes it the norm [. . .] if the marvelous is to be found everywhere, it should be a shareable, public language rather than a solipsistic burden."[48]

It is this paradigm that O'Hara triumphantly uncovers in his final "Ode to Michael Goldberg," bringing the painter's influence fully and finally to bear on his own poetry. Cataloging the deeply joyful and deeply painful events, momentous and mundane, that shape O'Hara's lyric self, from birth to his earliest homosexual experiences, and from his years in naval service to ordinary nights at the local "Five Spot" (*CP* 296), "Ode to Michael Goldberg" shifts wildly and unpredictably (if its repeated use of "suddenly" is suggestive) between elation and despair. The poem's pattern is unmistakable: no sooner does the ode vault its lyric speaker toward transcendent heights, "presenting," as Marjorie Perloff notes, "Wordsworthian moments of vision,"[49] than it plunges him back into his corporeal humanity where "a not totally imaginary ascent can begin all over again in tears" (*CP* 293). Evoking the child-hood splendor of

> climbing the water tower [where] I'd
> look out for hours in wind
> and the world seemed rounder
> and fiercer and I was happier
> because I wasn't scared of falling off (*CP* 292)

the speaker, like a poet-master of the universe, describes a sublime world where "the wind sounded exactly like / Stravinsky" and "I first recognized art / as wildness" (*CP* 292). Yet it is a condition that the poem refuses to sustain, dropping down back down into the filthy barn rafters of O'Hara's "secrets at an early age, / trysts," where we locate the speaker "on colossally old and dirty furniture with knobs," amid "the twitching odor of hay," fumbling through an early, awkward sexual encounter (*CP* 292). Inasmuch as "Ode to Michael Goldberg" indulges in moments of supreme awe, it is not a poem of meditative rapture. It is instead, as Wilkinson rightly contends, the luminous, and at times profane, testimony of "a lyric voice emerging and made flesh."[50]

Chastening the speaker's tentative claims to transcendence, "Ode to Michael Goldberg" offers a meandering, Odyssean account of an out-

sider bracing against "the cold wind . . . in febrile astonishment," and navigating "a cruel world [. . .] / wondering where you are and how to get back" (CP 297), but one for whom, any meaningful "return" or homecoming is impossible since "to 'return' safe . . . will never feel safe" (CP 296).[51] The poem offers an account of a lyric or epic hero whose embodied position in the world is fundamentally insecure, figuratively and expressively displaced: "the center of myself is never silent" (CP 293). It is unsurprising, then, that the speaker aligns himself not with the statuesque "hero of demi-force . . . upon / an exalted height," as he writes in the earlier "Ode on Lust" (CP 282), but with the nomadic dispossessed: first, the Indian, and later, the slave: "I am really an Indian at heart, knowing it is all / all over but my own ceaseless going" (CP 296). Conceding, in a witty pun, both the end of Action Painting and his own abjection ("knowing it is all / all over"), the speaker must identify himself and his alliances anew. If as a form of poetic red- or blackface from a white male writer the poem's racial identifications are troubling, at best, and indefensible, at worse, they nevertheless continue a pattern O'Hara establishes earlier in Odes when in "Ode: Salute to the French Negro Poets" the lyric speaker alternatively adopts the role of colonizer and colonized in order to articulate his own alienation and the concomitant possibility of self-determination.[52] In the Goldberg ode, O'Hara appropriates these marginalized identities to fashion a speaker free of normative allegiances (national, political, and aesthetic): one who might find independence in being beholden only to himself and his own art, unencumbered by personal inertia or aesthetic precedent.

As in the earlier de Kooning ode, however, "Ode to Michael Goldberg" again suggests that any independence the speaker locates is unsustainable, tempered by the recognition that he is, in this state, a wreck: not a prolific "hill of dreams and flint for someone later," but a vacant "hull laved by the brilliant Celebes response, empty of treasure to the explorers who sailed me not" (CP 296). In this wreckage, in fact, the only salvageable good ("a glistening blackness in the center . . . gleaming profoundly") are his interpersonal connections: the "ornamental / human ties and hates" (CP 293) that tether the speaker, unwittingly or not, to others. Though "Ode to Michael Goldberg," like so much of O'Hara's poetry, at first makes a claim for "absolute independence," it also con-

cedes that such independence is, in Epstein's terms, an "unfeasible" or "illusory" goal, since the self "can't help colliding with other selves"[53]— since the self is inevitably embroiled with others, socially as well as artistically. Indeed, though the Goldberg ode begins with its speaker's crude attempt to colonize the world that he enters, as he comes "moaning into my mother's world / and trie[s] to make it mine immediately" (CP 291)—a valiant effort at sovereignty—the poem denies its achievement when the speaker's body is relentlessly besieged by others, from the claustrophobic presence of city strangers, "too many, too loud / too often / crowds of intimacies and no distance" (CP 296) to the all-consuming grief of recently deceased friends: "death belonging to another / and suddenly inhabited by you without permission" (CP 293). As in the Pollock and de Kooning odes, "Ode to Michael Goldberg" undertakes a complex negotiation of freedom and allegiance that confirms the impossibility of "absolute independence." It therefore comes as no surprise when the freedom that speaker finally claims, "because it moves / yes! for always / for it is our way" (CP 298), is not individual but collective ("our way"), again underscoring the lyric subject's irrepressibly marvelous but consummately social spirit.

O'Hara's final ode is not a paean to individual freedom but a soaring account of collective liberation. As though announcing the arrival of the pioneers who, in the de Kooning ode, set out to "he[w] a clearing in the crowded abyss of the West," the Goldberg ode's last lines recount,

> a fleece of pure intention sailing like
> a pinto in a barque of slaves
> who soon will turn upon their captors
> lower anchor, found a city riding there
> of poverty and sweetness
> paralleled
> among the races without time,
> and one alone will speak of
> being
> born in pain
> and he will be the wings of an extraordinary
> liberty (CP 298)

The poem witnesses a rebellious cohort of artists ("a group of professional freshnesses," *CP* 297) staking out their place in a "city . . . of poverty and sweetness paralleled / among the races without time" not unlike O'Hara and Goldberg's beloved, if gritty, Lower East Side. Nevertheless, O'Hara's ode makes clear that the achievement of this collective freedom is not without individual sacrifice, as "one alone will speak of being / born in pain." Consistent with Mutlu Blasing's sense that O'Hara "views the artist as a self-destructive, sacrificial figure,"[54] often "ascrib[ing] such a role to Jackson Pollock," the final ode seemingly ascribes this role to its own dedicatee, recasting Goldberg ("the wings of an extraordinary liberty") in Pollock's original image (the "Ode on Causality" *Bird in Flight*). Of course, given the lines' ambiguity, the poetic shift from the lyric "I" to a third person "he" might serve not to venerate Goldberg as a sacrificial model but to reinforce the slipperiness of the lyric self, as in so much of O'Hara's work. That the poem's "he" is identified as a pinto (Latin for "to paint"), makes its connection to Goldberg especially apt. In either configuration, however, the pronominal ambiguity—the poem's I/he slippage—confirms the indelible presence of someone or something besides or beyond the self: the sense that "I" is also another. More, the final lines affirm that the sacrificial provenance of "one alone" is always embroiled with that of the collective ("a barque of slaves") whom he liberates through his aesthetic risk. As the poem's subtitle ("'s Birth and Other Births") itself attests all along, the poem is not the account of a singular, prodigious birth but of a collective (re)naissance: one artist, like one person, always and inevitably comes out of another. "Ode to Michael Goldberg" resolves not the speaker's "rugged individualism" but, as Brian Glavey puts it, his utter "interdependence," his "irreducible intersubjectivity."[55]

"Two Russian Exiles: An Ode," the ninth and final poem that O'Hara completed for the artist's book, solidifies the point. A last-minute addition to what was originally conceived as an eight-poem volume but that was prudently called "Odes" without a "number in the title" in case O'Hara could "'have' another [poem] before curtain" and "could add it if it's good,"[56] *Odes*' penultimate poem is not only dedicated to Russian musician Sergei Rachmaninoff and writer Boris Pasternak but draws inspiration from the latter's *Doctor Zhivago*, which had been translated

into English in 1958, the year O'Hara penned the poem. Patterning itself on Pasternak's novel, which features a central character who, O'Hara notes, "forego[es] the virtual suicide of his retreat in the snowy wilderness . . . which has offered him . . . the solitude for his poetry" and returns to Moscow to find "the 'active manifestation' of himself . . . in his life in others,"[57] the ode's own lyric hero relinquishes exile's "interminable desolation"—which, while artistically generative, is socially suicidal ("cloud-rack men in off from their own lost kind" (*CP* 313) O'Hara puns)—to return to the city's mortal, connected life: "as one moves from the Ural's / eaglish clearness towards the muddy heart of Moscow" (*CP* 313). It is, O'Hara writes, a "birdlike rite" (*CP* 313) of passage from solitude to intersubjectivity that presages the Goldberg ode's triumphant flight.

That the central figures in both "Two Russian Exiles: An Ode" and in "Ode to Michael Goldberg" ultimately forgo absolute social and aesthetic freedom to unearth "the active manifestation" of themselves in others well suggests *Odes'* intersubjective orientation. More fundamentally, O'Hara underscores this orientation through his generic choice of the "ode" all along: a genre of lyric poetry centrally founded on address—a call to another. Throughout *Odes*, O'Hara's poems call out to the others on an expansive list laden with friends and other artists: Pollock, de Kooning, Pasternak, Rachmaninoff, Walt Whitman, and Aimé Césaire ("Ode: Salute to the French Negro Poets"), Joe LeSueur ("Ode (to Joseph LeSueur)"), Beethoven ("Ode to Joy"), and, not least, Goldberg himself. Yet if the ode, and especially the Romantic ode that O'Hara so often parodies, customarily relies on an apostrophic address that "posits a subject asked to respond in some way, if only by listening," then "few poets," Jonathan Culler notes, "actually have the temerity to imagine an explicit response."[58] O'Hara is himself among Culler's exceptions— a poet who not only "uses canny strategies"[59] to lampoon the addressee's conventional unresponsiveness but whose odes demonstrate, even earnestly, the value of a real respondent and interlocutor: in this case, Goldberg himself. *Odes* seems, in this regard, a vibrant demonstration of what O'Hara would famously call "Personism" in 1959: an "exciting movement" that "has nothing to do with philosophy, it's all art . . . one

of its minimal aspects is to address itself to one person (other than the poet himself), thus evoking overtones of love without destroying love's life-giving vulgarity."[60]

Perhaps nowhere is the value of a real respondent, nor the "overtones of love" inherent to interpersonal and lyric address, more humorously relayed than in "Ode on Necrophilia": the only silkscreen O'Hara and Goldberg completed together. In a letter to Tiber's Richard Miller, dated October 13, 1958, O'Hara enthusiastically reports: "Incidentally, [Mike and I] did Ode on Necrophilia on several screens in script which I think is quite readable (very readable), and I think it's terrific. It's red, white, blue, and black (mat) and the writing to be shiny black. Wait till you see it! I hope you like it as much as we do!"[61] What emerged from that session was not only the book's most visually stunning print but its collaborative centerpiece. Amid Goldberg's red, white, blue, and black abstract print, O'Hara's poem reveals:

Well,
 it is better
 that
 OMEON
 S love them E

and we
 so seldom look on love
 that it seems heinous[62]

Opening with an initial rationalization ("Well, it is better that . . ."), the poem both signals its tongue-in-cheek take on acceptable social norms (advocating for "necrophilia" is a vexed position, no doubt) and interpolates the imagined revulsion of the speaker's unheard addressee—perhaps the reader herself. But because the poem makes us privy only to the speaker's position rather than to that of its addressee, who is invoked in absentia or who is, in fact, deceased—taking the ode's conventional unresponsiveness to its sardonic extreme—O'Hara transforms his perverse desire for the dead into an utterly defensible position and, more, a dutiful service. The speaker enlists himself to

"look / on love," to act both as its loyal bard and its consummate voyeur, while chastening others—"we"—who "so seldom" do. Flipping the poem's initial defensiveness on its head, the "heinousness" here is not, in the end, the speaker's necrophilia but the addressee's or reader's own callousness: their refusal to return the (amorous) gaze—to love the speaker back.

If the poem displays O'Hara's subversive wit on its own, however, the real triumph of "Ode on Necrophilia" lies in the way it connects to Goldberg's print in the context of the collaborative artist's book: a connection that serves not just to subvert the addressee's unresponsiveness—the painter and his art here return the call (love the poet back)—but to solidify the work's broader collaborative claims. Evoking the American flag, Goldberg's red, white, blue, and black silkscreen situates O'Hara's poem within a chaotic national landscape, further intimating its allegorical underpinnings by arrogating O'Hara's considerations of love and death to larger considerations about (American) democracy and public loyalty. Framed by the print, in other words, the "campy-horror combination of love, devotion, death"[63] found in "Ode on Necrophilia" extends to patriotism: art, love, death, and country coalesce in Goldberg's blood-red paint strokes. That Goldberg also subtly but unmistakably scrawls "DIE" in black paint in the print's lower left quadrant, dramatizes the love-death fusion suggested by the poem's title. The poem-print conflates a love of dead men (necrophilia), a love of (dead) artists, a love of other men (allegorically graphed in O'Hara's Othered "them"), and love of one's country (patriotism), wherein each seems no less "heinous" than the others. In blind devotion to each, one confronts the prospect of an unrequited love that is humiliating, at best, and fatal, at worst. Most significant, "Ode on Necrophilia" magnifies the limitations of viewing O'Hara's poem sans print, much as it appears, for instance, in *The Collected Poems*. For it is in the poem's relation to the print, invoking as it does a complex web of associations between art, love, and sociopolitics, that *Odes'* major thematic threads converge and the volume's larger conflict surrounding the vicissitudes of national, interpersonal, and artistic allegiance and (dis)loyalty are granted both visual dimension and visual urgency. At last, in allowing their works here

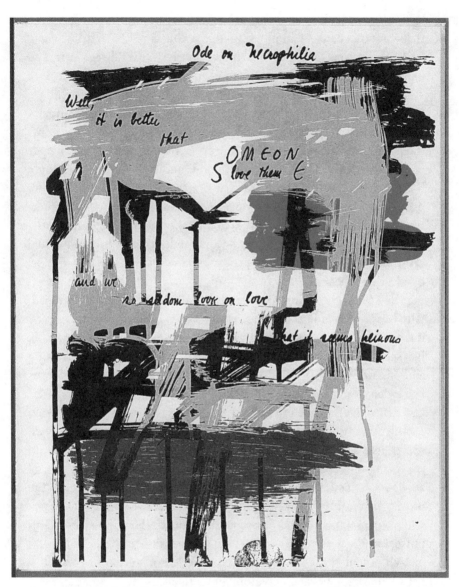

Figure 3. Michael Goldberg and Frank O'Hara, *Ode on Necrophilia*, color screen print and letterpress on paper, 17¾ × 14⁵⁄₁₆ × ½ in. Artwork © Estate of Michael Goldberg; courtesy of Michael Rosenfeld Gallery LLC, New York, NY. Images of *Odes* furnished by Houghton Library and Library Imaging Services, Harvard University.

to directly address each other, the collaborative poem-print forestalls the worst outcomes of an unrequited love that threaten to destroy it.

When, in the collaborative artist's book form, Goldberg's prints finally actively reciprocate or respond to O'Hara's lyric call, and vice versa (even when they do so less overtly than in "Ode on Necrophilia"), *Odes* inevitably evokes strong feelings of attachment and reciprocity between its two artists, two people, and two works, even as it confronts the potential risks inherent to such connection: loss (of independence or artistic identity), betrayal, stagnation, and death itself. Striking a balance between the uniqueness of O'Hara's poems and Goldberg's prints and their inseparable connections in the book form, *Odes* effectively helps to "establish a theory of collaboration that counteract[s] some of the more extreme Romantic and modern versions of individual creation"[64] that dominated the post–Abstract Expressionist landscape, by locating "the autonomy of the individual within the field."[65] Refusing the idea of the monumental individual, since "the rock is," recall, "the least living of forms," *Odes* reminds us that all "art is inflected by its sense of the addressee" especially at a moment when "the addressee has seemed to slip away, as in much twentieth-century lyric painting and poetry."[66] By foregrounding address *explicitly*, *Odes* also encourages its reader-viewers to think about how each man's art might address the other's *implicitly*. More crucially, it trains the reader-viewer's attention on the extradiegetic circumstances not just of collaboration but of all social occasions in the first place: how, it asks us to consider, should two things (art, people) speak to each other, come together, or engage at all? Anticipating once more O'Hara's "Personism," which places "the poem . . . at last between two persons instead of two pages,"[67] *Odes* positions artmaking itself as a thoroughly human, thoroughly social impulse, born of a desire for contact with something or someone beyond oneself—something beyond one's own work. For it is in this contact— between artists, between creators and audiences, between addressers and addressees, or, in O'Hara's "Lucky Pierre" formation, between lovers)—that art is not simply conceived but brought (back) to life. And if such "Personism" sustains the work, then the collaborative artist's book addresses itself, finally, to its audience, entreating its reader-

viewers' response: our contact with it. *Odes* beseeches us to answer its call, perhaps to love it back. In fact, it leaves us no other choice. As "Ode on Necrophilia" well reminds us, after all, to refuse to respond—to refuse the artists' overtures—would indeed "see[m] heinous." We would be dead inside.

A Form of Accounting

Robert Creeley and

Robert Indiana's *Numbers*

In 1974, the Whitney ran two simultaneous exhibits curated by its art history students. The first, "Frank O'Hara: Poet Among Painters," was mounted at the museum's central uptown gallery and paid homage to the poet's art world connections eight years after his death. The second, "Nine Artists / Coenties Slip," was shown at the museum's lower Manhattan branch and celebrated a group of artists—James Rosenquist, Ellsworth Kelly, Agnes Martin, and Robert Indiana among them—who lived at the Slip in the 1950s and '60s. Together, the exhibits made lively display of two vibrant New York art scenes that coexisted at midcentury, but that, at least by Robert Indiana's account, did not always readily mesh.[1] Robert Indiana, art historian Susan Elizabeth Ryan relays, "felt uncomfortable at the famous Eighth Street Club ('one evening there was enough') and had no interest in the Cedar Tavern, the legendary artist's bar" that O'Hara and his artist friends frequented, dismissing the art produced by them as "'the work of alcoholics.'"[2] Coenties Slip was "entirely different from where the abstract expressionists lived, around Tenth Street. South of the Bowery there was nothing like the celebrated Eighth Street Club that served New York as a kind of 'surrogate Parisian café.'"[3] Less the

panache of a "Parisian café," the Slip was an industrial wasteland: an "out-of-the-way warren of warehouse loft spaces [which] dated from the nineteenth-century heyday of commercial shipping in that precinct," Thomas Crow elaborates, "that abounded in discarded artifacts and paraphernalia of a bygone commercial boom," like the metal stencils that lent the artists' work a distinctly mercantile ethos.[4] To consider these two exhibits, then, is to consider something fundamental about the difference between the artist's book that O'Hara and his visual collaborator, Michael Goldberg, had created at the dawn of the 1960s, Chapter 1's *Odes*, and that which Robert Indiana and his own poet collaborator, Robert Creeley, created at their close: the 1968 *Numbers*. Not only had Pop's explosion in the intervening years made vogue of the "found" material that had long infiltrated Indiana's works as a matter of location and course, but it had shifted the art world's class sensibility in turn, placing art more firmly within the purview of the commercial masses rather than of the artistic elite. It is therefore fitting that Creeley and Indiana's *Numbers* should take its cue not from the urbane, aesthetic concerns of O'Hara and Goldberg's *Odes* but from the familiar, even mundane, primary number system itself.

Differences in the two books' origins are further revealing. Architected not by an established small press, as *Odes* and many European livres d'artistes had been, but by the designer William "Bill" Katz—a recent college graduate who moved to New York in 1965 and assisted "Bob" Indiana in his studio—*Numbers* seems more a product of fortuitous circumstance than of artistic idealism. Katz recalls:

> I'm one of those people I meet somebody and then something else happens. For instance, on a plane to Pittsburgh I met Domberger [*Numbers*' German printer], and then Domberger did some things of [Indiana's] and then published some things. I commissioned Creeley, whom I'd known from school, to write the Number poems. And then there was a need to write about the number poems, the posters and the prints, and nobody else was really that interested in doing it. Bob was always thought of as kind of difficult.[5]

Given Indiana's "difficult" nature, it fell to Katz not just to publicize the artist's work but to make vital connections on his behalf to bring that

goal to fruition. With a proletarian sensibility well matched to Indiana's own—"I learned more about poetry as an actual activity from raising chickens than I did from any professor at the university," the poet once quipped—Creeley was likely a receptive audience for Katz's solicitation.[6] Indeed, the poet would find lifelong friends in both Katz and Indiana, whose correspondence, featuring colorful variations of Indiana's signature "LOVE" and numbers prints, proliferates in his archives after the mid-1960s. Nor was Creeley a stranger to the sort of collaboration Katz proposed, having previously worked with French artist René Laubiès on *The Immortal Proposition*: a 200-copy, string-bound book of poems and drawings published by Jonathan Williams's Jargon Press. Creeley was, finally, accustomed to collaborating with other artists from afar, having taken up residence in New Mexico, outside of the central New York and Bay Area art hubs. Creeley's "distant collaborations," as Barbara Montefalcone calls them, even became something of a trademark; in these works, including *Numbers* and those in its wake—*Presences* with Marisol (1976), *Mabel* with Jim Dine (1977), and *Life and Death* with Francesco Clemente (1993)—"The dialogue . . . takes place through an interposed medium: the telephone, the fax, and the letter . . . work as partners in the collaborative project."[7] More striking still, in *Numbers*' case, was that Katz himself, often conversing with Creeley by phone and letter in Indiana's stead, added yet another intermediary layer to this dialogue, consecrating Stephen Fredman's sense that Creeley's collaborations "rais[e] [his] network of communications to the status of a work of art in its own right"[8] and that in them, in Montefalcone's pithier terms, "one plus one always makes something more than two."[9]

Of course, the "network" dimensions of Creeley's poetry are well known, bolstered by the many scholarly titles that virtually announce themselves as social occasions, from an early *boundary 2* issue dedicated to the poet, "Robert Creeley: A Gathering," to an exhibition catalogue of his collaboration bearing the supertitle *In Company*.[10] Still, few works epitomize this communal orientation better than Creeley's collaborative artists' books, and none more than *Numbers* itself: a project thoroughly and titularly committed to multiplicity. Indexing the efforts of Indiana and Creeley (its attributed creators), Katz (its

unacknowledged orchestrator), as well as its German publisher Luit-pold Domberger, type-master Dr. Cantz'sche Druckerei, and translator Klaus Reichert, whose German translations of Creeley's poems succeed their English counterparts throughout the book, *Numbers* not only evokes multiplicity in its collaborative form but proceeds through a thematic exploration of the same idea. As a central conceit, the number system affords Creeley and Indiana fertile ground for probing the relationship between the individual and the multiple or the one and the many—a relationship with especial salience in the midst of a 1960s "Aquarian age" of "massification."[11] At a time when Americans belonged to ever-expanding networks, from bourgeoning civil rights movements to large corporations; relied increasingly on mass com-munication technologies like the television and telephone (which had switched, in 1961, from an exchange name to an "All-Number" calling system);[12] and lived under the cruel shadow of a Vietnam War that lit-erally consigned young men to (draft) numbers or, more bleakly, to a body count, what continually stood to be lost amid the vast scale of late 1960s life was an experience of personhood as such—not as a statistic or a cipher but, to invoke Oren Izenberg, as "a value-bearing fact—as the necessary ground of social life."[13]

Numbers is both symptomatic of and acts as an antidote to its late 1960s milieu. Setting out not from zero, as the number system conven-tionally prescribes, but from one, *Numbers* moves from the individual toward the collective, establishing reciprocity between them. Refusing the impersonality that threatened to define 1960s life and, not least, much of the period's Pop and Conceptual art (with which Indiana's work is often too quickly aligned), *Numbers* remains invested in people: past and present, real and imagined. In this context, Indiana's numeric screen prints are not rote posters but affective "portraits," as Susan Elizabeth Ryan rightly describes—images that bespeak real people rather than mere figures.[14] Creeley's poems respond in kind, lending credence to the idea, as he notes in 1968, that "People are the most important things in the world for me . . . I am a person. And how my world is, is intimately related with how all other worlds of persons can be. I am never, never apart from that concern in working."[15] Without abandoning the importance of "one"—the individual ("I"), the lyric

subject—Creeley's poems refuse its totality, opening out instead to other people and to other art: to seriality and multiplicity. In Indiana's prints and Creeley's poems, and through their relation in book form, *Numbers* conceives of a subjectivity, and a complementary form of art, that accrues.

At roughly 10½ inches tall and 8½ inches wide, just smaller than a legal pad, and "bound in cardboard" such that "it looks like it has a piece of brown wrapping paper," as Katz excitedly tells Creeley on a fall 1968 phone call upon receiving his first copy, *Numbers* is, at first glance, somewhat unremarkable.[16] A "little thing" printed on "off brown kind of veined lined paper," the book initially "looks like it's cheap but if you look at it, it's not cheap."[17] With scant embellishment on its front cover beyond "stencils at the bottom that sa[y] 'Numbers' and the top in heavier letters with small type [that] says 'Robert Creeley dot Robert Indiana,'"[18] the artist's book looks staid and economical, especially compared to a work like *Odes,* which, at nearly double the size and bearing Goldberg's vivid abstract print on its cover, strikes the viewer both as more sensuous and more expensive. Yet *Numbers'* inconspicuous cover is at odds with its dynamic interior, where one encounters, first, Creeley's poems, "printed one to a page first in English in black and then in German [translation], red on the next page" followed by Indiana's brightly colored, impactful, "Number [prints which], boom socks it to ya. And it's just gorgeous."[19] Such incongruities are endemic to *Numbers,* a book whose pedestrian premises (a plain cover, a simple number system) belie the complex, rousing feat of its visual and poetic execution. In Indiana and Creeley's hands, the automatic, even ascetic, nature of art that advances according to a fixed pattern—following both the numeric sequence and the repeated procession of "One" (Creeley poem), "Eins" (German translation), *One* (Indiana print); "Two," "Zwei," *Two*—gives way to a surprisingly affective set of conclusions.

By altering the order of digits, such that the book moves not from zero to nine, but instead from one to nine to zero, Creeley and Indiana undermine the teleological imperative of the rigid, predetermined systems on which the book operates, transporting the work from the realm of sober mathematics into the domain of metaphysical inquiry. Setting out from one, *Numbers* explores whether art can account for

subjectivity without becoming consumed by it. This exploration be-
gins in the first poem, where Creeley considers the number one, and
by extension, the traditional lyric "I," which he had once described as
"intensely singular" and ultimately "pathetic," barring the possibility
of "relationships to others."[20] "One" begins:

> What
> singular upright flourishing
> condition . . .
> it enters here,
> it returns here. (*The Collected Poems* 395)[21]

From the start, the poem plays on the visual similarity between the
number one and the letter *I*, both "singular upright" symbols that, as
straight lines, "ente[r]" and "retur[n]" to the same place. Though Cree-
ley's number poems are sometimes described as ekphrastic, the visual
description he offers in the poem is nearer to the Roman numeral one
(I) than to the Western Arabic numeral one (1) that appears in Indi-
ana's subsequent screen print. Instead of attempting to ekphrastically
re-present Indiana's prints, Creeley develops his own meditations on
each digit, musing on an array of conceptual associations with each
number, including their visual composition. In fact, the poem's more
pressing visual parallel—that between the number one and letter *I*—
becomes pronounced in its second section when a lyric subject finally
emerges:

> Who was I that
> thought it was
> another one by
> itself divided or multiplied
> produces one. (*TCP* 395)

Creeley develops an I/1 paradigm, denoting the solipsistic nature of
both the singular individual "I" (the lyric subject) and "one." Not only
does "I," like one, "enter" and "return" to the same place, but it "by itself
divided or multiplied" can only ever "produce one." The poem clarifies
the risks of hermetic singularity, and then of conventional lyric subjec-
tivity, underscoring Creeley's trepidation about "The solitary thinker

[who] has always been fearful to me, as has the condition of being isolated."[22] Likening I/1 to "a stick, a stone," "One" interpolates this anxiety, conjuring

> . . . some-
>
> thing so
> fixed it has
>
> a head, walks,
> talks, leads
>
> a life. (*TCP* 396)

a (lyric) subject whose "life" proceeds from, and appears contained within, its "head"; one whose life, in other words, is solitary, programmatic ("so fixed"), and circumscribed.

In *Numbers*' opening poem, the number one, the lyric subject, and by extension, the autonomous lyric poem, become coextensive, each underpinned by a similarly uneasy sense of self-containment. As Creeley himself noted in 1976:

> Sometime in the mid-sixties I grew inexorably bored with the tidy containment of clusters of words on single pieces of paper called "poems." What specific use to continue the writing of such poems if the need therefore be only the maintenance of some ego state, the so-called me-ness of that imaginary person. So writing, in this sense, began to lose its specific edges, its singleness of occurrence, and I worked to be open to the casual, the commonplace, that which collected itself.[23]

Abandoning the "single of pieces of paper called 'poems'" as well as the "singleness of occurrence" associated with the autonomous lyric subject ("the so-called me-ness of that imaginary person"), Creeley endeavors in *Numbers* to overcome the initial fixity of art, self, and number that he establishes in "One." It is a feat accomplished, first, by the book's collaborative framework, as Creeley's poems open out to their German translations and to Indiana's prints, positioning each English poem not as a standalone (lyric) reflection but as an integral part

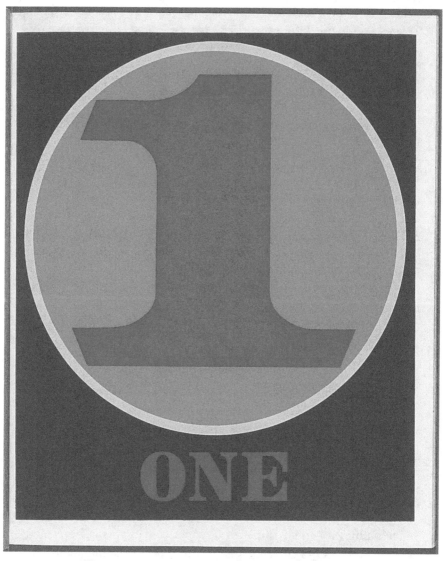

Figure 4. Robert Indiana, *One* from *Numbers* 1968, color screen print on paper, 23⁷/₁₆ × 19⁵/₈ in. Artwork © 2022 Morgan Art Foundation Ltd / Artists Rights Society (ARS), NY. Images of *Numbers* furnished by Houghton Library and Library Imaging Services, Harvard University.

of larger, intermedial series. The immediate presence of the German translations and of Indiana's prints, that is, attenuates the solipsism of the lyric pose from which Creeley's initial poem sets out. In the artist's book, the poems refuse the pervasive university model of New Critical "lyric reading" that, as Virginia Jackson has argued, reduces the "I" to an "isolated lyric subject" and an "abstraction" by denying its "developmental history" and myriad "social relations,"[24] and insists instead on a collaborative "circuit of exchange in which the subjective self-address of the [lyric] speaker is replaced by the intersubjective practice of the writer, in which the writer's seclusion might be mediated by something (or someone) other than ourselves."[25] In *Numbers*, "One" constitutes neither an autonomous lyric poem nor a fixed, delimited "point of so-called consciousness," as Creeley calls it in "Two," but becomes a shared, intersubjective occasion as Creeley's poem both addresses itself to and is met by a response from its German translation and Indiana's screen print; the shared numeric "occasion," becomes, to adapt Miriam Nichols, an "alternative to both the heroic (the great man)"— autonomous individualism—"and the statistical (rule by bureaucracy and opinion poll)"—the faceless mass.[26] The artist's book's collaborative form transforms each of Creeley's numbers from an isolated lyric event into a common human denominator.

In this light, Indiana's prints are similarly transformed; within the collaborative artist's book they are denuded of standalone meaning as they participate in the book's broader intersubjective and intermedial exchange. Numbers are among Indiana's prominent motifs, from his *American Dream* and *Exploding Numbers* series, where the painter works with a limited set of digits, to his *The Decade Autopilot Series* and sculptural *Numbers 1–0*, where all ten digits appear. In many of these works, numbers purport a stable, allegorical trajectory, in which each digit corresponds to a life stage, from birth (the "numeral 1, which is red and green") to old age ("7, blue and orange, stands for early autumn") and finally to death ("the zero, in shades of gray").[27] That Indiana's prints in the *Numbers* collaboration are colored accordingly, ending with a final, deathly gray zero, initially suggests the same arc, intimating a life, much like that described in Creeley's "One," whose course is fixed from the start. So too despite the generally non-ekphrastic nature of

Creeley's poems, does his "Zero" echo the deathly pall of Indiana's print. Negation is its abiding trope:

> . . . You
>
>> walk the years in a
>>> nothing, a no
>> place I know as well as
>>> the last breath. (*TCP* 405)

Creeley's "you," like Indiana's gray zero, seemingly concludes a life journey and "will also go nowhere / having found its way" (*TCP* 405).

Numbers' actual ending, however, undoes this sense of arrival, as the artist's book's visual-verbal sequence concludes neither on Creeley's "Zero" nor on Indiana's *Zero* but on "The Fool": an entirely "found" prose poem. Creeley explains: "The last part of the zero-sequence called 'The Fool,' is simply a quote from Arthur Waite's *A Pictorial Key to the Tarot*. I just looked at that because it was a beautiful estimation of the experience of nothing."[28] Describing the Fool tarot card, the collaboration's final poem conjures,

> a young man in gorgeous vestments pauses at the brink of a precipice among the great heights of the world; he surveys the blue distance before him — its expanse of sky rather than the prospect below. (*TCP* 406)

Upending the deathly arrival of Creeley's "Zero" and Indiana's gray *Zero*, where the "you" has "found its way," the Fool's "experience of nothing" evades finality or death. Poised on a precipice, his "eager act of walking is still indicated . . . his dog is still bounding," and his "countenance is full of . . . expectant dream" (*TCP* 406). The Fool's journey forgoes closure:

> The sun, which shines behind him, knows whence he came, whither he is going, and how he will return by another path after many days . . . (*TCP* 406)

At its conclusion, the collaborative artist's book is quite literally elliptical. While a cynical reading could suppose that the Fool's journey is no

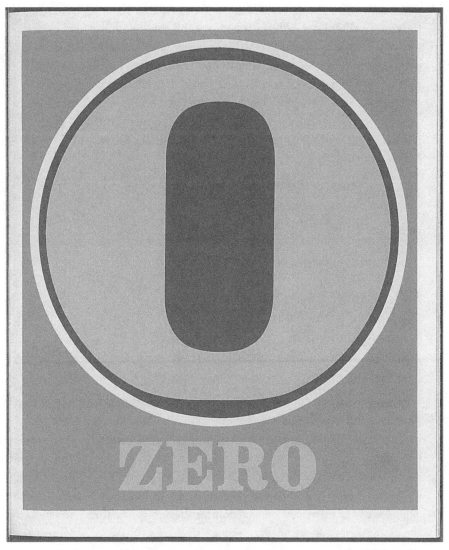

Figure 5. Robert Indiana, *Zero* from *Numbers* 1968, color screen print on paper, 23⁷/₁₆ × 19⁵/₈ in. Artwork © 2022 Morgan Art Foundation Ltd / Artists Rights Society (ARS), NY. Images of *Numbers* furnished by Houghton Library and Library Imaging Services, Harvard University.

more than a "fool's errand"—a naïve wandering without destination—the poem's ellipses herald continued possibility: though the Fool passes into some "other world," "he will return by another path." Far from a definitive ending, this "return" initiates a new journey, echoing the fact that the tarot card itself is read to connote new beginnings.

Ending with "The Fool," the book's final Zero sequence (Zero, Null, *Zero*, "The Fool") tricks us, culminating not in an arrival but in a departure, and sending us back to the beginning—back to one. Creeley muses in "Zero":

Reading that primitive systems
seem to have natural cause for
the return to one, after ten—
but this is *not* ten—out of
nothing, one, to return to that—
[. . .]

 •

What
by being not
is—is not
by being. (*TCP* 406)

Forcing a perhaps "unnatural" "cause for / the return to one," "The Fool" ("*not* ten") becomes a conduit between the end (zero) and the beginning (one). Of the number poems' subsequent reprinting in Creeley's 1969 *Pieces*, Charles Altieri observes that the poet imagines in them "a relation between zero and one [that] is a perpetual dialectic by which each creates and defines the other, while both at the same time generate the number system that contains them."[29] The lines' chiasmus "by being not / is—is not / by being" sharpens Altieri's observation, suggesting that the movement between "being" (one) and "nothing" (zero) is not linear but fluid or circular—indeed, dialectic. As such, if Creeley and Indiana's *Numbers* proceeds from one, then it is the zero that, dialectically, makes the one legible. Such a dialectic relation generates a whole system of numbers and, figuratively, of existentialism. Neither state—"being" (1/I) and "nothing" (0)—exists without its opposite; each term only becomes intelligible through the other. The

1/*I* paradigm—the individual artwork, the lyric subject—from which *Numbers* sets out cannot exist a priori. After all, "To return to one" is to recognize the one's (or the *I*'s) indelible position in a larger pattern; it is to be reincorporated within the many. *Numbers'* proposition is thus philosophical, sharing something essential with the later work of Alain Badiou, who posits in *Being and Event* that "mathematics is ontology"[30] insofar as what we perceive as "one" "is always a result."[31] Accordingly, if the *I*/1 paradigm that we encounter at the collaboration's beginning is a straight line that denotes fixity and singularity—a stand-in for the individual (lyric) subject—then the zero we find at its end is a circle that denotes a continuous, expansive whole—a symbol for community. In *Numbers*, "one" and "zero" do not signify a set of opposites: beginning and ending, being and nothing, the individual and the collective; these terms are coextensive—utterly contingent. Concluding with "The Fool," the book's trajectory from one to zero no longer represents an individual's immutable life journey from birth to death but augurs a process of continual (re)generation, as in the 1–0 binary language of computer programming. Circularity thus becomes a defining feature of *Numbers'* collaborative artist's book form.

In course, the book form undermines any predetermined or fixed meaning we might initially seek to ascribe to Indiana's prints or to Creeley's poems. Upon returning to "One" and cycling through the numbers again, for instance, the reader-viewer may recognize that Indiana's gray *Zero* seems less to foretell deathly conclusiveness than to portend the unknowability augured in the final tarot-card-inspired poem. More broadly, in following a prescribed, systematic pattern (poem, translation, print), the works, as they are presented in the artist's book form, resonate, echo, and invigorate each other. The poems (both in English and German) and the prints call out and respond to each other in dutiful repetition and numinous renewal—one, one, one, two, two, two, three, three, three. The effect is twofold. First, as Katz has elsewhere described, the numbers become "incantatory" in a manner resonant of Gertrude Stein, a recording of whose *Four Saints in Three Acts* Indiana had "played in art school again and again."[32] Far from dulling the reader-viewer's response to each number, however, the book's repetitions seem to refine it, as in Stein's own characteristic

reprisals. Much as each individual poem or print may take on new resonance in successive reading, the book's repetitive cycling deepens, and perhaps alters, reader-viewers' sense of each number, in turn. As Katz himself once wrote to Creeley:

> I wanted to write and tell you how really delighted I am with the continual and returning sense of yr. numbers. Again and again they come to stay (differently) with me. In some ways it is one of the happiest occasions of my life to be in some way on the "cause" of their coming into being. And how, how through them so much, beyond and forward come, are coming.[33]

Through the artist's book's repetitions, meaning accumulates. Second, such repetition lends the work a distinctive rhythm that Creeley himself credits to Katz's design: the feeling of clustered "intervals rather than just [autonomous] sheets of images" that "act as pace."[34] Each repetitive cluster ("One," *Ein*, *One*) comprises a small circuit that powers the work's larger temporal machinery; thus, even if each poem and print retains its individuality, none transcends its status as an integral part of the artist's book's larger signifying system.

Mediating between parts and wholes in this way, *Numbers* is well situated within a longer of tradition of serial poetry and visual art for which such a relation is programmatic—a tradition spanning from the early poetic examples of Louis Zukofsky's *A* and George Oppen's *Discrete Series* in the 1920s and '30s to the rise of the "serial attitude"[35] in the Conceptual art of the 1960s. Unlike its Conceptualist or Pop counterparts (e.g., Mel Bochner and Sol LeWitt's serial works or Andy Warhol multiples), however, *Numbers* rejects the methodological or automatic principles that such artworks frequently entail. Uninterested in the "deaestheticized and deskilled, aggressively unexpressive and resolutely nonsubjective minimalism,"[36] that much Conceptualist and Pop work, galvanized by the mimeograph's reproductive capacity, tend to favor, *Numbers* itself exploits a tension between serial order and subjective expressivity that makes its own conceptual and formal orientation closer to that of someone like Jasper Johns: an artist whose own number works, including *Zero–Nine* (1958–60) and *Numbers* (1967) prefigure Indiana's prints. Like Johns's serial number drawings, which,

according to John J. Curley, "recreat[e] the subjective, near obsessive marks so associated with abstract expressionism" and thus "check the chaos of his marks through his use of the individual numbers as limiting templates,"[37] *Numbers* stresses the interface of expression (subjectivism, chaos) and system (objectivism, order). Inasmuch as *Numbers* presents its own witty take on the "multiple" and, in its artist's book form, highlights the potential of duplicative or reproductive technology, both Creeley's poems and Indiana's prints, like Johns's work, deny the notion that

> seriality in art [is] a concept devoid of the personal, the narrative. With its affinity to mathematical structure, its meaning derived from numbered order, and its process graphed by system, serial art offers a maddeningly abstruse efficiency. It has been understood as a way of killing off expression and refusing signification or individuation through deference to self-generating systems.[38]

As Creeley himself once noted, "I want to say almost didactically that there is no information that does not have an affective content, even if it's blinking lights or numbers in random series."[39] By retaining a sense of "the personal, the narrative" in its art and poetry, *Numbers* preserves art's expressive premise even as it works through the system's procedural terms.

The most arresting of Creeley's poems in the volume, "Seven" and "Eight," offer the clearest feat of how the collaborative artist's book reconciles the number system's "abstruse efficiency" to art's "affective content," tendering a form of expressive, but inclusive or expansive, lyricism absent its stultifying isolation—bearing us further away from the solipsistic lyric subject and toward intersubjectivity. A palimpsest of internal memory and extraneous quotation, "Seven" charts Creeley's disparate reflections over twenty-four hours, moving from seven in the morning to seven in the evening. Its first section reads: "*We are seven*, echoes in / my head like a nightmare of / responsibility" (*TCP* 401). The poem opens allusively, recalling William Wordsworth's "We Are Seven" from the *Lyrical Ballads*. Recounting a conversation between a lyric speaker and a young girl, "We Are Seven," much like Wordsworth's well-known "Lucy" series, centers on a child's untimely

death. Throughout Wordsworth's poem, the lyric speaker queries the young girl about her brothers and sisters as she repeats, to his confusion, that "we are seven," although two of her siblings have died: "Seven boys and girls are we; / Two of us in the churchyard lie / Beneath the churchyard tree."[40] Creeley's allusion to this poem in *Numbers* is not incidental. The poet himself had "seven" children at the time of writing—three with his first wife, Anne McKinnon, and four with his second wife, Bobbie Louis Hawkins, including two biological daughters and two stepdaughters. One of those stepdaughters, the eight-year-old Leslie had, however, died in 1961 after a tragic accident in which she was buried under a collapsing sandbank.[41] It is therefore unsurprising that the haunting refrain "*we are seven*" should "ech[o] / in [Creeley's] head like a nightmare of / responsibility" recalling as it does not just Wordsworth's poem but likely Creeley's own sense of grief and even guilt-ridden torment.

The several forms of repetition Creeley develops in the poem further enhance its sense of anguish. While the repetition of the word "seven" three times in the space of a few lines recalls the little girl's insistence in Wordsworth's poem, the idea of

> . . . seven
> days in the week, seven
> years for the itch of
> unequivocal involvement. (*TCP* 401)

also suggests another form of redundancy, conveying time's tedious cycles. Time moves unrelentingly on, but Creeley's grief over Leslie's death endures. The number poems were also written and published roughly "seven years" after her accident, lending gravitas to the otherwise common cliché (the seven-year itch) that Creeley invokes as he mourns the "seven years" of "unequivocal involvement" now lost. Assonance is also a prominent force in this section, particularly in the final two lines, as the short *i*—"seven," "in," "itch," "unequivocal involvement"—recurs. This concerted focus on the letter *i* seems both to emphasize Creeley's culpability—"I" am responsible—and to endow otherwise distant, allusive material with lyric sentiment, transforming the number seven from an abstract sign into poignant symbol.

Creeley's next poem, "Eight," builds on these themes. Having announced the "end of the seven," the next determinate step is to "Say 'eight' — / be patient," to wait for associations to accrue (*TCP* 402). Gradually they do. Immediately, as elsewhere in the series, Creeley muses on the number's constituent parts: "two fours / show the way" (*TCP* 402). Next comes the number's astronomical association, the eight-year lunar cycle (*octaeteris*):

> Only this number
> marks the cycle —
>
> the eight year interval —
> for that confluence
>
> makes the full moon shine (*TCP* 402)

Though astronomical in scale, this temporal preoccupation with "cycles" echoes the less monumental ellipses and other formal modes of cycling that pervade *Numbers*. More, the ancient Greeks used *octaeteris* to structure their calendar, which was divided into two four-year periods that echo Creeley's opening section "two fours show the way." Creeley's subsequent association of eight with the modern calendric month of August follows suit: "Now summer fades. / August its month — / this interval" (*TCP* 402). "Eight" foregrounds the utility of numbers for calculating "intervals" and measures of time. Not only does it begin by demanding "patience," suggesting duration, but it later considers the tally: "In light lines count the interval. / Eight makes the time wait quietly" (*TCP* 403). Creeley considers the passage of time at various scales — the astronomical lunar cycle, the current occasion ("Now"), and the distance between past and present. Situated at the poem's center, the fourth section considers this final "interval":

> She is eight
> years old, holds
> a kitten, and
> looks out at me. (*TCP* 402)

As in "Seven," we are reminded of Leslie's death when Creeley conjures this imploring young girl's image. Creeley potentially overlays temporal

frames as his biological daughter Kate, born in 1959, would have been about eight herself when he was writing. The present image of Kate may herald that of the other eight-year-old figure. When, however, the poem continues, "Where are you. / One table. / One chair" (*TCP* 403), Creeley's continued grief over Leslie's death is palpable. As the imploring question "Where are you[?]" affirms, that loss, though years earlier, remains painfully proximate.

Even more than "One," Creeley's "Seven" and "Eight" are intensely lyric poems. Through its apostrophic address ("Where are you."), Creeley's "Eight," in particular, moves us into a "lyric present" that, as Jonathan Culler describes, "displace[s] a time of narrative, of past events reported, and place[s] us in . . . the 'now' in which, for readers, a poetic event can repeatedly occur."[42] In "Seven" and "Eight," the narrative past of Leslie's death is displaced by a "lyric present" in which Creeley and then the reader-viewers continually register that event. Fittingly, Culler notes that the "clearest example" of this lyric temporality surfaces in the elegy, which "replaces an irreversible temporal disjunction, the movement from life to death, with a reversible alternation between mourning and consolation, evocations of absence and presence."[43] Lending credence to John Steen's contention that Creeley was a much more "prolific elegist" than is traditionally recognized, "Seven" and "Eight" "undertak[e] a non-traditional work of mourning that serves less as a tribute to a lost loved one than as a testament to grief's problematic ongoing."[44] Creeley particularly contemplates this idea at the end of "Seven," imploring:

> . . . Why
> the death of something now
>
> so near if *this*
> number is holy.
>
> Are all
> numbers one?
> Is counting forever
> beginning again. (*TCP* 401–2)

Consumed by grief, to count is not to move from 1 to 2 to 3—to progress—but to start at "one" and "forever begi[n] again," as if in a

ceaseless tally; here, *Numbers'* formal cyclicality takes on a darker pall, conveying the at once cyclic and nonlinear nature of mourning. The elegy's meditation on time is also accentuated, as Creeley implies that time moves on, but grief endures, defying rational or sequential logic. Creeley himself admits in "Eight" that there is

> No going back —
> though half is
> four and
> half again
> is two. (*TCP* 403)

Mired in a perpetual, painful "lyric present," Creeley's poems, like grief itself, grows large, assuming inordinate time and space. As the final section of "Eight" reveals:

> Oct-
> ag-
> on-
> al. (*TCP* 403)

Though it is only one word describing an eight-sided figure, Creeley wrenches its sections apart to elongate grief's painstaking duration. The poet considers "Oct"— the prefix for eight, which perhaps also calls to mind October, when Leslie's death occurred (October 1, 1961) — and the central "agon," struggle, trial — the root of agony. "Octagonal" languishes in the poem's extended temporality, bringing readers into the poet's enduring grief and perhaps, empathetically, their own.

"Seven" and "Eight" remain standouts not just for their ability to explore the way the (elegiac) lyric subject occupies grief's vexed temporality but for their more radical proposal that *I* is never alone in these occupations. "I like time's accumulation of persons,"[45] Creeley has said, and in "Seven" and "Eight," persons, indeed, accumulate: Wordsworth's little cottage girl, Leslie, and reader-viewers are even implicated as time, and the poems, go on. That *I* infrequently appears in both poems (and in the number series writ large) is instructive in this regard. Characteristic of his *Numbers* poems, "Seven" and "Eight" embrace parataxis, reveling in the vastly different registers of meaning that each digit

might provoke—allusive, astronomical, private, idiomatic. Juxtaposing the specificity of personal or autobiographical remembrance to the innocuous ubiquity of found speech or quotation, "Seven," moves, for instance, between the event of Creeley's own birth, marked by "a monument / of stone, a pillar" (*TCP* 401) that his father erected at the hospital where he worked, and a common idiom, "At sixes and / sevens" (*TCP* 401). Later, in "Nine," Creeley similarly juxtaposes a quote from E. A. Wallis Budge's *Amulets and Superstitions,* which yields a description of nine as the "'triad of triads,' / 'triply sacred and perfect / number,'" with a husband's recollection of his wife's pregnancy:

> . . . The nine months
> of waiting that discover
> life or death—
>
> *another* life or death—
> not yours, not
> mine, as we watch. (*TCP* 404)

Such abrupt shifts illuminate Creeley's working method particularly well. "In some halfhearted sense I looked up texts of numbers and got some information that way," the poet has explained, "but it was immediately so scholastic and scholarly in tone that I couldn't use it. I was really using something as simple as 'what do you think of when you think of the number eight; is that a pleasant number for you?'"[46] Collaging personal memory with "scholastic and scholarly" association or found quotation, Creeley's lyric *I*, like the "pillar" erected in "Seven," may demarcate a point of origin, but one whose occasion marks only a fleeting moment in a longer sequence of events and a whole, encompassing world of persons. Apposing one perspective on a digit to another, cubist-like, the lyric "I" who speaks is one voice among many others; *I* is one mark in a larger tally.

Neither the lyric "I" nor the singular poem constitutes an endpoint—a complete or autonomous entity. If Creeley momentarily dwells in the elegy's meditative temporality—the iterable, painful "now" of lyric enunciation—then he also refuses to idle there. Shored up by the forward, continuous movement that both time and serial artwork compel,

Creeley, and his reader-viewers, must go on. The beginning of "Nine" is emphatic: "There is no point / of rest here" (*TCP* 403). To "rest," after all, might risk turning Creeley's dynamic, contiguous poetic series into a contained, generic lyric poem. Put differently, by insisting on an open, serial form of poetry, Creeley denies our ability to turn "Seven" or "Eight" into another example of "intensely singular" or self-contained art. Instead, his serial verse, to appropriate Joseph M. Conte, operates according to a metonymic logic in which each poem composes "a point on the periphery of some whole or context"—perhaps the circular framework of the collaborative artist's book itself.[47] Through seriality, Creeley undercuts the lyric self-absorption that threatens to consume "Seven" and "Eight," leading us away from what he calls in "Nine" the "fading containment," which "resolves" nothing (*TCP* 404). In fact, it was through writing the poems for *Numbers*, inspired by Indiana's prints, that Creeley first discovered how to work in this serial poetic mode, which would subsequently become central to his late 1960s and 1970s verse. Speaking to Bill Katz in 1968, having recently completed his 1969 *Pieces*, Creeley relays:

> Well I'll tell you one thing's happened this summer I got . . . we went to Mexico . . . I think I wrote you . . . that I finished [*Pieces*] and that's terrific and "Numbers" sits, like, right, well no it's right in the center, so I'm feeling really very good [. . .] Because frankly, the means of writing that that sequence got to is really . . . what I was frankly looking for, something that didn't have to continue in the usual thematic or, you, know, the developed thought business. And that sequence broke that. [. . .] It really helped me extremely.[48]

Moving beyond "the usual thematic" or "developed thought business," Creeley's serial poetry in *Numbers* and afterward could, as Alan Golding has argued, finally work toward an "inclusiveness" that his "own [earlier] lyric practice did not allow."[49]

In the context of the *Numbers* collaboration, this serial "inclusiveness" extends to Indiana's prints as well. Accustomed to reading Creeley's poems, replete with personal reflection, viewers may impulsively search for private meaning in Indiana's numeric screen prints or, more radically, attach their own. This is not to suggest that Creeley's poems

restore some Benjaminian "aura" to Indiana's work, but that their intense presence does condition the collaborative artist's book's reader-viewer to see each of the *Number* screen prints as particular, reflective occasions as much as routine, constituent parts. The poem-print cycling is again crucial to the feat, since Indiana's prints, on their own, might appear to reflect nothing more than an objective or abstract system, with each print's template-like resemblance—each with a brightly colored, encircled number in foreground and a contrasting color in background, accompanied by the number spelled out in full ("THREE"; "NINE") beneath—evoking the mass-produced advertisements or posters central to Pop's canon. As Jonathan Katz muses: "Without enough words to form a thought, without enough imagery to suggest a scene, neither precisely abstract (for they do spell out words) nor exactly representational [. . .] the paintings can seem, for all their high-keyed color and aggressive design, anti-expressive, remote, even cold."[50] Of course, each number's varying color scheme (one is red, two green, three orange, etc.) and the nature of numerals themselves, such that "seven" is just like but necessarily different from "eight," counter a sense of sheer reproduction. Placed after Creeley's poetry, however, the mechanical elements of Indiana's prints are thrown into greater relief. A testament, in Stephen Fredman's terms, to the poet's "uncanny ability to mimic the form and retrieve the experience underlying a work of visual art,"[51] the number poems address something in Indiana's screen prints, that, Susan Elizabeth Ryan elaborates, only "Creeley and a few other astute observers" have recognized in them: the "sharp dichotomy [that] separates the works' impersonal, patterned forms and rhetorical subject matter, and the submerged networks of memories and experiences that indeed manage to inflect surface messages."[52] Creeley himself confirms, "With an Indiana number . . . it is like someone's particular number, and [the artist] gives an extraordinarily emotional feel that he can make manifest in, say, 'Number Two.'"[53] Replicating the tension between the "impersonal, patterned forms" and the "submerged networks of [personal] memories and experiences" in his own poems, Creeley effectively primes reader-viewers to see Indiana's number prints as something more than merely colorful shapes or automatic facsimiles.

That Indiana's numbers are quite personally revealing has been well documented in the years since *Numbers'* debut. Throughout Indiana's oeuvre, the number six is, for instance, often associated with the painter's father, Earl, who worked for Phillips 66. The *Six* print that appears in *Numbers* functions accordingly. Boasting a vivid green six encircled in a striking red-orange on a sky blue background, *Six* recalls "the bright red and green of the old Phillips [gas station] signs against the equally strong blue of the Midwestern sky of [Indiana's] youth," that Adrian Dannatt observes in similar Indiana prints.[54] In the same vein, Indiana's frequent association of the number eight with his mother Carmen—a pun based on her apocryphal last words "eat"—recurs in *Numbers*.[55] Indiana's *Eight* not only intuits the same clever play on words (eat/eight/ate) found elsewhere in his oeuvre but reprises the black, red, and brown color palette of Indiana's earlier diptych *EAT/DIE* (1962), also created in his mother's memory, situating the vivacity of an encircled bright red number eight (a color often used for Carmen) against the idle, deathly void of a black background. Taken together, the screen print's "eight" pun and its color palette offer an uncanny tribute to Indiana's mother, evoking Carmen's life and death (*EAT/DIE*). In this sense, the *Six* and *Eight* prints also suggest another source of inspiration: Charles Demuth's "poster portraits." A series of eight works that famously includes *I Saw a Figure 5 in Gold* (for William Carlos Williams)—Indiana's "favorite American painting"[56] in the Metropolitan Museum of Art and a sort of verbal-visual collaboration in its own right—Demuth's "poster portraits" combine the "brash techniques of advertising combined with [a] fascination with abstraction" with "objects . . . and typography associated with his subjects to depict the essence of his subjects' professional lives."[57] Following the example of Demuth's "poster portraits," Indiana's *Numbers* prints interpolate the "brash techniques" of advertisement (the template) or here particularly, the abstract, nonrepresentational number system to invoke the spirit of the people they summon. In them, the juxtaposition of the poster's bald, reproductive efficiency with the portrait's ethereal sentimentality provokes for their viewers a striking, if inscrutable, magnetism.

No less than Creeley's "Seven" and "Eight," Indiana's *Six* and *Eight* are elegiac, eliciting the simultaneous presence and absence of loved

ones whose memory lay just below the work's surface. Much like Creeley's elegiac poems, Indiana's screen prints proffer a sense of interpersonal relation endemic to portraiture itself. "Making portraits," Richard Brilliant maintains, "is a response to the natural human tendency to think about oneself, of oneself in relation to others, of others in apparent relation to themselves and to others."[58] In this sense, Indiana's "poster portraits," like Creeley's poems, incorporate the individual subject (artist, figure, lyric speaker) into a world of other people, including, for both men, into familial relation. Together and separately, Creeley's number poems and Indiana's number prints evince, in the poet's own words, a "field of action among persons": a mode of art that endeavors, in Creeley's own words, "to move into form . . . with others, with one's wife, husband, children, the sudden instances of relationship, the worn ones, all of it."[59] This relational "field" at last extends not just to the "others" who immediately populate their works—parents, children, artistic forebears—but also to the artist's books' reader-viewers who later encounter them.

Though numbers can appear like nothing more than rudimentary shapes—"Five," Creeley writes is "a way to draw stars" (*TCP* 400) and "Six," "two triangles interlocked" (*TCP* 400)—the artists' interest in them transcends mere geometry, a point stressed in Creeley's insistence that "Three" is a "triangle" not just "of form" but "of people" (*TCP* 398). At once thoroughly quotidian and personally resonant, Creeley's poems and Indiana's screen prints are potent reminders that numbers are unparalleled loci of particular and common designation: they demarcate our qualitative individuality—birthdays, Social Security numbers, addresses, lucky numbers—as much as they account for our collective, quantifiable lives—the common time (hours, dates, years) and spaces (distance, population) we occupy. Charles Altieri duly notes of Creeley's number poems: "Number, like language, absorbs into itself the gap between individual and universal. In common sense terms, at least, numbers and words refer to specific events; yet they also incorporate these particulars into communal form."[60] By "incorporating the particulars" of their own lives into a "communal" form—that of the number itself but also, on a broader scale, of the collaborative artist's book—Creeley and Indiana reimagine numbers as stirring, shared

occasions or events. As Barbara Montefalcone notes of Creeley's collaborative practice: "the book is a [shared] physical place, a ground where a relationship is not only engaged, but where it develops and becomes real because it is framed by physical borders and thus visible, tangible . . . it is physical and concrete evidence that he is part of this company"[61]—a company that includes both collaborator and audience. More, Creeley's number poems and Indiana's prints engender a relationality between artist and audience that is not predictable or rote but almost tangible: immediate, accessible, and even surprising. An October 1968 letter from Bill Katz to Creeley conveys,

> I read the ten Numbers each day, alternating English and then German. Ten years ago, if I were Gertrude Stein (and alive) I probably would write you that they "mark the beginning of the second half of the century." They have an unobtrusive flawlessness, like Juan Gris (I might say) . . . What more would you have me say: They hold up together with such necessity that they are present as something which exists in the sudden, real way as in the way of woods and weather and snow and sun and hurricanes and thunder and blizzards. Yes. And I thank you for having written them, not personally thanking, but for all of us.[62]

In the book, numbers themselves become, in Katz's terms, "present as something which exists in [a] sudden, real way." Consider that "Eight," as Creeley describes it, is not octagon but *octagonal*. In this view, numbers are not remote entities but modifiers: they qualify the experiences that define our individual lives and those that we share—grief, birth, death, even love. Divesting reader-viewer of a mode of (lyric) reading that would elicit, in Virginia Jackson's terms, an "intersubjective relation to the poem which is selective and utilitarian," such that "rather than live in the poem's presence, [the reader] fiddles with its parts,"[63] *Numbers'* poems and prints, in their own right, invite reader-viewers neither to ponder digits from afar nor to dissect them piecemeal but to dwell in their presence. "Don't leave me. / Love me / One by one," "Two" implores, issuing at once an intersubjective appeal and readerly command (*TCP* 397).

Perhaps "mark[ing] the beginning of the second half of the century"

in its late 1960s moment, as Katz describes, *Numbers* issues an art consumed with and by other people. If, throughout the 1960s, visual artists associated with Pop, Op, and Conceptualism adopted copying techniques like mimeograph, Xerox, and offset printing that risked evacuating the human subject from its place by privileging technological procedure and automation, then *Numbers* offers a response reinvested not just in the individual subject or figure but, more accurately, in the inevitable relations between subjects, including, in book form, the artist and audience. Out of the circumscribed particularity of "This time, this / place, this one," where "You are not / me, nor I you" (*CP* 396), which Creeley initially inscribes in "One," the poet, and *Numbers* itself, increasingly moves toward empathetic mutuality, imagining in "Two" that "What you wanted / I felt, or felt I felt / This was more than one" (*CP* 396). Such a prospect grows more capacious—perhaps predictably doubles—in "Four":

> and two by two
> is not an army
> but friends who love
>
> one another. (*CP* 398)

Moving from solitude into friendship, and, more boldly, into love, Creeley's numbers resonate once more with Indiana's own. Done in shades of blue and green that recall the signature colors of Ellsworth Kelly, a fellow Coenties Slip artist and Indiana's sometime partner, *Two*, like *Six* and *Eight* seemingly offers another subtly affective, if wistful, "portrait poster" and a tribute, ultimately, to love. "Two," Indiana himself affirms, is "just my own personal number. My studio that I lived at, the place that I lived at the longest of all in New York was at 2 Spring Street on the Bowery, and it does require two for love, and love [as his most famous sculpture work attests] has been my greatest preoccupation."[64] And if love requires two, then so does art. Both in its collaborative generation and its reception, art, as *Numbers* suggests, is fundamentally a meeting of two people—poet and artist, creator and audience; art has a social life. As Creeley's poem makes plain, the number two is creation itself:

When they were
first made, all the
earth must have
been their reflected
bodies, for a moment—
a flood of seeming
bent for a moment back
to the water's glimmering—
how lovely they came. (*TCP* 396)

Whether biblical, reproductive, or aesthetic, two is a moment of creative potential, "a flood of seeming," and an initiation into community: "how lovely they came." Two is, at last, a release into plurality.

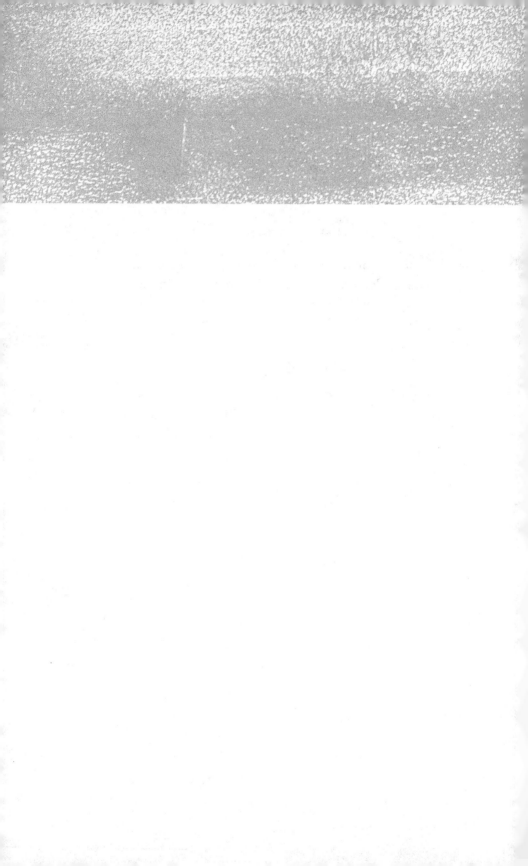

CHAPTER THREE

Lyrical Instruments

Anne Waldman and George

Schneeman's *Homage to Allen G.*

T he year 1966 was a turning point for experimental American poetry. It was just around this time, on the heels of Frank O'Hara's untimely death, that a group of young writers and visual artists—Ted Berrigan, Joe Brainard, Alice Notley, Anne Waldman, and George Schneeman among them—coalesced on the Lower East Side as the so-called "Second-Generation New York School." As Daniel Kane, Yasmine Shamma, Nick Sturm, and others have vividly documented, these artists concentrated their energies on collective readings and performances at the Poetry Project at St. Mark's Church and on the alternative little magazines that emerged during the burgeoning "Mimeo Revolution."[1] Poetry Project director Anne Waldman recalls:

> All this activity was blossoming, ironically enough, during the summer of Frank O'Hara's death—he had been such a catalyst between the uptown and downtown art worlds and suddenly a lot of energy was definitely downtown and on its own and involving many of the younger poets who had been acquainted with Frank. So there were readings and workshops and *The World* magazines, and endless gatherings and collaborations in poets' apartments.[2]

If O'Hara's death coincided with the emergence of this downtown scene, then his legacy as a generous, collaborative presence also invigorated it.[3] Waldman avers: "Collaboration was always there as a possibility" both because of the vital "lineage and legacy of the New York School poets and painters [that] was exciting, compelling" and because of a "particular bohemian lifestyle" that made collaborations consummately "social occasions. . . . You dropped in on painters at work, they dropped in on you."[4] Motivated by location and circumstance, Waldman and her cohort became even more prolific collaborators than their first-generation counterparts, compulsively working on multimedia projects, including numerous artists' books.

Vital among Waldman's own collaborative relationships was that with George Schneeman. A self-taught artist who had rebuffed the commercial gallery scene and was enamored of literature, Schneeman became the quintessential "painter among poets"[5]—as Ron Padgett, inverting O'Hara's famous epithet, christened him—after moving from Italy to New York and settling near Waldman and her (then) husband, Lewis Warsh. Proximity was a boon, providing ample opportunity for the collaborative "social occasions" that Waldman describes. Of her frequent drop-ins at Schneeman's apartment, she recalls:

> George was generous and available to me and others as well. His studio, a small back room on the fourth floor, was filled with cut-out images from old magazines—various crayons, paint, pens, paper . . . We would get to work, have a tea break, and then his wife Katie would make a delicious Italian dinner. Afterward, we would swoon and fuss over our brilliant productions.[6]

Often working on several "brilliant productions" at once, the two developed a "usual [working] procedure" that began with an "open sheet—usually a quality Arches-type paper—on which George began to dab a little color (paint, gouache, crayon, ink), or actually draw an object, sometimes a cut-out image" and proceeded with Waldman adding a "few lines milling about, sometimes [from] a notebook. Or riff off his shapes, pictures."[7] Waldman, Schneeman remembers, was always "quoting herself . . . things that [were] already going around in her head. She [would] rus[h] in, giv[e] me some words to use and fl[y] out!"[8] Spontaneous

and frenetic, this collaborative method persisted for three decades until Schneeman's death, resulting in several dozen works.

Among their most important projects, the 1997 artist's book *Homage to Allen G.* essentially arose by happenstance. Shortly before Allen Ginsberg's death from cancer, Schneeman had traced several of the poet's photographs for a potential collaboration and had visited his loft to discuss the project. After that visit, however, Ginsberg expressed reservations about the collaboration's direction. Schneeman recalls: "A few days later [Allen] called me and said, 'I can't really think of what to do with these drawings. Why don't you bring over some nice paper and we can start fresh.' But that's as far as it got, for this was only days before he died."[9] Soon after, Schneeman returned to the sketches and proposed a new collaboration to Waldman, who immediately "took them home and penciled in words at the bottom of each one. Then I inked the words in and did some more work on the drawings. After they were done, Anne and I suddenly saw them as a homage to Allen, hence the title *Homage to Allen G.*"[10] What emerged were ten stunning ink-on-paper drawings—"'ghostlier demarcations,' in Wallace Stevens's phrase," as Waldman describes, "traces, hints, murmurs of the original compositions"—strewn with sparse, poetic "Beat musings" and published in a limited 145-copy edition by Granary Books.[11]

An uneasily categorized composition, *Homage* is part fine art folio, part scrapbook, part elegy, and part archive. It is a collaborative artist's book that serves both as an emotional repository for its creators' grief over Ginsberg's death and as a Keatsian living hand—a corporeal testament to the poet in "literal traces . . . that seem extensions of the artist's own hand, his own line, which in a way continues the line of the photographer's (Allen's) eye."[12] Yet if the book memorializes Ginsberg and the Beat circle that he captured in his photographs for posterity, then it also betrays an opposing impulse, defamiliarizing the same figures by turning them into fading ghosts. Such dualities characterize the project. More than a specific tribute to Ginsberg, *Homage* is a volume that trades in literary-historical nostalgia without indulging it unequivocally, conveying an ambivalence toward its primary material compelled by its creators' wariness both of Beat iconicity and of artistic ego. Throughout the work, Waldman and Schneeman reassess the

ideal of art, including lyric poetry, as a conduit for self-expression and self-aggrandizement. They instead admit the feint of expressive art, inviting reader-viewers to access a familiar, and even intimate, world while continually revealing that access to be highly mediated and impermanent. Neither the product of a singular mind nor a vehicle for self-disclosure, *Homage* both celebrates collaborative composition and offers its reader-viewers a portal to a transformative, if temporary, public performance.

For an artist's book, *Homage* is startlingly unadorned, lacking the fine art finesse of first-generation works like O'Hara and Goldberg's *Odes* (Chapter 1) or Creeley and Indiana's *Numbers* (Chapter 2). In lieu of the glossy, brightly colored screen prints found in these earlier volumes, *Homage*'s drawings are printed on textured, deckle-edged paper in black ink. Waldman's spare, poetic text is, moreover, not relegated to its own page, but appears haphazardly scattered around the figures Schneeman depicts, freed from the stanzaic order of O'Hara's and Creeley's earlier poems. Mimicking the highly visual poetry of her best-known work, the *Iovis* trilogy, Waldman "Literally writ[es] all over already-oversized pages or leav[es] large white spaces . . . set[ting] no particular pattern but commi[tting] to the visually heterogeneous, even nonlinguistic page."[13] With Waldman's scattershot poetic text strewn about the page and Schneeman's imprecise ink traces, *Homage* offers the aesthetic illusion of something unfinished, emphasizing the work's senses of spontaneity and irresolution.

While the book's "in-progress" nature may function as testament to Ginsberg's own artistic contribution as a thing equally unfinished upon his too-sudden death, its unfinished quality is also characteristic of Waldman's and Schneeman's works—she a poet who routinely improvises her verse in performance and he a visual artist whose figures often appear hurried and imperfect—"'peculiar,' something in the limbs and torso a little distorted or 'wrong,' and not artfully calculating enough [. . .] adolescent-drawing style? Or lightly cartoon style but without that unwavering virtuoso line," as Alice Notley has described.[14] A sense of hasty, impulsive creation was a precept the artists held in common, influenced not only by Ginsberg's "first thought best thought" credo but also by the mimeograph technology that vitalized their creative

scene, allowing as it did for "cheap, speedy reproductions" that lent the "materials an urgency allusive of newspaper 'extras' . . . serving as carriers of fresh and vital information."[15] This "urgent" quality further distinguishes *Homage* and other second-generation artists' books from those of the first. While first-generation collaborations, like O'Hara and Goldberg's *Odes*, were typically commissioned for "'high-quality' journals and limited editions books . . . ([that] had budgets and employed publishing companies)," as Jenni Quilter relays, second-generation artists like Waldman and Schneeman often "made the books themselves, using low-tech methods of reproduction."[16] And although it is true that a "high-quality" press (Granary Books) did eventually publish *Homage* in a limited-edition portfolio, collating the pages in a beautiful crimson cloth-covered clamshell box, the book maintains, even in its finished form, a *sprezzatura* virtue that signals its artists' "do-it-yourself" ethos. At once urbane and unstructured, *Homage* well reflects the competing traditions that shaped Waldman's, Schneeman's, and their cohort's careers, embodying less the "shift . . . from New York Personism and formalism to Beat shamanism and open form"[17] that Peter Pucheck has described in Waldman's work than their synthesis. With the trappings of a professional fine artwork but the essence of a casual exchange, *Homage* exaggerates its own dualistic tendencies.

Above all, *Homage* amplifies the tendency of Ginsberg's own photos to skirt the line between private documentation and public display. Throughout Ginsberg's life, as Jason Arthur, Oliver Harris, and Daniel Morris recount, the poet curated an image of the Beats as revolutionary figures through his poetry and photographs.[18] In addition to mining personal journals and letters for poetic material (thanks to William Carlos Williams's early suggestion), Ginsberg transformed images of his friends into public artworks by belatedly adding captions to them for the 1990 collection, *Allen Ginsberg: Photographs*. That Ginsberg could capitalize on what was, by the late 1990s, an established Beat legacy and generate much-needed income was an incentive for projects like *Allen Ginsberg: Photographs*, to be sure, but perhaps a prescient sense of his own and his peers' mortality also compelled retrospection, especially if his final, posthumously published volume, titled *Death & Fame*, is indicative. Though Ginsberg himself took pains to downplay

self-aggrandizement, noting in the afterword to his photograph collection that a "vulgar interpretation would be: 'These guys knew they were historic,' or 'These guys knew they were mythical,'"[19] it is nonetheless clear from his extensive captioning efforts that he harbored some "intense awareness of [his circle's] literary-historical importance."[20] In reframing his private journals and photographs for public consumption, Ginsberg elevated the artistic significance of the writers and thinkers they referenced, transforming them from personal friends into stylized subjects worthy of the art-historical record. The result of this reframing, Jason Arthur notes, was Ginsberg's ability to "craft a biographical gesture that formalizes 'public privacy' as the essential condition of Beat literary production . . . highlight[ing] the importance of intimate, collaborative exchange as a precondition of the kind of revolutionary texts that have emerged from the Beat movement."[21]

Proof not just of its own artists' close working relationship but of their ongoing experiments with visual-verbal hybridity, *Homage* crystallizes Ginsberg's sense of the "importance of intimate, collaborative exchange" as a "precondition of" generically innovative and perhaps even "revolutionary" art. A form born of private, collaborative exchange and friendship (between Waldman and Schneeman as much as between both artists and Ginsberg) but packaged, in a limited edition, for the public collector's market, their artist's book encodes the same sense of "public privacy" on which Ginsberg's original photos operate. While Ginsberg's photographs offer a public, if stylized, record of his friends' private lives, however, *Homage* both extends and subverts their premise. Inasmuch as Schneeman's retracings of Ginsberg's photographs immortalize the figures in them as indelible—literally inked—characters, transforming them once more into spectacular, public icons, they also trouble such apocryphal posturing by subjecting the same images to modification and palimpsest, clarifying their impermanence. All but one image (which designates "H. Smith," for Harry Smith) appears without indication of the depicted figure's name or the image's time and place, offering a marked contrast both to Ginsberg's own extensive captioning/contextualizing practice and, more broadly, to the iconic "acts of naming"[22] central to first-generation New York School collaborations. Schneeman's traces resist identification, and even the few con-

textual details that he preserves can be misleading, prone to creative liberty or slight alteration (a supplementary chair, an errant arm), not only troubling each portrait's iconicity but finally making it irrelevant.

Wresting the figures in Ginsberg's photographs from any immediate context that the original images and captions would have afforded (background, captions, time/space markers) and presenting them instead as floating specters surrounded by white space, beholden only to Waldman's scattershot poetic phrases, the traced characters take on a preternatural aura that matches Schneeman's proclivity, in Alice Notley's terms, for painting figures in a "totally idealized . . . in some perfect world . . . some Platonic world."[23] No longer locatable within the real "Beat" scene that Ginsberg had intimately captured for posterity in his images, the figures appear to dwell in a "perfect" or "Platonic" but fundamentally unreal world—perhaps the romanticized space of nostalgia and memory. Yet Schneeman's ample use of white space also supposes a darker potentiality: that the "perfect world" his pages depict is also, more bleakly, a "void," as Alice Notley observes in other works.[24] Whereas the figures might have, in Ginsberg's photos, appeared to us as fully realized, familiar characters that defined and were defined by a specific milieu, they become spectral and unmoored in the blank "void" of Schneeman's reworking—threatened by oblivion or nonexistence, as if moments away from fading entirely. Suspended amid the page's vast white space, Schneeman's traced figures are at once idealized and displaced, ethereal and wraithlike, immortal and departed. Permanently memorialized yet precariously close to being erased entirely, Schneeman's figures are situated uneasily between infamy and obscurity—death and fame, to borrow from Ginsberg's late poetic title—where each term seemingly compels the other.

Whereas Ginsberg's photographic subjects were made, by the poet's own hand, into literary- and art-historical figures who would have been eminently recognizable to those familiar with the Beat scene, Schneeman's traces often render them unidentifiable to contemporary reader-viewers, presenting them less as intractable personae than as indeterminate ghosts.[25] The result is not just that *Homage* makes its central characters difficult to identify without a cross-reference like *Allen Ginsberg: Photographs* or other "private" insider knowledge but that, in

doing so, it further complicates the book's public/private duality and the attendant question of audience: for whom does *Homage* signify and how? Waldman's poetic text begins to offer a partial answer. As much as *Homage* seems to indulge in an uncritical Beat nostalgia for both its creators and its audience alike, it also inhibits it. Like Schneeman's traces, at once straddling the public/private divide, Waldman's captions also betray opposing impulses, functioning both to preserve and to reassess the Beat's legacy. Consider the poetic text that Waldman has (perhaps ironically) added to Schneeman's retracing of lesser-known Beat poet Ray Bremser, which reads: "Clenched / on an era / Folds / eyes: OLD BEATS."[26] With the admission that *Homage*, and by proxy its creators, are "Clenched on an era"—suggesting a loyal steadfastness and a fatigued admission—Waldman's text both announces and reexamines her debts to Ginsberg et al. The attendant anxiety in Waldman's text becomes clearer in the final "OLD BEATS." While evoking a private chumminess ("old friend"), the phrase not only reminds us that Beats are now "OLD" (both in age and in news), but it also insinuates that *Homage* risks simply hitting the "old beats" in perpetuating a tired public mythos. Consider, then, another page in *Homage* that depicts Beat artist Harry Smith sitting alone at a table surrounded by what Waldman unsubtly labels "detritus under thumb"—a literal reference to remnants of a consumed meal on the table but also a figurative, if playful, jab at the textual Beat fragments that line the page. "Best Minds," Waldman scrawls, conjuring the notorious opening line of Ginsberg's "Howl," and "(the NAKED Lunch . . .)," evoking William Burroughs's novel. Though such allusions may well count among the "detritus" depicted on the page, Waldman is careful not to discard them outright. The "found" text instead reveals *Homage*'s dueling impulses to lay waste to the remains while also recuperating them as such. Waldman's ability

Facing page: Figure 6. George Schneeman and Anne Waldman, folio from *Homage to Allen G.*, 1997, printed letterpress on paper, 11 × 13½ in. © George Schneeman and Anne Waldman. Permission to reprint work by George Schneeman is granted by Katie Schneeman. Permission to reprint work is granted by the poet, Anne Waldman. Images of *Homage to Allen G.* furnished by Special Collections & Archives, The University of Iowa Libraries.

to position these notorious Beat lines as "detritus," despite the work's competing efforts at preservation, begins to indicate the limits of reflexive devotion central to *Homage*. Like an erasure poem—fragmented, partial—Waldman's allusive text evokes a Beat legacy both willfully abandoned and fondly salvaged.

In *Homage,* Waldman and Schneeman forward a cautious reevaluation of the Beat legacy they've inherited—a tribute that is nonetheless unafraid to confront that legacy's lapses, including its notorious erasure of women and Black poets affiliated with the circle (a group that includes, among others, Waldman, Diane di Prima, Joanne Kyger, Joyce Johnson, Carolyn Cassady, Hettie Jones, Bob Kaufman, and to lesser extent, Amiri Baraka).[27] While it might belabor the point to call *Homage* a feminist rewriting per se, the irreverent attitude that surfaces in the word "detritus" does imply, at least, that the Beat mythos that Ginsberg's own photographs sought to cement need not be preserved uncritically. It is further suggestive that Waldman ascribes the epithet "The Skeptic" to the only woman depicted in *Homage*. On Schneeman's retracing of Olga Rudge—a violinist in her own right but best known as poet Ezra Pound's mistress, with whom Ginsberg developed a close friendship[28]— Waldman pens: "Squint / Behind / Eyeglasses / The Skeptic / Pause." Though the text is ekphrastic, describing Rudge's squinty, incredulous-seeming gaze in Schneeman's retracing, it also seems to interpolate Waldman's own skepticism, such that the poet denotes her own ancillary place in Beat history via that of Rudge. A woman artist who has, in most accounts, been discussed only as a peripheral member—as mistress or correspondent—within the artistic circles that she freely traversed, Rudge ostensibly acts as a stand-in for Waldman, hinting at the poet's awareness of her own marginalization within the same literary tradition she formatively claims.

That the Rudge image and its accompanying text might ventriloquize Waldman's misgivings is pertinent, since Waldman had been explicitly grappling with women's place within the Beat legacy in her epic *Iovis*, the second section of which, from 1996, was written around the same time as *Homage*. In *Iovis II*, Waldman includes a by-now famous epistolary exchange with poet Kristin Prevallet that simultaneously endorses the Beats' lasting influence and qualifies the same position. "I think the

Beats are still vital as a cultural force primarily because their art—their writing—holds up," Waldman writes, before quickly adding: "As I see it, with some exceptions—and the biggest is the inattention to women and the often sexist attitudes about women, and even racism . . . the Beats are popular because they represent an alternative (in their work, philosophy, action) to the status quo."[29] Waldman continually walks this line in *Iovis II*, acknowledging the Beat movement's particular (and society's general) misogyny while insisting both on her own equitable relationships with the men involved in the scene and their greater literary-historical importance. Speaking to Waldman's conflicted feminist sensibility, Rachel Blau DuPlessis maintains: *Iovis II* both "defends the Beats for their achievements" and "acknowledges a specificity of female cultural history . . . that even somewhat undercuts her Beat-analysis, and indeed, puts in her headnote her own resistance to what she said: 'sleepless, she rises once again to be an apologist for the macho Beat Literary Movement' (*Iovis II*, 134)."[30] Such a stance, DuPlessis continues, emblematizes Waldman's "both-both" attitude: a "brilliant formation that rejects as too binarist the notion of 'both-and'—not just toward her artistic forbears but toward the contemporary feminist movement, more generally."[31] Echoing DuPlessis, Peter Puchek posits that Waldman's "variant of Beat desire" is that as she "begins to adopt a Beat sensibility, she also demythologizes it, committing herself to its individuality of outsiders-within-a-group but not to its figure of the heroic male hipster/tortured artist. . . . [S]he enacts the postmodern impulse to install and subvert simultaneously."[32] For Waldman, a "both-both" attitude enables her to embrace the Beat's influence while disavowing both their macho posturing and outright group affiliation.[33]

The "both-both" formulation also well encapsulates Waldman and Schneeman's conflicted stance toward the "OLD BEATS" in *Homage*. Following *Iovis II*, *Homage* portrays Waldman's simultaneous reverence for and wariness of dogmatic allegiance to the "big daddies"[34] of the avant-garde, among whom she has counted not just Ginsberg, but Charles Olson, Robert Duncan, John Ashbery, William Burroughs, and Frank O'Hara. *Homage* in fact takes this idea further, for if Waldman's captions and Schneeman's drawings occasion this duality, then they also mediate it. In her introduction to the *Women of the Beat*

Generation, also from 1996, Waldman proposes that the watershed anthology makes readers "privy to what else—what 'other'—was going on at the same time, in parallel time, and how the various lives—of both [Beat] men and women—interwove and dovetailed with one another."[35] *Homage* similarly evinces a "parallel time" through its visual and textual palimpsest, not only challenging the "natural equation of Beatness with maleness [that] demanded female invisibility" but highlighting "what else—what 'other'"[36] art can exist within, alongside, and after the received canon. Take *Homage*'s image of Julian Orlovsky (the brother of Ginsberg's lover, Peter Orlovsky), in which Schneeman's tracing is accompanied by Waldman's on-the-nose pronouncement: "up against the grain America." The text at first reads as a sly in-joke since Orlovsky is, in Ginsberg's original photograph, pictured alone in front of a dense, wooded area, literally positioning him "up against the grain." When that background is rendered more abstract in Schneeman's drawing, however, the phrase doubles broadly as aesthetic (and political) Beat *cri de coeur*—one that Waldman and Schneeman have not merely inherited but intend to reenact. Positioning their own art in *Homage* "up against the grain" of Ginsberg's Beat narrative as well as of conventional aesthetic practices (as we'll continue to see), Waldman and Schneeman adopt what the poet has elsewhere called the project of the *"avant-derrière,"* which, she muses, "sounds like a joke but perhaps it's more challenging to have to look in opposite directions at once—forward and behind."[37] In *Homage*, Waldman and Schneeman reinscribe themselves into the Beat legacy, content not simply to be its passive recipients but to reproduce it on their own terms.

Nowhere does *Homage* enliven this "avant-derrière" intersection more clearly than in its juxtaposition between the Ray Bremser "OLD BEATS" portrait and the Harry Smith "detritus" image, discussed earlier. Bearing an immediate visual resemblance as tablescapes, the Bremser image nonetheless mirrors and inverts the Smith one. Where the Bremser figure appears self-assured, his gaze confrontational as it meets the reader-viewer directly—"Looking at you," Waldman writes—Smith's figure looks dejected or pained, his palm resting on his downcast head, failing to meet the viewer's gaze. More telling, the emphatic declaration "KNOW IT ALL" that attends the Bremser image—suggesting

a macho impertinence that Waldman (and critical lore) has attached to the "OLD BEATS"—is transformed in the Smith image into a probing rhetorical question, "WHO KNOWS?" casting the same surety in doubt. Quintessentially "avant-derrière," the shift elucidates the gap in which *Homage* operates, suspended between the epistemological certainty of the past ("KNOW IT ALL") and the epistemological doubt of the present and future ("WHO KNOWS?").

Homage's desire to galvanize these temporal and epistemological gaps, and the equivocality they engender, is fitting, since they are endemic to photography itself. Underscoring the centrality of these gaps to Ginsberg's original photographs, Erik Mortenson contends that the interim "between living and recording"[38]—between the real event and its photographic representation—"effects a subjective experience in the viewer . . . a feeling of the movement of time itself."[39] Viewing Ginsberg's photographs, he suggests, becomes an event through which the audience is led less to dwell on the picture's content than to experience time's passage. *Homage* dramatizes this feeling by making its reader-viewers further cognizant of the temporal "gap" between Ginsberg's photographs and their subsequent retracings, highlighting not just the "movement of time itself" but the inevitable alterations, including death, that time compels. As such, *Homage*'s epistemological and temporal gaps deepen reader-viewers' sense of the spatial and interpersonal gaps that the figures' anonymity earlier provokes, widening the public/private chasm the work elicits between "us" (audience) and "them" (depicted figures, creators).

Schneeman's imprecise belated tracings and Waldman's spare paratactic text knowingly impede the reader-viewer's total comprehension or complete decipherability, keeping us at a reverent distance and thus undermining the sense of readerly intimacy that artists' books, elegiac work, and not least, lyric poetry, typically afford. The first page—the only one, notably, to include the first-person pronoun—makes this final inclination plain. Alongside Schneeman's retracing of the Chilean "anti-poet" Nicanor Parra sitting on a chair, Waldman scrawls "I am / my own reward" and "I sit down, etc." At first glance, the text appears to inscribe traditional lyricism, offering the illusion of a stable speaker whose consciousness readers can readily access. In its insistent

self-referentiality, "I am / my own reward" (perhaps a sardonic play on Gandhi's "Peace is its own reward") even seems to hyperbolize the insularity that has been associated with the Romantic expressive lyric. In line with this model, the lyric speaker, as Jonathan Culler explains, "absorbs into himself the external world and stamps it with inner consciousness, and the unity of the poem is provided by his subjectivity."[40] Yet Waldman's subsequent text, "I sit down, etc." deflates this illusion of poetic or lyric unity, devolving into a routine statement that hardly deserves elaboration. If lyric poetry is traditionally "absorptive" both for the speaker, as Culler suggests, and for the reader, as Charles Bernstein suggests, insofar as it "emphasiz[es] a seamless, self-enclosed continuity," then "etc." is deliberately "antiabsorptive" in its discursive discontinuity, refusing to uphold poetic/lyric (generic) convention and to sustain subjective or narrative coherence in the first place: whatever the speaker does or says next, we readers cannot know.[41]

More, while lyric poetry customarily works to "lif[t] [speech] out of ordinary communicational contexts" in a "ritualistic, hortatory act"[42]—such as we find in Waldman's "I am / my own reward"—then "I sit down, etc." replaces it within ordinary communicative channels. Responding to its use in Mei-mei Berssenbrugge's poetry (discussed in the next chapter), Laura Hinton suggests that *et cetera* "leaves 'lyric' diction" because of its function as a "colloquial, speech-like elemen[t]" or "interruption[n]" that "breaks down and recombines literary genres and discourses."[43] In a similar manner, Waldman's own "etc." departs from or interrupts the "ritualistic, hortatory act" by offering in its place an unceremonious list. Waldman's specific use of the written abbreviation *etc.* versus the spoken term *et cetera*, further underscores the secular materiality of her own poetic text rather than the ritualistic, elevated, aura of lyric speech. Within the space of the page, Schneeman's drawing further compounds the text's anti-lyric proposition by offering another "interruption" both to the monastic continuity of Waldman's "I" (who may or may not be the man depicted in Schneeman's image) and to the possibility of poetic and lyric absorption, given the competing, simultaneous visual demands it makes on the reader's attention. By including an arrow in his tracing that points to an opening conspicuously marked "DOOR," Schneeman's drawing indeed consecrates

the idea: if Waldman's text initially evokes lyric absorption, then both its conversation with Schneeman's art and its connection to the page's broader context ultimately shows us the way out.

Rather than directing our attention toward a lyric speaker's "inner consciousness," Waldman's poetic captions and Schneeman's drawings consistently redirect our attention toward something beyond or external to the page, shifting the audience's frame of relation to the work. A motif throughout *Homage*, the arrows that Schneeman has added to his drawings (i.e., not originally in Ginsberg's photos) recur on multiple pages. These arrows, like the one marked "DOOR," often point away from the page's depicted figure toward something else, including, at times, back to reader-viewers themselves. One such arrow is, for example, accompanied by Waldman's text that reads "looking at you" (turning the gaze back on the audience), while another explicitly entreats us to follow an arrow pointing beyond "the frame." Particularly revealing is an arrow that Schneeman includes in his retracing of an iconic image of Harry Smith pouring milk into a glass. Here, Schneeman has added to the original image both a halo surrounding Smith's head and an arrow pointing to it that reads "The World." The arrow perhaps constitutes a tongue-in-cheek jab at Ginsberg's own apotheosizing tendencies, transforming Smith into a strange demigod, but it also functions to destabilize the viewer's relationship to the image. Not only does it suggest that "The World's" deific view of Smith may diverge from the artists' more familiar one, but it perhaps also offers an insider nod to the eponymous little magazine Waldman had helped found at the St. Mark's Poetry Project, reifying the sense of uneasy "public privacy" fundamental to the work. Second, it gives viewers pause, forcing them to contemplate whether they are of "The World" claimed by the page or outside of it. Finally, the halo and arrow alter the image's scale such that the vastness of "The World" and the intimate space of the page suddenly collide. When "The World" accordingly intrudes upon the page, it notably remains external to the figure, making his subjectivity—and, reflexively, our own—suddenly appear to us conditional rather than secure.

Emphasizing the contingent positionality of both the images' depicted figures and that of the reader-viewers within the space of the

collaborative artist's book (and, existentially, "The World"), *Homage* reproduces a central effect of Ginsberg's photographs and their original captions. Discussion surrounding the photographs has indeed often centered on their captions, a practice inspired, depending on the account, by Robert Frank, Elsa Dorfman, or Berenice Abbott, Ginsberg's key photographic influences. And scholars have often suggested that the captions work to engender intimacy between the photographer (Ginsberg) and his viewers. While Oliver Harris, for instance, claims that the captions "revoke the technical anonymity of the camera . . . [and] thus re-inscribe authenticity and subjectivity . . . the graphic equivalent of the grain of voice,"[44] Sarah Greenough suggests that they "establish a direct link between Ginsberg and his audience . . . as if Ginsberg himself had written a generous letter to us, his future readers, or shared with us a page from his notebooks, revealing himself in an intimate, genuine, and occasionally heartfelt manner."[45] Such readings, then, ascribe to the captions the *sui generis* qualities of expressive or "absorptive" lyric poetry, perhaps reinforcing the sense of confessional self-disclosure that many find in Ginsberg's most famous poems like "Kaddish" or "Howl." Yet if these captions do provide some authentic "grain of voice," they reveal little about their photographer or subjects at all. The captions, on further inspection, are "intimate" in gesture only. Take, for example, two such captions added to images showing the view outside of Ginsberg's home window. The first reads:

> I sat for breakfast tea mornings almost a decade looking out my kitchen table window, one day realized I was viewing my own world. The familiar backyard against wet brick-walled Atlantis undersea garden waving with Ailanthus trees, Stinkweed "Trees of Heaven," the chimney pots along Avenue A topped by Stuyvesant Town. Apartment floors two blocks distance, I focus'd [sic] on the clothesline raindrops, August 18, 1984, New York.[46]

The second notes:

> I got more conscious of the kitchen window backyard's seasons' daily view, here morning snow-dropped windowsill January 23, 1987, white

roofed toolshed, bare branched trees of heaven, fence & fire escapes visible snow-lined, *Times*.[47]

Though diaristic, to be sure, the photographic captions are nearer to Pound's imagistic poems ("wet brick-walled Atlantis undersea garden waving with Ailanthus trees") or Williams's observational ones ("white roofed toolshed, bare branched trees of heaven, fence & fire escapes") than to revelatory tracts; they neither confess nor howl. Note their elliptical nature. In writing that "I was viewing my own world" the caption—not unlike Waldman's "I am / my own reward"—pretends to absorb us into its subject's psyche while precluding its adoption. The tautology "my own" is, in both cases, pointed, functioning as a reminder that this is not perspective to which reader-viewers can claim unmitigated access; the syntax simulates lyric revelation ("I am," "I was viewing") but forecloses its realization, recursively folding in on itself ("my own reward," "my own / world"). Ginsberg's photographs and captions may locate viewers within his home or even in his head, but they also demonstrate that making an interior visible does not itself guarantee or produce intimacy, giving lie to the traditional codes of domesticity and, of course, of lyric poetry.

Ginsberg's photographs and captions work instead to denaturalize: to signal that we are seeing something deliberately arranged—a still life. Daniel Morris elucidates this distinction well in noting that Ginsberg's portraits, "Like signature works by [Annie] Leibovitz and [Arnold] Newman . . . are stylized compositions that generally occur indoors, often in Ginsberg's home. They are posed and composed images often, as in Leibovitz, with subjects acting out their public roles through witty, ironic, or humorous props."[48] This is on especially sharp display in the witty Harry Smith milk photograph that Waldman and Schneeman reproduce in *Homage*. Ginsberg's original caption for the image reads: "Harry Smith, painter, archivist, anthropologist, Filmmaker & hermetic alchemist, his last week at Breslin Hotel Manhattan January 12, 1985, transforming milk into milk" (*Allen Ginsberg: Photographs*). As if in a sardonic "Got Milk?" advertisement, Ginsberg depicts Smith looking magician-like, caught in the act of performing a neat, if

banal, trick: pouring milk into a glass. The irony of the image, however, is less that it depicts Smith's quotidian alchemy—"transforming milk into milk"—than that it reveals Ginsberg's own: the transformation of private, domestic routine into iconoclastic public performance. If Ginsberg's photographs and captions reside uneasily between the "private" and the "public," their intent is less to collapse these categories of analysis—postmodern art and poetry's calling card—than to dramatize the artifice in doing so.

Like its source material, *Homage* makes conspicuous the highly mediated, public-private experience that it affords reader-viewers. After all, what we come to know of its subjects is doubly filtered from the start, mediated both by Ginsberg's photographs and by Schneeman and Waldman's reworking after them. Writing of Schneeman, Joe Brainard, and Rudy Burckhardt, Jenni Quilter argues that these artists' works are "sentimental. A lot of their art was domestic, meant for intimate scale of consumption: portraits of family and friends, assemblages that resembled small altars, films of friends goofing around."[49] While Quilter rightly points to the "domestic" nature of Schneeman's work and its "intimate scale of consumption"—a description especially apt for a limited-edition artist's book like *Homage*—her reading also risks enacting the same mode of reading that threatens Ginsberg's captions: one which mistakes their veneer of domesticity or their "intimate scale" for a deeper sense of self-disclosure, even though estrangement is often more central to their effect. Tim Keane thus more accurately captures the denaturalizing effect and wry sensibility inherent to Schneeman's collaborations, including *Homage*, when he observes that:

> Though operating partly in figurative and illustrative modes, visually speaking, [Schneeman's] works involve abstract, semi-abstract, impressionistic and color field components. The overall dreamscape effect is enhanced by cryptic poetry expressions integrated into the composition. The collaborations' written components consist of typed, painted, sketched, or cut-and-pasted language in the form of imagistic aphorisms, lyrical effusions, metaphoric and analogical statements, compressed ekphrasis, and excerpted diary or travelogue.[50]

Schneeman's collaborations, he continues, "replace mimetic, discursive ends with objectivist enigmas surrounding pictures and words."[51] Schneeman's drawings and Waldman's captions in *Homage* function similarly, superficially employing "figurative and illustrative modes" that theoretically seem to *represent* something while continually revealing the gaps, absences, and enigmas within them—making them actively *anti*-representational in practice. The absence of Ginsberg's own image in a volume that bears his name is accordingly thrown into relief. Though *Homage* ostensibly offers a glimpse into Ginsberg's world through his lens, he himself is never laid bare by it. If literary history has inherited an image of Ginsberg as a declamatory poet, issuing hallucinatory visions and personal histories in long, forceful poems, then *Homage* tends in the opposite direction, revealing to us nothing specific of its titular honoree, nor of its creators, at all.

The frequent absence of pronouns in Waldman's text further underscores its anti-representational bent, rendering oblique in *Homage* any central, locatable speaker or subjectivity, authorial or lyric. Such a pattern is consistent with Waldman's broader poetic ethos, which holds that the "I [of poetry] is no longer a personal 'I'" and that "Art is not to be seen as an expression of an individual subject" but as an "open system" or a dynamic "event."[52] Take, then, the caption attached to the Harry Smith image—"drinks milk in an insane century." While evincing what Culler has called the "iterative and iterable performance of an event in the lyric present, in the special 'now' of lyric articulation"[53]—such that the "insane century" is continually reanimated rather than historically fixed—the line leaves ambiguous whose "performance" ("drinks milk") it is. That is: Waldman's caption preserves the "here-and-now" urgency characteristic of lyric poetry ("the special 'now' of lyric articulation") even as it dissociates the articulation from an identifiable subject—a particular "I"—in the first place. Though New Critical lyric and ekphrastic reading practices habituate readers to ascribe the utterance to a particular actor—either to the figure, Harry Smith, on view ("he drinks milk") or to the author herself—the text, absent pronoun, rejects this conflation. Like Schneeman's arrows, Waldman's text shifts the reader's referential frame away from the actor

to the act itself—"drinks milk"—figure to ground. Taking a Barthes-ian turn, Waldman's text is "cut off from any voice, borne by a pure gesture of inscription (and not of expression), trac[ing] a field without origin—or which, at least, has no other origin itself than language itself."[54] Thus, "drinks milk" seems less like one man's pedestrian act or a decipherable authorial message than an oracular proclamation: a "performative, a rare verbal form . . . in which the enunciation has no other content (contains no other proposition) than the act by which it is uttered."[55] Much as in Schneeman's works or Ginsberg's own photo-graphs, the "intimate scale of consumption" seemingly inherent to Waldman's poetic text (and made literal in the phrase "drinks milk") belies its wry distortion, as the text magnifies the absurdity of our bearing witness to this act, especially in light of whatever else may be occurring in "an insane century." Waldman and Schneeman transform the page from a particular (closed) lyric "performance" into a canny, ongoing spectacle and event.

As if wittily granting Waldman's anti-subjective stance, *Homage* con-cludes on an image of self-sacrifice, perhaps making a further spec-tacle of "the death of the author." On the artist's book's final page, Schneeman traces a photograph of Beat poet Gregory Corso that, per Ginsberg's original caption, depicts the poet "addressing [a] Cross atop the Grey Nuns' Orphanage Grotto, Lowell, Mass, a 'gigantic pyramid of steps upon which the Cross itself poked phallically up with its poor burden the Son of Man all skewered across it in his Agony and fright— undoubtedly this statue moved in the night—.' (Kerouac, Dr. Sax)."[56] In both original image and re-tracing, the man in the picture beholds a Christ figure; the sacrificial allusion virtually announces itself. Where Ginsberg's caption is humorously sacrilegious ("the Cross itself poked

Facing page: Figure 7. George Schneeman and Anne Waldman, folio from *Homage to Allen G.*, 1997, printed letterpress on paper, 11 × 13½ in. © George Schneeman and Anne Waldman. Permission to reprint work by George Schneeman is granted by Katie Schneeman. Permission to reprint work is granted by the poet, Anne Waldman. Images of *Homage to Allen G.* furnished by Special Collections & Archives, The University of Iowa Libraries.

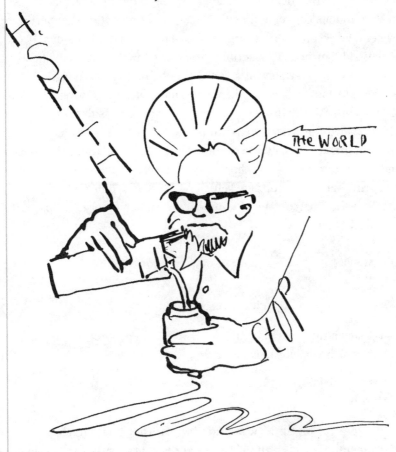

phallically up"), however, Waldman's poetic revision is wistful: "Hero in a Thousand Places," it reads, "poète maudit w/ Tuned string / Look up & Strum." An epithet that Waldman often used for her "idol" Corso, whom she has elsewhere called the "epitome of the 'damned poet,' the poète maudit, and gorgeous,"[57] Homage's description aligns Corso with the other doomed Christ figure in view. But the invocation of his "Tuned string" appears more broadly allusive, evoking another melancholy poet-guitarist: Wallace Stevens's "The Man with the Blue Guitar." Such an allusion, though surprising, is salient, since Waldman has remarked that hearing a teacher read Stevens aloud "acted on [her] like a religious conversion experience"[58]—a foundational experience, by her own accord, akin to Ginsberg's infamous Blakean visions. Recall that Waldman herself describes the images in Homage as "ghostlier demarcations" after Stevens's "The Idea of Order at Key West."

The allusion to Stevens therefore takes on new pertinence. Consistent with Waldman's own belief that the poetic "subject is just the place or medium where the truth of the world speaks or enacts itself, and it is this truth which we hear. It is an accumulation, that power gathering over time, which bursts forth in song at the appropriate moment through an appropriate vehicle,"[59] Stevens's "Blue Guitar" figures the "I" as an instrument of composition rather than as its basis. In Canto XII, Stevens writes:

> The blue guitar
> And I are one [. . .]
>
> . . . And where,
>
> As I strum the thing, do I pick up
> That which momentously declares
>
> Itself not to be I and yet
> Must be.[60]

In Stevens's poem, the lyric speaker is portrayed as an improvisational instrument ("The blue guitar / and I are one") rather than a stable poetic center—"not that gold self aloft," as he later writes.[61] The subject instead emerges and is transformed through his musical performance.

As soon as the "I" "momentously declares / Itself"—with an evident play on the declaration's temporariness ("moment")—it is unsettled, "not to be I and yet / must be." Stevens's proclamation at once sanctifies and negates the lyric "I"; to perform the "I" here, in other words, is to sacrifice it. More, this sacrifice is enacted for a community of listeners, who themselves fill in the subject position that the restrictive, singular "I" vacates: "Ourselves in poetry must take their place / Even in the chattering of your guitar."[62] Following Mutlu Blasing's persuasive reading of Stevens's "Of Modern Poetry," which posits "a community of discrete listeners and hearers" in which "The 'audience' is a plural, made up of members with different 'ears,'"[63] Bonnie Costello notes that "The Man with the Blue Guitar," featuring the plural subject ("Ourselves") "produces an unusually dialogic poem, full of improvisations and syncopations, and sensitive to dissonant voices" that not only "cues us repeatedly to the interactive, if often contentious, nature of the poet/public relationship" but that "evokes an inclusive communion of a generation and its future."[64] What Stevens and his guitarist therefore compose through the artistic performance is not simply a song but an audience.

Recasting Stevens's guitarist in the Beat image, *Homage* extends its premise, both through Waldman's particular text and through the book's collaborative form. Calling to mind both Stevens's "A million people on one string"[65] and Joseph Campbell's *The Hero with a Thousand Faces*, which recounts how the archetypal hero returns home from a spectacular quest to redeem his fellow men (among whom, fittingly for Waldman, Buddha is an important example), Waldman's performer, a "Hero in a Thousand Places," indexes a plurality. Unlike the first-person speaker with which *Homage* begins—who, collapsing into itself, proclaims "I am / my own reward"—the anonymous "Hero" with whom she ends opens outward, graphing an expansive collective in "a Thousand Places." Thus, when she enjoins her own guitarist to play on, "poète maudit w/ Tuned string / Look up & Strum," Waldman imagines that her musician also "evokes an inclusive communion" of hearers; her guitarist allows reader-viewers to find their place in poetry. The result is twofold. First, in building on Stevens's lyric impersonality and shifting away from the singular lyric "I" toward a plural audience, Waldman

restores lyricism to its pre-Romantic origins, deemphasizing, in Marjorie Perloff's terms, "the equation of 'poetry' and 'lyric,' coupled with an understanding of 'lyric' as *the* mode of subjectivity—of self-reflexiveness"[66] and replacing it within the realm of song, stressing "the coupling of words and musical accompaniment [that] has been a hallmark of lyric from ancient times."[67] Thus, the figure's "Tuned string" might suddenly register differently: not as guitar but as *lyre*. Second, the shift away from the singular lyric subject toward the poetic event and the audience's participation in it allows Waldman to subvert the "the heroic male/macho artist" trope that has been central not just to Beat mythology and to many accounts of "great" avant-garde movements in both literature and visual art but more foundationally, to the non-collaborative "individual genius" myth of artmaking itself. If O'Hara's *Odes* (Chapter 1) upends this paradigm by reimagining the heroic lyric individual as an agent of social connection, cementing its Abstract Expressionist revision, then Waldman goes further in *Homage*, bypassing both heroic lyricism and "individual genius" to position the art itself "as an instrument of community building."[68]

Homage's first image of Gregory Corso, depicted sitting alone in his Paris apartment, solidifies the point. As Waldman describes that image:

> One page I really like is a drawing of a mendicant Gregory Corso holding a stick. The lines read "a bowl"—"a rod"—"a staff"—"Poetry's [large letters] accoutrements"—"stabilize"—"the void." I was thinking perhaps of Gandhi's possessions at the time of his death, as well as [Ginsberg's] particular modesty.[69]

If, according to the logic of Waldman's text, poetry acts as a stabilizing force amid the ostensible chaos of "the void," then it does so only through a "particular modesty": self-effacement. Though aligning Corso or even Ginsberg with Gandhi is no doubt hyperbolic, the text acutely reveals Waldman's Buddhist-inspired poetic conscience. Absent among "Poetry's accoutrements" here is a lyric "I" or any intractable sense of subjectivity. For Waldman, poetry is less an act of individual ego—authorial or lyric—than a momentous performance or event made of unassuming stuff: "a bowl / a rod / a staff."[70] Such a view was one that Waldman and Schneeman held in common. Notice the pointed way

in which poet Bill Berkson describes George Schneeman's apartment with its "long worktable with Rapidograph pen, ink, gouaches, brushes, glue, poster (or 'composition') board, and stacks of collage materials at the ready. Over these accoutrements and their uses George presided gently."[71] Resonant of Waldman's text in *Homage*, Berkson's description privileges art's humble "accoutrements" over the figure of Schneeman himself, who appears only as a conductor or a composer, "presid[ing] gently" over his instruments. For Waldman and Schneeman alike, the artist orchestrates but is not herself the work's crux.

That such a precept should find its way into *Homage* is therefore unsurprising, given its centrality to both Waldman and Schneeman's artistic and collaborative imaginary. "Fundamentally," Waldman intones with an air of spiritual dogma, "collaboration is a calling to work with and for others, in the service of something that transcends individual artistic ego and, as such, has to do with love, survival, generosity, and a conversation in which the terms of 'language' are multidimensional."[72] Schneeman himself avers: "I think the artist has to have a certain disposition for enjoying collaboration—a fundamental concept of painting as something other than a form of self-expression. I never painted anything with the idea that I was expressing myself."[73] *Homage* does not simply offer an enduring testament to its artists' collaborative "dispositions"; it also actualizes this disposition through its own humble instrument—the artist's book itself. If, as book artist Ulises Carrión has noted, "The poetry of the old art . . . establish[es] an inter-subjective communication . . . in an abstract, ideal, impalpable space,"[74] then "In the new art [of concrete poetry and artists' books]" intersubjective communication "occurs in a concrete, real, physical space—the page." Accordingly, *Homage*'s artist's book form transports the "ideal, impalpable" space of the guitarist's song (both Stevens's and Waldman's own) into the "concrete, real, physical" realm. Because *Homage*'s unbound pages force attention to their individuality and the tracings and scrawled text index the artists' hands, the book exaggerates evidence of its meticulous human craftmanship, foregrounding the work's concrete materiality in ways that "ordinary" (nonaestheticized) books often allow or enjoin us to forget. Moreover, these details summon us, as in Stevens's earlier poem, to locate "Ourselves"

in the physical site of the page, incorporating reader-viewers into its intersubjective imagination. When *Homage*'s loose-leaf pages can be freely rearranged by each reader-viewer and Waldman's text, unbeholden to fixed lineation, read in a different order, the book is recomposed, making the audience an integral actor in its performance.

Nevertheless, it is the artist's book's very materiality that also signals the limits of this arrangement; for if the work allows reader-viewers to feel a profound connection with or involvement in it, the physical boundaries of the book-as-object remind us that this connection is ultimately impermanent—relegated to the spatio-temporal confines of the page itself. It is this final duality that the work declaims on its cover. There, Schneeman unveils a tracing of Ginsberg's photograph of his uncle Abe in his hospital bed before his death—an image whose original caption reads:

> My uncle Abe Ginsberg, Daughters of Israel Geriatric Facility, West Orange, New Jersey, April 13, 1986. He was too weak to sip from a straw. He lifted his hand and [I] stood at the foot of the bed with camera. He died a week and a half later. He had whispered, "I love you" when I first came in his room. (*Allen Ginsberg: Photographs*)

In Waldman and Schneeman's hands, however, the image and its accompanying caption are wholly reimagined. Devoid of the tender, familial sentiment that Ginsberg's original caption provides, the figure that appears on *Homage*'s cover more closely resembles an ageless spiritual being or Buddhist monk with a comically enlarged hand raised in the *abhaya mudra* (no fear) gesture than a frail Jewish uncle. In Schneeman's retracing, the moving image of Ginsberg's dying uncle takes on the epic proportions of the sacred world. Waldman's text sanctifies the idea, denoting "A hand in eternity." The cover page, like many that follow,

Facing page: Figure 8. George Schneeman and Anne Waldman, cover page from *Homage to Allen G.*, 1997, printed letterpress on paper, 11 × 13½ in. © George Schneeman and Anne Waldman. Permission to reprint work by George Schneeman is granted by Katie Schneeman. Permission to reprint work is granted by the poet, Anne Waldman. Images of *Homage to Allen G.* furnished by Special Collections & Archives, The University of Iowa Libraries.

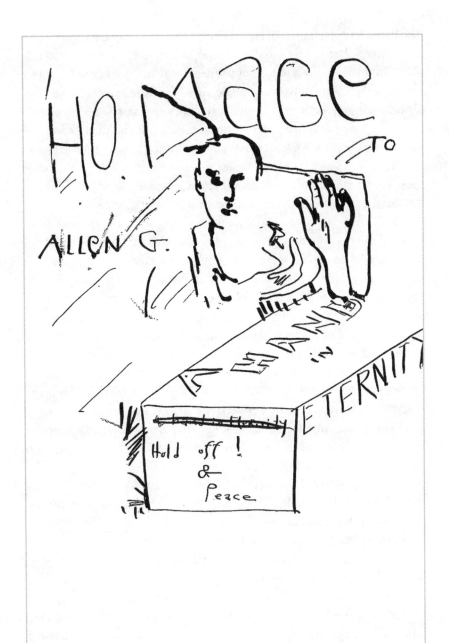

oscillates between frames of reference and scale, juxtaposing the intimate and universal, the mortal and immortal, and indeed the public and private. To this end, Waldman's supplementary text, "Hold Off! & Peace," conveys the volume's paradoxical gesture of welcoming reader-viewers in but haltingly or incompletely. Waldman's text implies both admission and distance, at once barring the audience from unmitigated access to the world of the book—"Hold off!"—and sanctioning their trespass within it—"Peace." Like the "No fear" gesture that it depicts, the cover page constitutes both an invitation and a warning: enter this world, it beckons, but understand that you are only a temporary visitor here.

Of Ginsberg's photos, Tim Keane once observed: "At their best, [the] pictures show how photography is a celebration within a rite of mourning" since "photography prolongs a lived moment that vanishes as soon as it arrives."[75] *Homage* itself elicits a somehow more conclusive "celebration within a rite of mourning," as the artist's book both celebrates and memorializes not just its titular addressee but the collaborative acts of exchange, both the artists' and our own, that have transpired, ostensibly prolonging these "lived moments" even as they elapse. *Homage* asks its audience to revel in a certain feeling of loss or transience even as they might lament it. Doing so, it further enacts the Buddhist-inspired dialectic between the eternal and the transitory, the holy and quotidian, that Ginsberg sought in his original photographs— an idea that the poet himself called "sacramental documentation," noting that, "The sacramental quality comes from an awareness of the transitory nature of the world, and awareness that it's the one and only occasion we'll be together."[76] *Homage* finally reminds us that artists' books may be somehow sacred forms, but they are, in many ways, exceptionally occasional ones. If artists' books uniquely facilitate our entry into richly elaborated material and social worlds, then our experience of them will nonetheless always remain partial. And yet it is this provisional entry that inures us to the work's refusals, allowing us to better recognize how "the poignancy of [the artist's book]" as Ginsberg once said of the photograph, "comes from looking back to a fleeting moment in a floating world."[77]

CHAPTER FOUR

Across the Margins

Mei-mei Berssenbrugge and

Kiki Smith's *Concordance*

P art autobiographical reflection, part feminist call to arms, Anne Waldman's 1994 "Femanifesto" opens with an epigraph from Mei-mei Berssenbrugge's "Alakanak Break-Up," a poem from the latter's pivotal 1989 collection, *Empathy*:

Inside the fog is a jail fire. Flames lure a quantity of what is going
to happen to her into equivocalness by softening her body with heat,
as if the house she is in suddenly rises, because people still want her.[1]

Characteristic of Berssenbrugge's poetry, the lines equivocate between figurative imagery and abstraction as they engage a familiar network of ideas: heat, femininity, malleability, desire. Haziness and containment ("Inside the fog is a jail fire") yield to something concrete and insurgent ("as if the house she is in suddenly rises") as the lines evidence a moment of clarity: a woman not just laying claim to but inhabiting desire, "because people still want her." That Waldman cites Berssenbrugge is a testament to the feminist sensibility that undergirds both women's work, as Waldman's revisionary impulses in *Homage to Allen G.* began to make clear in Chapter 3. The epigraph situates Berssenbrugge as a poet whose verse, like Waldman's, seeks "to explore and dance with

everything in the culture which is unsung and mute, and controversial so that she may subvert the existing systems that repress and misunderstand feminine 'difference' and, doing so, to "Turn the language body upside down."[2]

The project is indeed a familiar one for Berssenbrugge, whose oeuvre, spanning myriad poetic volumes and collaborations with playwrights, dancers, and visual artists, not only makes gender central to its social and aesthetic imaginary (and thus to many subsequent critical analyses), but continually subverts received linguistic and epistemological premises, including "feminine"[3] and, crucially for the Chinese American poet, racial "difference."[4] Nowhere has this project been more apparent than in Berssenbrugge's artists' books with printmaker and sculptor Kiki Smith (an artist, not incidentally, with whom Waldman also collaborated).[5] Produced in a limited edition run at the storied Universal Limited Art Editions (ULAE) and reprinted in a trade edition at Kelsey Street Press—an outlet specializing in women's collaborations, including Erica Hunt and Alison Saar's *Arcade* (Chapter 5)—Berssenbrugge and Smith's first book, *Endocrinology* (1997), takes Waldman's call to "turn the language body upside down" literally, endeavoring, in Berssenbrugge's words, to "feminize scientific language" by "making continua" between the "masculine" domains of mind, rationality, and language with the "feminine" domains of embodiment, feeling, and art.[6] *Endocrinology*, as Joseph Jonghyun Jeon, Yugon Kim, and Angela Hume have shown, investigates corporeal and representational systems while making visible the inner workings of these systems themselves.[7]

Berssenbrugge and Smith's second collaborative artist's book, *Concordance* (2006), continues in this vein. Created, first, at the Rutgers Center for Innovative Print and Paper with acclaimed book artist Anne McKeown in a stunning limited, 30-copy, accordion format edition and later reprinted in a 2,000-copy trade edition by Kelsey Street Press, *Concordance* is less explicitly consumed with physiology than the artists' first book, but it is equally invested in making "continua" in form and in theme. Taking its collaborative premise and its title seriously, *Concordance* decenters the primacy of any of its constituent elements in favor of mutuality and reciprocity between them; the artist's book

boasts no fixed, organizing center—subjective, aesthetic, epistemic, or otherwise. Instead, it affords an elegant choreography: the blue ink of Smith's delicate prints bleeds into and sometimes lightly obscures Berssenbrugge's three-part poem, which is itself rendered in elongated lines that allow one thought, image, or emotion to cascade into another. These horizonal poetic lines in turn reflect Smith's images, primarily of flowers and animals, which spill onto the margins of subsequent pages, traversing the normal codex borders in a way that evinces a spacious, continuous landscape in poem and print alike. Throughout *Concordance,* one thing continually brushes up against another: word and image, human and animal, art and nature; here, poem encounters print, lyric speaker meets addressee, and body confronts body. The artist's book's thesis is plain: "Relation is in the middle."

Nevertheless, the book's aphoristic claim belies its difficulty, both because, in *Concordance,* "the middle" is shifting ground and because "Relation" is figured as a mode of encounter fraught with contingency. Acute in *Concordance* are both the hazard of communicative, and, for Berssenbrugge, lyric failure and the thrill of its eventual achievement. To enter into "Relation" with oneself, with the environment, and, not least, with other people (addressee, audience) requires, Berssenbrugge and Smith suggest, a certain openness, vulnerability, and thus liability, which parallels the act of collaboration itself. Relationality requires a practice of routine adjustment, negotiation, and even reversal. Yet it is, Berssenbrugge and Smith insist, a worthwhile endeavor, not only facilitating for its artists a generative sense of aesthetic possibility but eliciting from its readers a more open perspective—an outcome with real stakes for those who create at the margins by virtue of gender, race, or both. To locate "Relation" in *Concordance* is to locate a reparative social model that can allay several overlapping crises of alienation and estrangement: artistic, lyric, environmental, and embodied. In its pursuit, Berssenbrugge and Smith oblige reader-viewers to see holistically; after all, the poem avows, "Numinousness in the psyche / emerges as from morphic fields" (section 3, lines 23–24).

Concordance began with a bookmark. As Berssenbrugge recounts, her poem was initially "inspired by a dandelion bookmark that Kiki [Smith] made which compares reading to dandelion silk floating to fill

the air."[8] Formally titled *The Sojourner,* the nickel-plated bookmark to which Berssenbrugge alludes was one that Smith had created, along with a temporary tattoo and a T-shirt—"in keeping with the exhibit's theme of prints and multiples"—for the first New York survey of the artist's print work at MoMA Queens (the namesake museum's library branch) in late 2003.[9] Though Berssenbrugge fails to elaborate further on the import of Smith's stirring art object, the bookmark hardly seems incidental to the subsequent collaboration they produced. First, the bookmark is a strikingly peripheral form: not only is a bookmark a marginal artform, ancillary to the primary artwork for which it is used (the book at hand) but Smith's bookmark is also peripheral to her central print exhibit, which was itself held in a space ancillary to the main MoMA gallery. The book's peripheral appeal is subsequently replicated in *Concordance*'s collaborative artist's book form: a putatively "minor" form ancillary to both the mainstream visual art and literature worlds, and one created by two women artists, making it further peripheral to the hegemonic (white, male) canon. As Smith herself has noted: "Making things from paper is marginal, making prints is really marginal, being a woman."[10] In taking the bookmark and, later, the paper-based artist's book as media, Berssenbrugge and Smith signal from the start their transformation of something ostensibly "marginal" into something worthy of our focused attention—a feat with clearly feminist connotations.

More than that, the bookmark, like Berssenbrugge and Smith's resulting artist's book, imagines an especially material form of relation between artwork and audience: both bookmarks and artists' books uniquely index readers' bodily participation in a work of art, even when those readers, and their bodies, are physically absent. That is: both the bookmark and the artist's book index the tactile interactions with the book form that have transpired and presage those that have yet to occur; both are, in this way, more closely aligned with the embodied *act* of reading or of experiencing the artwork than with the art object *qua* object itself. Perhaps in deference to this idea, Smith observes, "I love things that people get to touch. It makes a whole history that evolves where everything holds information."[11] Consider, then, Berssenbrugge, Smith, and Anne McKeown's choice of the accordion format for *Concor-*

dance's initial limited-edition run. Favored by many book artists since the '60s and '70s, the accordion format enjoins its reader-viewers not simply to touch the work but to manipulate its movement: its opening and closing. The accordion artist's book purports a readerly encounter with the book that feels temporally and spatially expansive—both "floating" and fleeting, like "dandelion silk in air." Both the bookmark and the accordion artist's book also suggest an experience of reading in which the audience proceeds through the work, physically and conceptually, in fits and starts. Both, that is, purport an aesthetic, to adopt Jonathan Skinner's apt description of Berssenbrugge's poetry, "not of metaphor but of metamorphosis . . . one is constantly being asked to release focus, and to reengage—constantly getting away from and back to things."[12] Like the bookmark that inspired it, the accordion artist's book denotes a mobile experience, allowing the reader to move with the work. But if this experience overtly models itself on a dandelion's— nature's—inherent flux, its design is also thoroughly human, patterning the mutability of all social relations, including collaboration itself: we make and release contact, we move into and out of physical proximity; we too open and close.

It is fitting, then, that Berssenbrugge's poem should begin (again) with Smith's bookmark. Self-consciously exploring writing's readerly import in its first section, the poem describes the kind of active encounter or reading experience that its artist's book form aims to produce:

> Writing encounters one who
> does not write and I don't try
> for him, but face-to-face draw
> you onto a line or flight like a
> break that might be extended,
> the way milkweed filling space
> above the field is "like" reading (section 1, lines 1–7)

From its outset, Berssenbrugge's poem dramatizes the "break" between "Writing" and reception; doing so, however, it eschews a traditional mode of detached or indirect "encounte[r]" between the lyric speaker and addressee and reframes that relation anew. Turning away from "one who / does not write"—a putative stand-in for the distant reader

or critic, markedly coded male ("I don't try / for him")—Berssenbrugge turns toward a familiar audience, "you." Ostensibly addressing her collaborator Kiki Smith, whose presence is metonymically inscribed on the page through her prints, the "you" whom Berssenbrugge's poem addresses is located within the work, "draw[n] / . . . onto a line or flight," rather than positioned beyond it. Even as this "you" seems to serve as a specific stand-in for the poem's immediate addressee (Smith), its dietic ambiguity allows it to double as an appeal to a broader addressee: the reader-viewer. While it might, in this sense, initially evoke what Jonathan Culler has called the "triangulated address" of lyric poetry, in which the reader is addressed via an apostrophic other (a muse, a natural entity, and/or here Smith herself), Berssenbrugge ultimately denies its "characteristic indirection."[13] Because the porousness of "you" makes it possible for Berssenbrugge to address both Smith and the reader directly and simultaneously, her poem subverts the indirect address-by-proxy model and instead situates the specific addressee and the reader-viewer as innate parts of the poem's environment rather than as distant or belated interlocutors. The poem, that is, dissolves hierarchical and spatiotemporal boundaries between "I" and "you" (speaker and addressee, writer and reader, poet and artist) by positioning them as equals in close, interpersonal proximity: "face-to-face."

In addition, Berssenbrugge's pointed rejection of "him" and embrace of "you," implicitly coded female via Smith, hardly seems incidental. While less overt than in her other verse, rife with mention of mothers, daughters, and girls, Berssenbrugge seemingly adopts in *Concordance* a "gender specific vocabular[y]" that, as Yugon Kim argues, intimates her rebuke of the "prevailing representation systems," and her attempt to "remake those systems from women's perspectives."[14] In employing a direct, feminized mode of lyric address that is neither distant nor asymmetrical but intimate and reciprocal, Berssenbrugge's poem imagines a relation between "I" and "you" determined from within rather than from without. "Then, it's possible," Berssenbrugge continues,

> . . . to undo
> misunderstanding from inside
> by tracing the flight or thread of

1.

Writing encounters one who
does not write and I don't try
for him, but face-to-face draw
you onto a line or flight like a
break that may be extended,
the way milkweed filling space
above the field is 'like' reading.

Then it's possible to undo
misunderstanding from inside
by tracing the flight or thread of
empty space running through
things, even a relation that's
concordant.

Seeds disperse in summer air.

Sunrays cease to represent parallel
passages in a book, lie, not coming
from what I see and feel.

Relation is in the middle, relay,
flower description to flower
becoming of the eye between light
and heart.

Figure 9. Kiki Smith and Mei-mei Berssenbrugge, *Concordance* (facsimile edition), acrylic stencils and screen printed text on paper, 2006, 8¾ × ¼ × 8¾ in. *Concordance* was published by Kelsey Street Press in 2006 and is reprinted by permission of the publisher. © Kiki Smith and Mei-mei Berssenbrugge. Images of *Concordance* furnished by Houghton Library and Library Imaging Services, Harvard University.

> empty space running through
> things, even a relation that's
> concordant (section 1, lines 8–13)

By inscribing the reader-viewer within the work, Berssenbrugge transforms them from a passive, deferred recipient of the work and into an active co-creator of it, not unlike Smith herself, allowing them to approach "a relation that's concordant." As such, the "empty space" or "break" between writing and reception that Berssenbrugge's poem initially carves out is not an impermeable chasm but a permeable, interactive field—mimicking the interactive space of the artist's book's accordion form itself.

The relation between Berssenbrugge's poem and Smith's prints further confirms the anti-hierarchial, interactive nature of their collaborative

artist's book. Throughout the work, Berssenbrugge and Smith share a common set of images between poem and print, especially images of animals; nevertheless, the poem and prints rarely correspond on a single page. An owl that Berssenbrugge's poem mentions on one page, for instance, will appear in Smith's prints on the next, or a frog that the poet conjures early in the book comes into view in Smith's prints only on the final page. *Concordance* proposes a sort of slant ekphrasis, in which word and image often bear a clear one-to-one correlation, but they are neither presented as straightforward analogues nor is their correspondence explicitly announced. Rather than foregrounding the equivalence of poem and print, the collaborative artist's book's layout charges the reader-viewers themselves with drawing connections between them, entreating us to activate the work's word-image relation by indeed "tracing the flight or thread of / empty space running through things." This not only transforms the space of the work into a permeable aesthetic field, but it critically denies the print's merely illustrative or subsidiary function. Both the poem and the prints inevitably speak to each other, existing in space both hesitantly and resonantly. Such positionality seems to reflect, in turn, the artist's book's collaborative origins. Of her preferred working method, Kiki Smith describes:

> I periodically like to use words in relationship to my work [. . .] Since I've met Mei-mei Berssenbrugge, we've made maybe four projects together. . . . For me, it's just a pleasure. . . . But it's interesting because it can't be illustration. You can't make something that is an illustration of something, because then that's just working for somebody else, which I'm not that into. Each one that I've done, for the most part, has really been a collaboration, and sometimes it comes from just talking. Mei-mei and I just talked for a long time, and then we did things simultaneous to one another. . . . In certain ways they go together, and in other ways they move apart from one another, or are antithetical to one another's meaning. I like that it's not a one-to-one correlation. It's just possibility.[15]

Smith describes a collaboration process intent less on achieving precise word-to-image correlation than on offering readers an enthralling

sense of coincidence—both of correspondence and of chance. "Mei-mei will make poems," she continues, "and I just use all the animals she mentions in the poems, or all the different kinds of natural phenomenon. I'll just make images of those. In that way it's maybe closer [to illustration] but it's just whatever is pleasurable."[16] As such, the slightly askew visual relation between poem and print, proceeding by resonance rather than by direct fealty, captures for the reader-viewer the spirit of spontaneity and evident delight in Smith's description, conveying to the reader a sense of ongoing visual-verbal "possibility." The book's reciprocal, spontaneous, collaborative ethos thus becomes endemic to its form.

If both the interactive form and the interactive relation between poems and prints in the collaborative artist's book not only bids the reader-viewer's participation but makes such participation feel tangible, however, Berssenbrugge betrays self-consciousness about her ability to approximate the same experience through poetic language alone. Although Smith's bookmark may prompt the poem's initial simile— "the way milkweed filling space / above the field is 'like' reading"— Berssenbrugge's attempt to re-present that dynamic experience poetically soon becomes suspect, hampered by the figurative language that should sustain it. That "'like' reading" is set off in scare quotes casts doubt on the figuration's accuracy even as it is invoked. Here, Berssenbrugge implies, mimetic representation broaches its limit, since to invoke the simile—to reduce the act or event of reading to a mere figurative description—is to turn it into something static and unnatural. The simile calcifies the word "reading" into a representative sign at odds with the dynamic experience of actually reading or experiencing the collaborative artist's book—a dynamism it shares with the milkweed flower whose "Seeds disperse in summer air." To achieve a more dynamic readerly relation thus requires that Berssenbrugge suspend figuration:

Sunrays cease to represent parallel
Passages in a book, i.e., not coming
from what I see and feel. (section 1, lines 15–17)

In course, Berssenbrugge's "sunrays" doubly refuse their representative capacity: "sunrays" both resist their textual expression ("cease to represent parallel / passages in a book") and they, in turn, refuse to represent the poet's lyric consciousness ("i.e., not coming / from what I see and feel"). Rejecting the equation of signifier and signified—art and nature, lyric utterance and personal expression—Berssenbrugge again galvanizes the "empty space" between them:

> Relation is in the middle, relay,
> flower description *to* flower
> becoming of the eye between light
> and heart. (section 1, lines 18–21)

Concordance inhabits the metamorphic gap between signifier and signified, "flower description *to* flower" rather than dramatizing its conclusion. By relinquishing the facile stasis of figurative and linguistic representation, the poem's first section aims to meets its reader-viewers in dynamic state of (visual) transition: "becoming of the eye between light / and heart."

This shift away also requires that Berssenbrugge imagine a different model of lyric subjectivity, for if *Concordance* meets its reader-viewers in a transitive space of "becoming," neither "I" nor "you" can stably signify. The poem consequently unveils a highly contingent speaker who bears a volatile relation not only to her own emotions and experiences but also to her poetic addressee. Berssenbrugge's speaker suddenly appears anxious, caught between an urge to repress feeling and an inescapable alertness to it: "At night, part of her numbed to / pain and part woke to what occurred" (section 1, lines 28–29). As much as the speaker tries to numb herself or to detach (the poem's switch to the third-person "her" here is revealing), she registers "pain." Detachment, the poem resolves, is futile since "Working backward in sleep, the / last thing you numbed to is what / wakes you" (section 1, lines 30–32). Detachment does not eliminate pain, it simply displaces it, shifting it from consciousness to unconsciousness, from one pronoun to another. The only solution, then, is to embrace this shifting: to recognize that speaker's feelings and her capacity to express them are conditional, not absolute. The poem proceeds interrogatively:

What if that image were Eros as
words?

I write to you and you feel me.

What would it be like if you
contemplated my words and I felt
you? (section 1, lines 33–38)

One of Berssenbrugge's most astute readers, Dorothy J. Wang argues
that the poet's frequent use of "as if," "reveal[s] to us the instability
of knowing and of being—in other words, epistemological and onto-
logical contingency, both of natural phenomena and of human states
of being in the world"[17] by "suggest[ing] contiguity, affinity, connec-
tivity but also dependency, uncertainty, chance . . . the possibility of
something fortuitous and/or something untoward."[18] Berssenbrugge's
lines in *Concordance* follow suit, their instability borne not by the
declarative "as if" but by the repeated question "What if?"—a question
whose answers likewise leave open both the "possibility of something
fortuitous" ("I write to you and you know me") and of "something
. . . untoward." The poem itself admits this second possibility several
lines later in a stark reversal: "For the first time, I write and you / don't
know me" (section 1, lines 50–51). The poem here intuits a desirous but
potentially elusive, highly contingent relation between "I" and "you"
which echoes that, more broadly, between word and image, both within
the space of the poem ("What if that image were Eros as / words?") and
that of the artist's book at large. In the chiasmus within her lines as
well as between them (I-you, you-me; you-me, I-you), Berssenbrugge
makes room for instability of these ontological positions as well as
for the many possibilities, fortuitous and untoward, contained within
relation: understanding, recognition, rejection, unease.

Indeed, Berssenbrugge suggests that if what is seen, felt, and known
in *Concordance* cannot be represented through figurative and mimetic
language or consigned to a stable lyric subjectivity, which are poetically
a priori, then they must be experienced, instead, as an intersubjective
event. Nevertheless, to come into such intersubjective and, by exten-
sion, collaborative relation is to assume the possibility of uncertainty,

failure, or even suspicion, as Berssenbrugge's searching questions make clear. When "I write and you / don't know me," the poem's interpersonal and collaborative reciprocity is jeopardized, threatening both to short-circuit the previously direct connection between speaker and addressee, "I" and "you," and, in its absence, to render the speaker's subjectivity permanently unknowable—a threat with added significance for a poet whose subjectivity is always already in doubt by virtue of gender and race. In *Concordance*, Berssenbrugge broaches the idea that to write outside of conventional, stable lyric structures—to experiment with new forms of address or interpersonal relationality—is to write from a position of insecurity: the position, allegorically, of the marginalized poet whose message is continually at risk of getting lost in translation. Berssenbrugge herself has stated: "Being non-white (and half Chinese), marginalized, is an insecure and at the same time dynamic situation. You have to identify yourself, and there's no set point of view."[19] Though less explicit than in her statement, the racial undertones of Berssenbrugge's lyric experimentation in *Concordance* appear to "reduce to elemental form,"[20] the deep "interest in racial positionality that [she] explored earlier in her career," as Joseph Jonghyun Jeon suggests of Berssenbrugge's other artists' books.[21] Magnifying the lyric speaker's insecurity and the potential for communicative failure, Berssenbrugge lays bare what Kamran Javadizadeh calls the "the whiteness of the lyric subject," exposing how the traditional expressive lyric, assuming a coherent, stable "I," proves insufficient for non-white poets whose "sovereignty . . . ha[s] been called into question, when the poet's self was thought of not as an internally coherent reservoir of Wordsworthian memory but instead as a linguistically and therefore . . . socially and politically—contingent and shifting site."[22] A Chinese American poet like Berssenbrugge, in essence, cannot assume the same intractable or coherent expressive authority. In such a situation, the poet confronts an impasse: "How can poetry continue to offer the opportunities for mutual recognition once thought of as lyric's purview after the very idea of the lyric has been exposed as theoretically naïve, even politically suspect?"[23]

For Berssenbrugge, one critical answer comes through the body; in the space of her poetry, somatic connection serves as an alternative to

written (lyric) connection, thus circumventing the "whiteness of the [traditional] lyric subject." Unlike a conventional (and conventionally white) lyric subject contained neatly within the representative, immaterial parameters of language, Berssenbrugge's embodied "I" is insistently site-specific and material. As in the poem's first section, its second section presents a threshold between "I" and "you" that the poem wants to cross, but it is less a theoretical "empty space / running through things" than a concrete and precarious physical barrier. It opens:

> One experiences another's energy
> as stress.
>
> At first, I felt attacked by this
> attribution of the symptoms of my
> illnesses.
>
> I was frightened thoughts and
> feelings could be externalized. (section 2, lines 1–7)

The body, Berssenbrugge imagines, might be under siege or prone to suffering or stress, manifesting "the symptoms of my / illnesses." The body, she observes, might also warn of imminent danger: "Look at my body as light / reflecting the thought and feeling: / it's not safe here" (section 2, lines 20-22). The interpersonal risk and threat of unknowability to which Berssenbrugge's poem earlier alludes here becomes acute, continuing a paradigm laid out in *Endocrinology* in which, Angela Hume suggests, "risk *is* form. To be a body is to be a body in proximity, a body perfused, and to read the book is to actively encounter *with one's body* the nature of contemporary risk."[24] Imagining relation corporeally sharpens for the reader-viewer the potential senses of trespass and harm.

Nonetheless this risk remains provisional or contingent since Berssenbrugge holds in balance the body's equal capacity to shelter and to thrill. While the meeting of bodies is, in *Concordance*, rife with fear and danger—perhaps intuiting the real, embodied social terror of marginalized subjects—the vulnerability that such an encounter both requires and produces can ultimately engender a more complete, specific form of "intimacy" that Berssenbrugge according to Charles

Altieri, "can take on the marvelous subtle physical analogues . . . of color [and] light."[25] Although the lyric speaker is "At first" beset by "illnesses" and "frightened [that] thoughts and / feelings could be externalized"—unsettled by her own vulnerable body and its unwitting capacity for expression—her encounter with another person restores her to intersubjective relation. "Light," as Altieri observes, becomes the modality that makes not just relation, but real intimacy, possible:

> Then, I saw sunrise frequencies
> emanate from your body, like music.
>
> An excited person in light absorbs
> wavelengths she herself gives off, as
> if light were the nutrient for feeling. (section 2, lines 8–12)

In this intersubjective encounter, the body's capacity for expression is no longer figured as a potential threat but as "nutrient for feeling," restoring mutuality. Functioning as a synesthetic site where visual sensation is perceived as aural event, the body allows for communication between "I" and "you" that occurs not through language but through sensational and corporeal transference. By making the speaker's body a privileged point of intersubjective contact, Berssenbrugge, to adapt Javadizadeh, can "experiment with reconfigurations of the lyric subject that avoid replicating the structures on which [it] was built while maintaining the possibility that the lyric might serve as a space for [its] intimate relationality."[26]

More than that, if Berssenbrugge's poem imagines that "intimate relationality" is vested not in conventional lyric address but in the meeting of bodies, then it is also, by extension, vested in the collaborative artist book's physical form itself. Any "intimate relationality" reader-viewers experience in *Concordance,* in other words, is a function not just of Berssenbrugge's lyric experimentation but also of the work's medium. Of Berssenbrugge and Smith's *Endocrinology,* Jeon suggests, "Books have always been associated with bodies . . . and bookmaking terminology has appropriated the names of body parts and functions to describe physical elements of the book (heads, tails, spines, bleeds, and so on)."[27] Citing her husband and frequent collaborator Richard

Tuttle, Berssenbrugge avers: "Richard says that a book is like the body, that it is a metaphor for the body. A book has a spine, and its cover is like the skin. And it has a heart."[28] Yet if books and bookmaking are associated with bodies in general, they have also been associated with specific bodies—women's bodies—in particular. To this end, Johanna Drucker maintains:

> the [craft] activities associated with bookmaking are socially coded in a positive way as feminine. The sewing of pages, deft handling of glue and paste, detailed drawings, and carefully cut figures and openings reflect the supposedly feminine traits of attention to detail and a disposition toward the aesthetic pleasure in the selection and combination of materials.[29]

Taken together, these insights well suggest *Concordance*'s collaborative artist's book form as a potent site of not just intimate relationality but of gendered relationality: one where women's bodies and bodies of art encounter each other and, ultimately, us.[30]

That Berssenbrugge and Smith's collaborations, including both *Endocrinology* and *Concordance*, frequently foreground bodily relations in this way is certainly fitting, since both women have long turned to the body as an important site through which to explore questions of intersubjective relation as well as, more specifically, "the experience of feminine alterity."[31] For both Berssenbrugge and Smith (inherently gendered) embodiment—physical proximity—has been an essential aspect of their personal collaborative practice. Berssenbrugge has not only described the act of collaboration as "a wonderful way to open to someone's else's sensibility, to use that openness like ocean or oxygen," but she has noted of working with Smith, particularly: "I collaborated with Kiki and our work and lives have been entwined ever since . . . I'm [actually] wearing her gold bracelets [. . .] I went to New York to [Smith's] place on Ludlow Street, and we met. Then she came out to New Mexico for the first time. And she's been coming to New Mexico ever since."[32] Even so, it is Smith whom Berssenbrugge fundamentally credits for their works' bodily emphasis. Smith, she elaborates, was "one of the artists credited with bringing the physical body back into art—as imagery, as subject-matter, after a period of abstraction. . . .

That's one reason I was interested in her work. I thought that, since my work is so abstract, I could use dialogue with her to find my way into a more concrete kind of narrative."[33] Inspired by the AIDS epidemic and well as "Cultural Wars" discourse surrounding prisons and reproductive rights—the "many social constraints on the body," the artist notes[34]—Smith's print and sculptural works have not only routinely depicted but have become widely identified with women's bodies. And Smith herself also valorizes physical proximity as a creative boon, noting of her own collaborative craftmanship: "It's very pleasant, that intimacy, working with other people, sitting around the house, having lunch. I like that communal situation, to be around other people working or people who know better than you how to make things, a hands-on, homemade, intimate relation to things."[35]

While *Concordance*'s bodily emphasis is therefore unsurprising, what does remain surprising is that bodies are strikingly absent from Smith's prints, even as the idea of corporeal relation consumes both Berssenbrugge's poem and the work's overarching book form. In a departure from Smith and Berssenbrugge's first book, *Endocrinology*, whose prints, resembling organs, glands, and nerves, continually evoke the human body, the only perceptibly human form in *Concordance* arrives in the shape of a disembodied, curved hand emerging from the top right corner of one page: a hand whose half-closed fingers are either poised to pluck the flower positioned beneath it or appear to have just let it drop. It is, as a result, a human hand that appears both to reach out toward something on the page and to retract from it—an image, in other words, that stunningly echoes the sense of contingency and hazard held within the human body that Berssenbrugge articulates in her poem immediately below: "Look at my body as light / reflecting the thought and feeling: / it's not safe here" (section 2, lines 20–22). Perhaps serving as a proxy for, or at least a striking reminder of, the reader's own hand, which is manipulating the work, as well as Smith's own, the human hand that the artist depicts in her print initially appears jarring within the artist's book's broader landscape. In a volume otherwise teeming with prints of flora and fauna (flowers, leaves, frogs, birds), the human hand seems notably foreign and even threatening, as if it could, potentially, disrupt or destroy the volume's delicate ecosystem.

Yet if the print, in this regard, again conveys the peril of bodily relation imagined in Berssenbrugge's poem, then the human form we encounter in *Concordance* ultimately resolves itself into something more whimsical than foreboding.

Despite the equivocality it prompts, Smith's hand, like Berssenbrugge's poem beneath it, gives over to connection rather than to alienation or destruction. After all, the reader-viewer soon notices the affinity between this Smith print and the many others that populate the work: the curvature of human fingers, for instance, echoes the roundness of the flower bud positioned below it, or else the human fingers quickly shape-shift into a bird's disembodied talons on the next page, which themselves morph into the blue, spiky plant leaves that Smith outlines on another. Smith establishes resonance, in other words, between the human fingers and the many animal and flower prints that occupy the work, concretizing humans'—and perhaps by extension the reader's and artists'—assimilation within the natural world and the space of the artist's book rather than their estrangement from or dominance over it. The continuity between human and nonhuman forms that Smith establishes also gives rise to what she has called "the symbolic morphing of animals and humans";[36] the prints, that is, confirm her long-held understanding that "[humans] are not to be separate from the rest of the universe, that we have this idea of autonomy, but really we're a part of a whole."[37] The effect in *Concordance*, as Julie Joosten beautifully describes in a rare volume review, is a "stunning ecology": a continuous environment of "plants, animals, people, water, air, light, idea, feeling, abstraction, concretion, and question."[38] In the work, she continues,

> transformation inheres in [the images'] presence; [feathers] recall the owl while also suggesting plant leaves bordering the text. Animal *to* plant. Smith's image becomes both at once, and a single body opens out, transformed, across distinct planes . . . concordance as harmony, index, context, cross-reference, and genetic trace.[39]

Prone to such quick transformation, Smith's images are unfixed. Sparse, light, and airy, they conjure a holistic landscape of transient, living things: a "morphic fiel[d]," in Berssenbrugge's terms, in which the body

Then, I saw sunrise frequencies emanate from your body, like music.

An excited person in light absorbs wavelengths she herself gives off, as if light were the nutrient for feeling.

Color is a mirror where we see ourselves with living things, scarlet neck feathers, infant asleep across your heart, like-to-like.

Attention gives light shine on a baby's scalp as he hears what I say, I become that.

Look at my body as light reflecting the thought and feeling: it's not safe here.

Remove anxiousness over persons you yearn for, stepping back to observe, like an animal in the fourth dimension.

Since animals don't judge, their evolving cosmic skills are a source of richness for us.

Figure 10. Kiki Smith and Mei-mei Berssenbrugge, *Concordance* (facsimile edition), 2006, acrylic stencils and screen printed text on paper, 8¾ × ¼ × 8¾ in. *Concordance* was published by Kelsey Street Press in 2006 and is reprinted by permission of the publisher. © Kiki Smith and Mei-mei Berssenbrugge. Images of *Concordance* furnished by Houghton Library and Library Imaging Services, Harvard University.

itself functions again as a fertile site of transformation and interrelation, here between human and animal realms.

This idea further inheres in the birds that populate *Concordance* and much of Smith's oeuvre, confirming how, in the artist's own words, birds act "as stand-ins for [human] souls, [suggesting] that our identity is deeply, sometimes tragically connected with the natural world."[40] Indeed, the most frequently depicted "bodies" in *Concordance* are not human, but avian: an owl graces the artist's book's front cover and is later reprinted within; several pages later, a parrot-like bird—perhaps the "beloved macaw" that Berssenbrugge's poem will later describe—emerges. Much like the human body that Smith references in *Concordance* through the disembodied hand she includes in it, these avian bodies are never depicted quite fully intact. While one page might depict a bird's head in close-up, the next will reveal just its tail

feathers; on another page, only its talons are visible. The effect is both formal and thematic. Formally, the bird images that extend from one page to the next deftly point to the collaborative artist's book's accretive landscape, making it appear as though one bird is taking off and landing again or that a whole flock occupies the book's terrain. Traversing the boundaries of the page—the margin, in the trade edition, and the fold, in the accordion format—the bird prints lend the work a sense of motion or animation, as if in a refined flip-book, which conveys "the sense," as Johanna Drucker describes of artist's books more broadly, that "a limit which an edge, binding, and spine provide" is countered by "the infinite space of the page and opening, capable of drawing the reader inward in an endlessly expanding experience of sensation and association."[41] Vincent Katz has remarked that for Smith, words "act as quiet catalysts, not defining or limiting the images but rather giving them more space to breathe."[42] That the terms could also be reversed, with Smith's intuitive layout catalyzing the formal spaciousness of Berssenbrugge's poem, is essential to *Concordance*. "Kiki's strips of text [in *Endocrinology*] have enabled me to break free from stanzas, ever since," the poet has said.[43] Her lines in *Concordance*—non-stanzaic and irregular, occupying nearly the whole page's width—function similarly, as if Smith's bird prints literalize Berssenbrugge's endeavor to create out of and across the margins. This expansiveness, however, also resonates thematically. The disembodied bird feathers that reader-viewers encounter at the page's edge suggest molting, visually confirming the idea of metamorphosis at play in Berssenbrugge's poem. As a result, Smith's bird prints, like Berssenbrugge's "I" and "you," defy stable representation; straddling multiple pages and appearing piecemeal, their forms are continually unsettled. Like the poet's lyric subject, Smith's birds become fully legible, if at all (the risk of illegibility or unknowability looms) not at the immediate site of inscription but within the larger field: only in relation to others.

Stunningly ecopoetic, *Concordance* establishes spiritual contiguity and relationality between species that decenters human exceptionalism and dominion in poem and print alike. "A bird lands on the rim of your tub," Berssenbrugge writes toward the end of the poem's second section, "a wolf licks your baby's head" (section 2, lines 30–31).

Like Smith's prints, Berssenbrugge's poem suggests that it is through the animal world that humans may better see or reflect upon themselves: "Animals, an owl, frog open their / eyes, and a mirror forms on the / ground" (section 1, lines 39–41). It is the animal world, then, that offers an instructive model for human relations. "Since animals don't judge," Berssenbrugge writes, "their / evolving cosmic skills are a source / of richness for us," highlighting a nonjudgmental, unprejudiced, and even primal perspective that might function, broadly, as a critical guide to encountering many forms of Otherness, including racial or gender difference. It is an understanding rooted further in Berssenbrugge's Chinese heritage, wherein "the visual images and philosophical concerns expressed through observations and experiences in nature are typical of Chinese poetry,"[44] as well as in the poet's and Smith's shared interest in Buddhist spirituality.

Concordance's fluid animal-human connection indeed seems to align particularly well with the Chinese poetic principle *xing*: a "lyrical energy" that is "predicated on a cultural orientation in which everything in reality, including human beings, is perceived holistically and as organically integrated."[45] Its effect, Cecile Chu-chin Sun elaborates, is to achieve a "persistent view of reality in which human beings and their environment, whether natural or supernatural, are intimately related and characterized by an 'affective-responsive' rapport between them."[46] As in Smith's prints, where human fingers morph into a bird's talons, this "'affective-responsive' rapport" is best rendered visually in Berssenbrugge's poem, once more clarifying the insufficiency of language alone (a human prerogative) as a primary basis of relation. "Color," Berssenbrugge writes,

> is a mirror where we see
> ourselves with living things, scarlet
> neck feathers, infant asleep across
> your heart, like-to-like. (section 2, lines 13–16)

Echoing its earlier positioning of "I" and "you" "face-to-face," the poem again assumes bidirectional contact and resemblance between humans and animals rather than hierarchical or asymmetrical relation: "like-

to-like." Like "light" before it, "color" is cast as a font of connection or "intimate relationality"—a choice that perhaps again insinuates the poem's racialized underpinnings.[47] Divorced from socially imposed meaning, the color found in nature is neither the basis for an exclusionary racial discourse nor exclusively the domain of "art," both products of human culture. Instead, "Color" reminds us that humans are forged in nature's image as much as the converse; it is, for Berssenbrugge, a visible force that entreats us to observe and connect rather than to adjudicate and divide.

Berssenbrugge and Smith uncover in *Concordance* a relational field whose expressive modalities cannot be contained in language but must be found instead in the physical and even metaphysical world: in the body, in visual phenomena (light/color), in nature, and in the cosmos. The poem's final section opens:

> My words unroll a plane of
> consistence they do not pre-exist—
> particles, fluxes the colors of spring.
>
> Desire individuates through affects
> And powers I place on a page or plane
> of light vibrations, like a flowering
> field. (section 3, lines 1–7)

Toward the end of Berssenbrugge's poem, language takes on preternatural form: "particles," "fluxes the colors of spring" "affects," "powers," "vibrations." Her "words" virtually come to life, transformed within and by the "page or plane" on which they are "place[d]." Following the lead of Smith's prints, which readily traverse the human, animal, and plant worlds, Berssenbrugge's "words" manifest in different, surprising, nonlinguistic and natural states ("light vibrations," "affects and powers"), finally unfurling, "like a flowering / field." For Berssenbrugge, Sasha Steensen notes, "the flower, an organism that relies on pollinators for reproduction, presents us with a model of inter-relation that beautifully illustrates the interactive, continuous world [she] experiences and aims to articulate."[48] *Concordance*'s "flowering / field" works to the same end,

as Berssenbrugge's poem, alongside Smith's prints, propagate a "model of inter-relation" between people, realms, and modes of signification predicated on convergence, interaction, and exchange.

Still, Berssenbrugge and Smith's "model of interrelation" crucially resists homogeneity; the whole never eclipses its constituent parts. "We see ourselves *with* living things," Berssenbrugge's poem makes clear, not *as* them. The work's abiding "consciousness / emanating from stars" is, in Berssenbrugge's trim phrase, "symbiotic / with individuation" (section 3, lines 10–12). *Concordance*'s symbiotic imaginary seemingly approximates what biologists call "mutualism": a model of reciprocity in which different species interact to ensure their joint survival. Applying not just to the human and animal realm, but to all manner of relation in *Concordance*—word and image, lyric subject and addressee— "Symbiotic / with individuation" purports a finely calibrated system that mediates, rather than subsumes, difference. Achieving a relation "symbiotic / with individuation," however, is neither effortless nor guaranteed, as we have seen; rather, it is a relation, *Concordance* makes clear, that we must strive to both create and sustain. "Life manifests everywhere in the / cosmos," Berssenbrugge declares,

> but as we eliminate species
> here, we lose access to other realms.
>
> So, discovering a new species is a
> great event. (section 3, lines 18–22)

To achieve a relation "symbiotic / with individuation" is to ward off two disastrous outcomes: hegemony, on one hand, and extinction, on the other. For Berssenbrugge and Smith, this is not just a theoretical or aesthetic position but a moral imperative. The poem's closing lines stress the point through an elaborate counterfactual: "When you doubt this," Berssenbrugge warns, "you place / a piece of 'someone' on a pedestal / to examine, a gap" (section 3, lines 28–30). To "doubt this" is to invite back judgment. It is, worse, to create an uninhabitable "gap" between "I" and "you": a "gap" that is not a permeable "empty space," as in the poem's beginning, but a cold, detached chasm, portending a return to subjective (lyric) hierarchy and inter-species estrangement.

Nonetheless, if "doubt" jeopardizes the delicate model of interrelation Berssenbrugge and Smith work to construct throughout *Concordance*, then the poem offers a quite literal directive back to it. "Breathe the shard back into yourself," Berssenbrugge instructs. Jonathan Skinner has observed that Berssenbrugge's work often involves a conspicuous "process, just this mode of breaking and reconnecting . . . that builds landscape."[49] The final lines of Berssenbrugge's poem are illustrative, offering a final command to reconnect, smoothing out the "shard" and restoring embodied relation anew. In fact, any "doubt" that the poem had earlier allowed is quickly allayed by color and light, which return:

> In your memory, scarlet feathers of a
> beloved macaw begin a glow arising
> from the exact color of connection.
>
> Warmth, which was parallel, moves
> across the shard, smoothes and makes
> it porous, matter breath, light
> materializing dear ants and dear words. (section 3, lines 32–38)

Working through prior images ("scarlet feathers of a / beloved macaw"), substituting "doubt" with "memory," detachment with "warmth," Berssenbrugge repairs the work's "porous" ground. Her gerund, "materializing dear ants and dear words"—like the "flowering / field" before it—restores us to a prolific space, once more begetting word and image, animal and art. In its final lines, *Concordance* rehearses its theoretical and formal crux, suggesting that relation is not a seamless process but one of continual rupture and repair (consider, again, its accordion format). Throughout the work, one entity confronts another, negotiates its relation to it, and reestablishes connection anew: person to person, human to animal, poetry to art. The artist's book itself becomes a mutable, contingent landscape forged through this continual process of "breaking and reconnecting," to recall Skinner, continually altering the audience's "frame of relation to it."[50]

Such a prospect restores us, once more, to the collaborative artist's book form itself, and especially to its Kelsey Street Press trade edition—a volume that formally realizes the expanded sense of relational

possibility that Smith and Berssenbrugge unearth conceptually in poem and print. Created in a paperback edition, *Concordance* is rare among artists' books in being reprinted in a more widely available but still high-quality format—one that, except in size and layout, closely replicates the first accordion edition. Discussing the *Endocrinology* trade edition, created several years before that of *Concordance*, Berssenbrugge remarks: "The Kelsey Street Press constructed a 'facsimile' at a reasonable price. For mysterious reasons, each layer of reproduction added energy, so in many ways Kelsey Street's 'cheap' edition is the more vital."[51] A subversion, no doubt, of Benjamin's axiomatic ideas about "aura" and artistic reproduction, the trade edition affords its reader-viewers, in Berssenbrugge's estimation, a more invigorated experience of the collaborative work. The reasons to which she alludes, however, may not be so "mysterious," after all. Pushing the boundaries of what the collaborative artist's book, even as a quintessentially mobile, interactive form, might accomplish, the trade edition is significant both because of its potential not just to undercut the cost and access limitations that curtail artists' books' reception and study (limitations which certainly apply to the accordion format) but also to renew the books' status as a site of ongoing relationality in a material way as much as a thematic one.

Though all artists' books afford readers a repeatable, interactive, and personal experience of the artwork *in theory*, the trade edition stands to achieve it *in practice*. The more cost-effective and accessible trade edition ensures that the audience's encounter with the artist's book is no longer confined to the rare-book museum or library. The reader-viewer can purchase it at will and for $30 on Amazon, no less; they can take it home. As such, the audience's relation to the artist's book is no longer institutional but profoundly quotidian and domestic, with all its pertinent gendered connotations. That the reader can easily return to the trade edition not only fulfills a primary function of the artist's book as practitioners envisioned it in its midcentury heyday—to make cheap, reproducible art available to a broader public—but also allows readers to continually revisit, reassess, and reestablish their relation to the work, reenergizing both the book itself and the reader-viewer's understanding of it. Much as the limited-edition accordion form of

Concordance complements its understanding of relation as a continual process of fracture and repair, the trade edition form presents the collaborative artist's book as space of ongoing relationality that emerges, for its creators and its audience, between design and discovery: between creation and reception.

Affirming the collaborative artist's book's sense of relational possibility one final time, *Concordance*'s concluding pages, relegated exclusively to Smith's prints, again bear its reader-viewers to a liminal or transitional space, much as its opening pages do. Nestled between two pages replete with recognizable nature images—first, a tangle of flowers and ants and second, a large frog—Smith depicts a not quite decipherable but noticeably castle-like structure or dwelling without any clear connection to the other prints or the poem at hand. Less readily identifiable than her other flora and fauna imagery, and thus less readily locatable within the known human and animal worlds in which *Concordance* otherwise dwells, the castle-like print seems to propose a fantastical place but one that is necessarily inchoate. Vincent Katz has observed that Kiki Smith's "stark printing" often "has the feel of woodcut [that] gives [her] drawings an intense, childlike presence."[52] The castle print substantiates this "childlike presence," by placing us within a fairy-tale world that seems to reside just beyond reach, suggesting both a wistful longing for what has been—perhaps the "nostalgia for childhood" that Wendy Weitman identifies in Smith's fairy-tale prints from the same early 2000s period—and an imaginative yearning for what could be. Whether the print recalls a lost world confined to memory or presages a nascent, imaginative space to come, its comparatively surreal quality tenders the same poignant sense of contingency that the artist's book repeatedly foregrounds, affording the audience a visual referent for the beautiful, but fragile relational structures—lyric, aesthetic, embodied, ecological—that Berssenbrugge and Smith erect throughout the work. The castle print with which *Concordance* leaves reader-viewers, like Berssenbrugge's poem elsewhere, finally asks us to contemplate not just how and where we exist in relation to the artist's book but, by extension, the many worlds (human, animal, aesthetic) it contains: where do we locate ourselves within them? How might we inhabit these structures?

Smith's print, and the collaborative artist's book itself, conceive of

an emergent world that entreats us to (re)consider our place within and relation to it. "I like that art is accumulative by nature," Smith has said, "that you are physically creating the world . . . and that you are in one sense, responsible for the world, for the image you're making it in."[53] Even so, Smith's art, as Wendy Weitman rightly contends, is not "polemical," never quite overt in its political investments, even if it insistently "revolves around feminine forms and content and could only have been made by a woman."[54] Her fairy-tale works, in particular, center on this idea, reframing well-known stories from a woman-centric perspective (and her castle print, in this respect, is no exception). Nonetheless, such concerns—about place, location, and relation— are not strictly feminist ones. They are also deeply human concerns, such that Smith's print reconciles, or holds in relation, its feminist and universal appeals. This is what Smith's art, in *Concordance* and elsewhere, seems to hold most closely in common with Berssenbrugge's poetry, which similarly approaches universal questions of the body, the environment, art, interrelation, and, not least, of place from a distinctly (eco)feminist or woman-centric vantage. It is a formulation that further aligns both Berssenbrugge and Smith with the many women artists of their generation who came of age amid the feminist and multicultural art movements of the late twentieth century, as Waldman's "Femanifesto" epigraph begins to make clear. Through Berssenbrugge's "poetics of place," which Marthe Reed links to her race and gender, the poem and, here the artist's book form, "becomes itself a liminal space affording connection," and one that allows not just the poetic subject "I" but its addressee, "you"—both Smith and the reader-viewer—to "move from a condition of alienation . . . to one of communion and reciprocity."[55] Individually and together, Berssenbrugge and Smith issue in *Concordance* an art alert to (embodied) difference, but one that nonetheless endeavors, in the poet's words, to "expand a field by dissolving polarities or dissolving borders between one thing and another" and in the process to cultivate new common ground.[56] Berssenbrugge and Smith at last unearth the collaborative artist's book as a feminist space: a form of and for world-building and perhaps more urgently, for rebuilding.

"each raising bodies from the text"

Erica Hunt and Alison Saar's *Arcade*

C aught between "their automatic representational status" and their "commitment to 'formal innovation,'" a generation of "innovative women poets of minority background" that includes both Mei-mei Berssenbrugge (Chapter 4) and Erica Hunt has, poet Harryette Mullen notes, suffered an "unaccountable existence . . . strain[ing] the seams of critical narratives necessary to make them (individually and collectively) comprehensible and thus teachable and marketable."[1] Mullen's diagnosis is hardly singular. The inscrutability of Mullen, Berssenbrugge, and Hunt and other experimental American poets, who, coming of age in the 1970s, reconcile the demand for "authentic representation" associated with the Black Arts and other multicultural movements to the poststructuralist aesthetic associated with Language writing has been well rehearsed by Evie Shockley, Timothy Yu, Aldon Lynn Nielsen, and others.[2] That Mullen confers on these writers the moniker "innovative women poets of minority background," however, lends especial credence to her charge. Linguistically tedious and taxonomically inefficient vis-à-vis O'Hara's "New York" or Creeley's "Black Mountain" school, which literally attest to the poets' (canonical) place, "innovative woman poet of minority background" declaims a poetics without place. The "innovative women poet of minority background" is thus doubly "unaccountable": if the "critical narratives" displace her, she is also absolved of responsibility to them.

It is perhaps fitting, then, that both Berssenbrugge and Hunt have been drawn to artists' books—forms that, by allowing women, in Johanna Drucker's terms, to "create authority in the world by structuring a relation between enclosure and exposure . . . [,] establish balance that gives voice to their own issues on their own terms," and thus enable their creators' to meet the "critical narratives" at their limits.[3] Nor it is it incidental that both poets have found a publisher in Kelsey Street Press: a Berkeley studio specializing in collaborations among women that has, since 1974, aimed "to address the marginalization of women writers by small press and mainstream publishers," by licensing "a poetics of allowance [that] encourag[es] women to write directly from their own creative imperatives" and a "poetics of inclusion that embraces racial and cultural diversity."[4] Buoyed by the press's priorities and collaborative artists' books' formal conceits, Berssenbrugge's *Endocrinology* (1997) and *Concordance* (2006) with Kiki Smith, and Erica Hunt's *Arcade* (1996) with the visual artist Alison Saar do not simply galvanize their makers to "create authority in the world" but manifest a collaborative model of authority that is not singular, but shared.

Featuring Erica Hunt's eighteen prose and free verse poems and Alison Saar's eleven woodcut prints, half in a restrained but rich cherry red, mahogany, and white on vellum and half in jet black and white on cream linen paper, *Arcade* is animated at least as much by what is proprietary to each artist—modes of signification, personal histories, artistic lineages—as by what is shared: social histories, Black womanhood, motherhood, revolutionary drive, aesthetic will. "We have this in common," the artists declare in *Arcade*'s "Collaborative Statement": "art and life, children, daughters named Maddy, indefatigable acrobatic capacity to surf multiple projects from zero to upheaval."[5] Despite the tonal differences that emerge in *Arcade*'s intermittent alternation between text and image, with Hunt's poetry exuding a "wary skepticism, as well as critical concern for the long-term effects of alienation" characteristic of her earlier volumes (*Piece Logic, Local History*) and Saar issuing, in her first collaborative book project, a "primal faux naïve quality" in warm "visceral prints that evoke raw emotions of and unguarded impulses of anguish, conflict, eroticism, self-exploration and mythic self-fashioning,"[6] the artists remain committed to their com-

monalities, including, above all, their mutual desire to expose and rewrite dominant, asymmetric models of authority: patriarchy, white supremacy, capitalism.

How, *Arcade* asks in poem and print, does one survive in the claustrophobic, fallen arcade where these brutalizing systems conspire to oppress? And what forms not just of poetry and visual art but of subjectivity and community develop through these acts of survival? Placing punishing regimes under close scrutiny, "erect[ing] scaffolding for [their] critiques," as the poet writes in "Risk Signature," "then isolat[ing] their objects with a deft / twitch of the knife" (43) Hunt, with her incisive use of language and observational acuity, and Saar, with a literal "twitch of the knife" in her intricate, haunting woodcut prints, do not simply raze the old orders to the ground but build them anew. By conflating or juxtaposing stereotypes of Black womanhood with Eurocentric art historical or mythic figures (Narcissus, Persephone, Venus), and by making these stereotypes—including, for Hunt the lyric "I"—at once hyper-visible and illegible, Hunt and Saar denaturalize both the old tropes and the oppressive systems that sustain them. In their place, Hunt and Saar unearth more inscrutable and more resilient (inter)subjectivities that jolt reader-viewers out of their customary modes of looking and knowing, seeing and reading, and engender more democratic modes of art and social life as a result. Together Hunt and Saar, in the poet's terms, "go off script": "Join the march . . . meet others over the dilemma, define a common cause: what tropes need inventing, what new rope a dopes, throw off the ropes, jam, or jook must we imagine, reframe, or play to new sound tracks?"[7] Defining a "common cause" and "meet[ing] [each] othe[r]" and their reader-viewers "over the dilemma" through their collaboration, Hunt and Saar reinscribe their figures and their audience alike. In unsparing, charged prints and poems, *Arcade* positions the collaborative artist's book as a form of movement building and social reorganization; in collusion and collaboration, the book suggests, one does not merely survive in the public sphere but rearchitects it.

From the start, Hunt and Saar's artist's book evinces a world that is utterly capricious and thoroughly overdetermined. *Arcade* is, as its title suggests, a volume preoccupied by games: a space that not only came

into being by chance, "research mediated by a blow on the dice" but that is borne by the dexterity and responsiveness that such games, and collaboration itself, requires:

> **Paper, scissors, stone** . . . two years of exchange, short, long, short lengths of sun, strips of fog, show and tell leads to drafts and drafts jiggle pictures, pictures snap back, flames curl figures of speech, shapes recall shadows, shadows box. ("Collaborative Statement," 53)

Yet for the real playfulness figured in the book's "Collaborative Statement," and, frequently, in its poetic language, exaggerated through Hunt's penchant for internal rhyme and wordplay—"tune / tin tongue / ritual / spoon / spin spun" ("Motion Sickness," 21)—neither *Arcade* nor its creators are naïve. Balancing the light and dark, the whimsical and the exacting, *Arcade* stages "spectacle and opacity, calculated innocence and cruelty, social flamboyance and boundary" ("Collaborative Statement," 53). Consider how "short lengths of sun" turn to "shadows," how "drafts *jiggle* pictures," but "pictures *snap* back," and language itself burns: "flames curl figures of speech." Consider that the childlike games, the acts of blithe exchange, from which the volume emerges ("paper, scissors, stones") morph in both the "Collaborative Statement" ("shadows box") and in Saar's final woodcut print—one boxer in red shorts and gloves squared off to another (or a man and his hostile shadow joined at the foot)—into a battle royal that intuits an adversary within as much as without. Like the boxer Saar depicts, embroiled in a match against both an internal and external opponent, "Hunt's writing," as Tyrone Williams notes, "overlaps with, runs up against, endorses, and contradicts Saar's images,"[8] even as the two artists jointly take on oppressive forces much larger than themselves. Still, if the parameters of collaborative exchange parallel those of a boxing match—anticipate, react, strategize, improvise—then their potential consequences are far different. To engage with one another, *Arcade* suggests, is to create or to destroy.

Throughout *Arcade,* games, including both their terms of engagement and their potential outcomes, often shift with equally dizzying speed. "Walked around / in the stopped clock / present," Hunt writes in a suspended and suspenseful moment in "Motion Sickness,"

wondering which
apparently random
twitch is worse
which right is worn
out, which one
to win back
to a short leash
or lash
or limit[.] (22)

In a poem whose title presages its unsettling lurch, chance's uncertainty fast becomes its threat, ("wondering which / apparently random / twitch is worse") and language turns from a vehicle of pleasure and possibility ("spoon spin spun") into one of punishment and coercion ("leash / or lash / or limit"). But the poem does not suppose that either chance's more pernicious outcomes or language's severer import are evenly distributed. While the title "Motion Sickness" suggests a relatively innocuous, generic affliction, Hunt's characteristically precise word choice, "twitch," "leash," "lash"—slavery's brutalizing metonymy—makes clear that neither chance's nor language's effects have ever been benign for those who inhabit Black bodies, either historically or at "present" (temporalities which collapse in the poem's "stopped clock" and throughout *Arcade*).[9] Randomness here is a mechanism for subordination, figured both as slavery's visceral circumstance and as its enduring consequence. Chance, like language, is not impartial but instrumental—not so "apparently random" after all.

Under these conditions, the speaker's ability to stay nimble—capable of anticipating sudden shifts—is not a way to win the game, since any victory is retributive ("win back / to a short leash") but a strategy for enduring it. "Start with A as in Ant," Hunt writes in the poem just before "Motion Sickness,"

> . . . and give to every terror a soothing name.

Death is a white boy backing out a lawnmower from the garage, staring
down the black girl's hello, silently re-entering the cool shell of his
house[.] (19)

Like the earlier poem's jaunty vowel shifts, which recall the *lingua franca* of children's books, "Starting with A" evokes the phonics lessons imparted to young children, as if inducting readers into a quaint literate community. Yet Hunt's imperative, "and give to every terror a soothing name," and the chilling, fatal impact of the young "black girl's hello" quickly fracture such pretensions, clarifying again that language and its effects—including children's speech—are never quite so innocent or so common. For people of color and perhaps especially for women of color, language is a zero-sum game: either it serves as a palliative for devastating injustices ("race talk / erases race / chases thought," "Motion Sickness" avers) or else it is weaponized to enable them. Given these impossible terms of engagement, anticipation and hypervigilance (and from there, collectivity, as we'll see) become operative means of survival. "Danger is engaged / as much as possible," Hunt later writes in "Risk Signature," "Organization entails foresight. / She tries to see things coming" (43).

Hunt's gendered specificity is no accident. To be on the offensive is, in *Arcade,* not just the habituation of the marginalized underclass but women's learned behavior—hence, "She tries to see things coming." "All the great heroes slept late," "Coronary Artist (1)" proverbially intones, "The common folks get up early and fight for the victory. It takes a lifetime to be steered in this direction" (13). If this offensive posture is broadly reserved for "The common folks," then it is, as Hunt continues, specifically reserved for women: "Custom has it that a woman gets up first to solve the dilemma of the burning moment" (13). Women are tasked with rising to meet both the "dilemma of the burning moment"—society's urgent, severe crises—and its no less urgent but more routine ones. Compelled by the relentless demands of domestic life, for which women bear outsized, if not sole, responsibility— "I think the dirty clothes are crying and want to be washed. Piles of clothes begin to mount from the sky down. I would say no, except for the empty chair where taking off is perfected" (13)—and by maternal expectation "To be bringing one's face into morning when it is barely light. To promote sunshine to my daughter while surviving my own ferocious will to sleep" (13), women are enculturated to anticipate and respond to others' needs, both at large and at home. The personal is

political, to be sure; but more than that, simultaneity is, for Hunt, a fundamental condition of womanhood. And its consequence is, as the poet elsewhere suggests,

> Displacement. Or, in so many words, several minds must occupy the same space at once. . . . Displacement. Each mind or role (mother, wife, Black woman, social justice worker, artist, lazy bones) starts as a relation, a position to be claimed until the position claims me back, to form finally, a rough equivalence to the self that I woke up with today.[10]

Its consequence is, in other words, that a woman's "self" exists in dialectical relation, both materialized through and constrained by any social (or socialized) role she might claim. "Socially we act in an echo chamber of the features ascribed to us," Hunt confirms in her formative treatise "Notes for an Oppositional Poetics," "And the social roles and the appropriate actions are similarly inscribed, dwell with us as statistical likelihoods, cast us a queen or servant, heroic or silent, doer or done unto."[11] As Hunt conveys in both "Coronary Artist (1)" and her essay, women are, through their socialization, remitted to a temporary simulacrum of personhood—the "rough equivalence of the self that I woke up with today"—unable to claim self-determination or full subjectivity.

Throughout her "Coronary Artist" triptych, Hunt illuminates, in Nicky Marsh's terms, "the claustrophobic impoverishment of social routine . . . and places this against iconic images of the female body."[12] Hunt's three "Coronary Artist" poems offer not just a general sense of how, as "Coronary Artist (1)" maintains, "One becomes an adult without knowing the details of how it was done," but the particular ways in which one is socialized to become a gendered and raced self, "knowing which team you're on, which hat corresponds to your glands" (14). Take "Coronary Artist (3)":

> In a dream I go to a room of spare parts.
> We apply porcelain to our hair.
> There are special scholars who study temples.
> Someone sweeps shoulder-length tresses across the floor.

Arms in varieties of salute beckon, bent and dimpled.
I have one leg up.
I'm not fast enough and they take the other.
They hand me costume lips.
My ears are festooned.
What remains after my waist is whittled is little more
 than a functioning crease.
I bat my eyes to practice fascination. (17)

Conferred the embodied trappings of socially acceptable femininity—styled hair, earrings, painted lips, a small waist, feminine wiles—and fashioned under intense, unforgiving scrutiny ("I'm not fast enough and they take the other"), the poetic speaker recounts a Frankensteinian fever dream in which she is "made" into a Black woman. Indeed, while the poem's early invocation of "special scholars who study temples" evokes racist phrenology, its later focus on hair concretizes the point. "But of particular concern is my hair, my hair, my hair," Hunt's poem insists, a refrain that attests to the specificity of the speaker's Black womanhood, for whom the fraught "concern" of "my hair"—how it is worn, how it signifies, and how it is policed—has always been culturally loaded and politically salient. In "Coronary Artist (3)," Linda A. Kinnahan maintains, Hunt "plunges us into a process by which the body's parts are organized under capitalist and racist collusions [. . .] The organization of the body as 'spare parts' underlies the disciplinary demands of industrialization."[13] Insofar as the determining forces of gender, race, and capitalism conspire to subordinate the speaker to their "disciplinary demands," however, she refuses to submit to them. Instead, her hair, "So dry it crackles, as it is French-twisted and painted vermillion," transforms into a sort of kindling:

With this hair I stop traffic, eliminate the inconvenience of
 passageways,
duration between significant events, for something is always
 happening.
I travel through mirrors, I'm on the subway platform and the train
 comes,
an IND. I get on. (17)

Like Sylvia Plath's "Lady Lazarus," who rises "Out of the ash . . . with my red hair" to "eat men like air," Hunt's speaker is set psychically ablaze. In the lines' zeugma—"eliminate the inconvenience of passageways, duration between significant events"—time, space, and syntax itself collapse at the speaker's directive. Existing everywhere at once, "for something is always happening," simultaneity is cast not as woman's burden but as her impetus: she "get[s] on."

Framing "Coronary Artist (3)," Saar's third print in *Arcade* anticipates its final reversal. As if depicting the woman forged in Hunt's factory of "spare parts," Saar's woodcut exaggerates conventional visual markers of gender and race, revealing a woman in a short red, form-fitting dress with a small "whittled" waist, prominent lips, and round breasts. Evoking "a tradition of representing the female body, especially the black female body, in so-called primitive positions," as Kinnahan observes,

> The [bent] angles of the legs and feet, the flat-footed bare feet, recall a visual history that both sought to contain and mark black women while also providing them with a visual mode to be appropriated in asserting control over negative stereotypes, as in the instance of the dancer Josephine Baker.[14]

Still, if any of the figure's corporeal traits suggest Saar's investment in depicting gendered and racialized markers that can "be appropriated" to "assert control over negative stereotypes," it is her hair, pouring down from the crown of the woman's tilted head along the length of her body's, and the page's, right side and curling into her hand on the left. No doubt the woman's, and the image's, defining feature, her hair, inordinately long and "painted vermillion" (as in Hunt's poem) delineates the circumference of her body and the print, as if visually announcing, in echo of "Coronary Artist (3)," "But of particular concern here is my hair, my hair, my hair." The figure's hair in this print seems equally freighted with import. Although the figure's titled head reifies the "so-called primitive positions" Kinnahan describes, it also suggests a more basic sense of heaviness, such that the women's legs are bent in deference to her hair's weight, which she buckles beneath.

Nonetheless, Saar is not content to position the figure's hair as a

Figure 11. Alison Saar, untitled print from *Arcade*, 1996, halftone reproduction of woodcut on vellum, 7¼ × ¼ × 9¼ in. *Arcade* was published by Kelsey Street Press in 1996. © Alison Saar. Courtesy of L.A. Louver, Venice, CA. Images of *Arcade* furnished by Harris Collection of American Poetry and Plays, John Hay Library, Brown University.

liability, even if it does intuit that long history for Black women. A prominent motif in Saar's work, including in her 1997 sculpture series *Hairesies*, Black women's hair serves a dual function: both to illuminate its historical stigmatization and to challenge such orthodoxies through its celebration.[15] To wit, the woman in Saar's *Arcade* print holds her hair firmly in her left hand, despite its evident weight. Saar's wood-cut thus elicits a competing interpretation, one in which the woman's hair symbolizes not something onerous but something controlled or wielded, if not as a weapon then as a shield. The woman's hair, which at first circumscribes her body, also fortifies it, armor-like, from external intrusion; encircling her body, her long hair "echo[es]" the "circular motif"[16] of Saar's earlier woodcuts, the first of which depicts a womb in the same shade of vermillion red. Like the red womb, the figure's red hair functions as another gendered site of both constraint and protection. More, the woman's hair lends Saar's static image a dynamic sense of movement, as the viewer's eyes trace its arc. As in Hunt's poem, where the speaker's red hair "stops traffic," reorienting time and space, the woman's hair configures the spatial field of Saar's image, inclining the onlooker's gaze to its sweeping will.

Not only does the woman's "vermillion hair" in this print echo the first print's red womb, but it also anticipates the fifth print's red fire, further recalling Hunt's "Coronary Artist (3)," in which the figure's hair becomes kindling. Taken together, such connections suggest that in Saar's *Arcade* prints, reader-viewers find a woman continually reborn—first of a womb, then of her hair, and finally of the flame. To this end, Saar's red-headed woman might also allude to Botticelli's *Birth of Venus*, whose own figure's head tilt and left-handed hair grip Saar seemingly exaggerates in her print. Such a connection is further primed by the black-and-white print (the volume's second) that precedes the hair figure—a print in which Saar, as Jessica Dallow observes, "quote[s] the 'Venus pudica' pose—nude, one hand over breast, the other over genitals" popularly associated with Botticelli's own.[17] Unlike the "Venus pudica" found in Eurocentric depictions, however, the Venus figure in Saar's black-and-white print is radically reworked: "the glistening white maiden," remade "into a stalwart black goddess, no longer demurely looking away but screaming out in anguish."[18]

Reimagined in this way, Saar's Black Venus figure is born not of the frothy sea but of the slave ship. Presenting her figure hung upside down with her ankles bound, Saar configures a Venus who, in her constraint, sems to signify "a system of enslavement," which, in Hortense J. Spillers's powerful formulation, "throw[s] into unrelieved crisis," the "customary lexis of sexuality, including 'reproduction,' 'motherhood,' 'pleasure,' and 'desire.'"[19]

Saar's centralization of this nude Black woman indeed aligns *Arcade*'s prints with much of her work, which routinely "throws into unrelieved crisis" issues of Black womanhood and sexuality, including of "reproduction and motherhood" (recall the book's womb) as well as of "pleasure and desire." "Saar highlights the female body," the artist's friend and prominent feminist theorist bell hooks noted, "precisely because within sexist and racist iconography it is often depicted as a site of betrayal. Just as the white female . . . most often symbolizes innocence and virtue, the absence of sexual passion, the black female body is usually marked as the opposite."[20] Saar's invocation of the Hellenistic Venus falls within this purview, serving as a foil for the Black woman's body that *Arcade*'s prints actually present: not a virgin but a Jezebel. Saar's bound "Venus" figure does not simply elicit the generalized "intensity of suffering" of the Middle Passage but specifically cites Black women's historical hypersexualization and fetishization. Hung upside down, Saar's figure displays a Venus inverse: a naked Black woman who signifies not prelapsarian chastity but an always already fallen body, "open for entry," hooks denotes, even "seductive."[21] In this sense, her tied ankles doubly suggest bondage, both as corporeal dispossession and as erotic titillation—"equal parts spectacle and punishment" (25), to borrow from Hunt's "Squeeze Play."[22] The Black Venus figure in Saar's print is an object both of punishment and of pleasure; neither her body nor her sexuality exist uncolonized.

Facing page: Figure 12. Alison Saar, untitled print from *Arcade*, 1996, halftone reproduction of woodcut on vellum, 7¼ × ¼ × 9¼ in. *Arcade* was published by Kelsey Street Press in 1996. © Alison Saar. Courtesy of L.A. Louver, Venice, CA. Images of *Arcade* furnished by Harris Collection of American Poetry and Plays, John Hay Library, Brown University.

Such a figure emerges simultaneously in Hunt's poems when in "Coronary Artist (1)," placed just after Saar's black-and-white print, the poet reiterates how (Black) women are forcibly estranged from their sexuality. "The rocks in our beds belong to them," Hunt writes, "Their sexual politics get the better of us sometimes and / we are left with dream transcriptions and delinquencies instead of passion outside the parentheses" (14). A formulation predicted in Saar's image, which frames its bound figure within two semicircular lines that both recall a tree hollow (and thus the violence of lynching) and presage Hunt's "parentheses," the poem's speaker and the women whom she indexes ("us," "we") are forced into sexual objecthood. Their "Passions" bounded by "the parentheses"—an amorphous symbol for the constraints of language, most immediately, but also for the punitive racist, sexist patriarchal order ("them") that circumscribes their lives—the women Hunt describes are divorced from their own spiritual and sexual needs. They are consigned, instead, to a longing both for the vivid, unencumbered lives that others deny them and for the small rebellions that manifest in their dreams. "I dream excess—high speed vision," Hunt announces at the poem's beginning, inviting readers into a personal reverie that becomes, at the poem's end, a collective hallucination:

> We make it to the crossroads only to come to a total stop. The idea we harbor is subversive. That there may be many moments in which we recognize the sources of our hunger, falling out of the sky, a complete thought in the center of our most visible selves. (14)

Incited by what Hunt calls in "Oppositional Poetics," "the consciousness of the subtractive quality of the primary vehicles of socialization that fuels the first intuition, the first sentiment of opposition,"[23] *Arcade's* women seek not just to "recognize" (see, name) but to pursue their own desires—"the sources of our hunger . . . a complete thought"—and reconstitute "the center of our most visible selves." "Who wouldn't kick in their sleep and wander off the path of managed impulse?" Hunt later asks, rhetorically, in "Coronary Artist (2)," "Who wouldn't aspire to become an alien in their own language for a moment to lose the feeling of being both separated and crowded by their experience?" (15). "My back bristled with the urge to give chase, to demand a say, to / reconfig-

ure paradise with perfect weather and regular elections," Hunt offers, as if in answer, alert to the possibility of a radically different mode of existence: "But the distance confused me. Where I stand now, I shout out of my body / armor. I whisper parts of the roar" (15). Tingling with the impulse to run away but stymied by the bewildering "distance" between her current reality and desired escape, Hunt's speaker becomes momentarily disoriented, "alien in her own language," vocalizing the "first intuition, the first sentiment of opposition" as she "whisper[s] part of the roar."

Against the reactionary forms of sexuality and selfhood to which they have been displaced—"to fend off the eros to which we react, never initiate grabbing instead what stales our everyday, our faded monotony" as Hunt writes in "Coronary Artist (2)" (15)—*Arcade*'s women in both print and poem long to recenter themselves beyond the parentheses. This requires not just that they circumnavigate the "distance" between their lapsed present ("what stales our everyday, our faded monotony") and desired future, but that they uncover modes of expression that will not be blunted or whispered. Such relocation requires, in Davy Knittle's terms, that the women embody "Nonsanctioned expressions (of language as well as sexuality)," and for Hunt, of lyric subjectivity, that "become a form of refusal": a refusal both to "compl[y] with an oppressive and teleological future" that "confines its subjects by demonstrating to them that their present is obsolete,"[24] or what Hunt herself calls in "Arcade," "*the complete dark . . . bureaucratic seizures of the possible . . . the body buckling itself against the irregularities of desire*" (27). Accordingly, Saar's poems and Hunt's prints reveal what such "nonsanctioned expressions" might look like. In her aptly titled, "so sex, the throne whose abrasions we crave," Hunt writes:

today or tomorrow I will shove the books off my bed
And pick up my lap and go somewhere where I have longed to go.

I will make myself narrow and let another body pass through.
I will let go of the wheel for the moment.
[. . .]
I will be the first to touch. (40)

In the ambiguity of "today or tomorrow" and the insistent use of the future tense "I will," Hunt's poem luxuriates in temporal possibility, imagining neither an oppressive present nor a teleological future but a voluntary, spontaneous, and precarious existence—"I will let go of the wheel for the moment." In the novel tempospatiality of "somewhere where I have longed to go," Hunt locates a place where women can willfully indulge rather than unwittingly gird against the "*irregularities of* [their own] *desire*": "I will be the first to touch."

Resonant of the shift in Hunt's poems from depicting another's sovereignty ("Coronary Artist") to claiming one's own ("so sex, the throne whose abrasions we crave"), Saar's prints portray an increasingly emboldened sense of sexual possibility and self-determination. In *Arcade*'s seventh print, the viewer encounters a figure posed with one arm clutching her bare breast and another wrapped sensually around her lover's head. Though reminiscent of the earlier Venus pudica figure, the woman in this later print is freed from both the figurative and literal parentheses that constrain her and remains in full command of her body and sexuality. This "Venus," as Christina Sharpe notes of Saar's similarly styled works, "seems caught in pleasure and not in the aftermath of attack."[25] That her hand is around her lover's head and not covering her genitalia showcases the figure in an unapologetically lustful rather than a demure or guarded pose. Although the print portrays the Black woman as a sexual, or even hypersexual actor, however, it does not reduce her to an exotic spectacle or stereotype. Positioning the woman in the foreground, Saar centers her sexual agency and pleasure; she is herself "the first to touch." Her ankles unbound, her hair notably cropped short, unburdened, the figure exudes what Jessica Dallow calls in Saar's works an "intense, confident sexuality," that "prove[s] to be [a] potentially active generato[r] of positive, ancestral, transformational energy" in turning Black women "from exoticized objects into critical subjects."[26] It is a transformation that takes further effect in Saar's subsequent image: a black-and-white print that reveals not a reinvented Venus but a reigning Persephone.[27] Flanked by two flaming torches that look like upturned brooms, this woman is not a domestic servant but a chthonic empress—her pose statuesque, a scepter in hand. With a rounded, perhaps pregnant belly that would further suggest the Perse-

phone myth, as goddess of both the underworld and of fertility, Saar's figure repudiates the "sexist racist iconography" in which Black women have been, as hooks notes, "Caretakers whose bodies and beings are empty vessels to be filled with the needs of others . . . born to serve," and instead "constructs a world of black female bodies that resist and revolt, that intervene and transform, that rescue and recover."[28] The Black goddess in Saar's two images is a lover and a mother, but she is neither vassal nor vessel; if Persephone was (Hades's) captive, Saar's likeness is no slave.

Rebecca McGrew argues that Saar's artwork depicts "resilient female bodies that activate legacies of bodily and spiritual survival," as we find throughout her woodcut prints.[29] Much the same could be said of Hunt's poetry in *Arcade*. Presenting Saar's Persephone image in verso and Hunt's "Madame Narcissist" in recto, the collaborative artist's book form affirms the author's shared Black feminist imaginary, visually aligning Hunt's "Madame" with Saar's underworld queen: two women who cannot be cowed. A two-part poem composed of paratactic, declarative statements—straightforward, at first, then increasingly abstract—"Madame Narcissist" unveils not only a world forged in its figure's image, but one in which that image is everywhere projected back to her, not unlike the mirroring effect between *Arcade*'s poems and prints. Like the myth for which it is named, "Madame Narcissist" presents a figure consumed by self-reflection and self-absorption, albeit one that transforms the tale to feature a woman protagonist. If women's self-absorption has historically been punished, however, Hunt's poem conceives of a world in which the Madame's self-interest is not just ubiquitous but interesting and lucrative:

Even my dark side is worthy of study.

nies turn a thought.

I see my ideas everywhere, on the brink of worldwide acceptance and potential profit. (37)

As in "Coronary Artist (3)," where the woman is forged in a room of "spare parts," the subject is again a capitalist project, but one that is here self-fashioned and thus within her own control. Though written in

the internet age's early years, Hunt's poem cannily anticipates a social media climate in which the self is the ultimate capitalist commodity—its every thought and move catalogued, broadcasted, observed, and (algorithmically) refracted. Harryette Mullen observes,

> Hunt's poetry evokes . . . a critical dialogue with the self-reflexive discursive universe of writing, print, and electronic media. A disjunctive parataxis gives many of her sentences the pithy eloquence of a literary aphorism wedded to the postmodern irony of an advertising slogan aimed at Generation X.[30]

It is, moreover, this juxtaposition between "pithy eloquence" and "postmodern irony" that structures not only Hunt's poem but its lyric subjectivity. For though "Madame Narcissist" can be read as a series of pithy or earnest lyric proclamations, its tone is frequently wry: "I believe my silence speaks volumes. / I have as many layers as any serial killer" (37). The "many layers" of Hunt's lyric I—sincere and sardonic, pursuing a brazen individualism while emanating universal appeal—refuse both reconciliation and essentialism and thus resist the poetic (and social) project of knowability, finally allowing the subject to exist only on her own shifting terms.

Throughout "Madame Narcissist," Hunt's lyric "I" serves as a smoke screen, pacifying readers' poetic expectations while allowing the speaker (and author) to remain two steps ahead. Hunt's "I," that is, directly addresses and lures its reader into a "cat and mouse" chase—"I play that game when I'm bored," she drily notes—leaving readers mired in pursuit of a definitive or stable lyric or authorial subjectivity that will always elude them. "I know they are after me," Hunt's speaker confesses, "I know the author. / I already have a better angle on this. / I do not go out of my way so I am never out of the picture" (38). By remaining insistently "in the picture" (an "I" appears in virtually every line), Hunt's speaker keeps the reader in active pursuit. This not only allows her to seize control of the (poetic) game and to lay its trap but to observe its casualties—"Everything around me is subject to decay. / I've lost count" (38)—and to cover her tracks: "The trail gives out; vines cover it" (39). It is a trap made the more damning in that it is detectable from the start. Hunt unveils in "Madame Narcissist" and

throughout *Arcade* a mischievous lyric speaker. By turns a lighthearted trickster or a cunning provocateur, the speaker hides behind many guises and feints, pronominal and otherwise ("I," "you," "she"), all of which, impossibly, reflect her back:

I have the power of simultaneous affect; it breaks off in a smile.

I adore the arbitrary embrace of *you*.

I light up the reader. (37)

A woman of many powers—of emotional manipulation ("simultaneous affect"), cutting observation ("Nothing escapes my notice") (38), and temporal command ("I hold on to time; I summon the past") (39)—Hunt's is an omnipresent lyric speaker, her presence everywhere felt but nowhere pinned down. Though the lyric speaker that emerges in "Madame Narcissist" and elsewhere in *Arcade* "functions as the text's central perceiver,"[31] as Allison Cumming notes, Hunt cultivates "distrust [of] the 'I,'" occasioning an "interrogat[ion] [of] fictions of autobiographical progression, coherence, or consistency within subjectivity."[32] At once exciting, inciting, and exposing "the reader," she seduces them— "still my gaze simulates connection" (39)—leaving them at the mercy of her capricious will.

Crucially, however, the speaker's roguishness is not self-serving; rather, her motivations are democratic. "I tend to color the facts," she admits, "unbinding private property so it multiplies" (39). Whatever transgression the speaker commits in "Unbinding private property" both lyrically and materially, it works not just to disassemble the proprietary relationship between author and speaker or speaker and reader (the "I" belongs no more to Hunt than to the reader) but to re-orient it. Recognizing, in Nicky Marsh's terms, that "the emphasis on the interiority of the poet could do little but affirm the politicization of the private rather than seek a reconstitution of the public,"[33] "the facts" of Hunt's speaker remain deliberately obscure. Uninterested in a conventional lyricism that does little to remunerate the commons, Hunt's poetry de-emphasizes individual interiority and resists enclosure to evince a more hospitable, collective public sphere. "Unbinding private property," Hunt's poetry seeks to enlarge "that darn / fraction

of a percent of the landscape / you say it is possible to live in" (28), as she writes in "the voice of no," and produces a speaker willing to do whatever is required to procure it. After all, she writes, "the ends justify the ends" (28).

Bearing witness to capitalism's devastating effects, she has no other choice. "Blistering routine," Hunt writes in the volume's titular poem,

> I muse through events until I'm in deep, so deep I no longer notice the D or P, the down down dirty dirt, the relative positions, who's behind the barbwire and who's in front, within and without, gagged angels of liberalism burying the hatchet in the social body, leaving it for dead. ("Arcade" 26)

Recognizing that capitalism's "blistering routine" threatens to deprive her of her keener faculties ("I no longer notice")—"Each day salved by a dozen analgesics applied to my sore spots, from my hemorrhoids to my teeth set on edge, [as] I travel to the 'World of Work!'™" (26)—the speaker will not be blunted. Becoming alert to "the stench of anesthetic sting [in] my nose," the speaker wants "to pull a tantrum, the emergency cord, slam on the breaks of this moving forward which is really standing still at the station" (27). Trapped in the arcade that takes, in this poem and often in the volume, the shape of the New York City subway system—both Hunt's metonym for the labyrinthine, interlocked civic systems that conduct the speaker's urban life and leave her "for dead," and a corollary to the underworld hellscape over which Saar's Persephone rules—the speaker numbs herself before she can be numbed.[34] Forced to navigate these unrelenting systems, disassociation becomes another kind of vigilance or anticipation—another strategy for the speaker and her fellow dispossessed to survive. The poem affirms:

> We wear our indifference with dignity, in fact, it gives us dignity, separates us from those who've been taken in or begun to fade in the glare of the bright arcade lights, the rings and buzzes—crowding those who live the war game instead of play it. . . . (27)

"Bring[ing] to the page a recognizably urban female persona that eludes common racial stereotypes," as Harryette Mullen notes,[35] Hunt

leads us in *Arcade* through a modern *katabasis* into the depths of the city's bowels—a far cry, no doubt, from the rapturous metropolis of the New York School poets whom Hunt succeeds (and to whose work she is partially indebted). In poem after poem, her speaker navigates a commute through a capitalist, dystopian hell where "Managers on ladders fight their descent on the food / chain. Everyone else cut off, cut out to fit or lose" (49), as she ironically muses in "City of Heaven," and emerges with the knowledge that "In the long run, there is no such thing as balance. You are all the way in or you are out of bounds" (49).

Bristling against the numbing pall of obedient industrial and poetic labor, *Arcade*'s speaker commits to being fully "out of bounds," refusing both to accommodate respectability politics and to become what Chris Chen calls in Hunt's *Piece Logic* an "automatic subject."[36] If the machinery of capitalism and traditional lyricism are maintained through an insistence on an unwavering, autonomous individualism—"the endless reign of disconnected singularities" (25)—then *Arcade*'s "central perceiver" emerges as an outlaw heroine whose speech and actions work to disrupt and rebuild the social order, redistributing authority. A folk figure rooted in oral tradition, the outlaw hero "rise[s] up against those seen as oppressors," where "there are histories of antagonism, suspicion and outrage to fuel the fires of defiance"[37] and has the "ability to outwit, elude, and escape the authorities, usually with some panache . . . in a way that makes the pursuers look like bumbling fools,"[38] as we find in "Madame Narcissist." In the African American tradition, this character has taken the more particular form of the "trickster" and, later, of the "badman" (or "badwoman") post Jim Crow: a folk hero whose characteristic violence or insubordination "were perceived as justifiable retaliatory actions" that repair an oppressed Black community.[39] Inscribing a communal "we" in "Fortune," *Arcade*'s speaker seems to inhabit this sort of figure, leading a movement of the disinherited who will not be taken in:

> We haven't entered enough contests and won. But we'll correct that—
> we'll break the bank and go from one to the other, sweepstakes winners, lotto lovers, zero demons, a terrible crew of arrivistes, swilling seltzer and ordering books they don't have in the kitchen. Watch out.

We will leave a winning streak in our wake, like the sign of Zorro, like a hunter with her ear to the ground, looking for the next roll of dice, like a window you can see *through*. (34)

Going rogue without remorse ("zero demons") and racking up all of the financial spoils, *Arcade*'s "terrible crew of arrivistes" rig the capitalist game on its own terms, gaining the upper hand. And their extortionist ends will justify the ends: "Go ahead, make some noise. This morning lives for racket. We wake up to make ends meet—to make ends meet" (34). In its destabilizing, coalitional subjectivity, "Fortune" illuminates Hunt's and *Arcade*'s aim to evince an anti-capitalist, "oppositional" poetics that works, Nicky Marsh argues, "to rewrite the public sphere to include relations of survival and need and also to imagine the new kinds of identity and relationships that would make this possible."[40] That is: their "racket" aims not only to collaboratively cultivate, in text and image, new forms of intersubjective or communal relation ("we") that can precipitate a more sustainable public sphere but to cultivate greater transparency or more complete visibility within it, "like a window you can see *through*."

Sharing in this project, Saar's fifth image cuts a slick figure, envisioning its own "outlaw" character who interpolates "new kinds of identity and relationships" that could help "rewrite the public sphere." Donning a pinstripe suit and tie and a fedora tipped over its eyes, the figure invokes a constellation of stock "badman" caricatures—racketeer, pimp, gambler, gangster—and is, through these visual signifiers, situated outside of the genteel capitalist and civic apparatus, much like Hunt's speaker and her band of outlaws.[41] Positioned with a blazing red flame behind, Saar's figure appears forged in fire, at once cursed and powerful, depraved and undaunted, leaving both the inferno and a past, ghostly self or lover—Saar's familiar Black nude hung and burned, rising up like smoke in the upper left quadrant—in its wake. Occasioning

Facing page: Figure 13. Alison Saar, untitled print from *Arcade*, 1996, halftone reproduction of woodcut on vellum, 7¼ × ¼ × 9¼ in. *Arcade* was published by Kelsey Street Press in 1996. © Alison Saar. Courtesy of L.A. Louver, Venice, CA. Images of *Arcade* furnished by Harris Collection of American Poetry and Plays, John Hay Library, Brown University.

what bell hooks calls in Saar's work an "odd mixture of torment and de-light,"[42] the print at once depicts a perverted, torturous scene and one of gratifying, even gleeful, vindication, inviting both repulsion and thrill (not unlike the mixed affective register of Saar's Black Venus). As such, the image's provocation lies in its inscrutability; with the fedora obscuring its face, the figure remains anonymous and unresolved. Moreover, while Saar's prints often clearly demarcate gender, her "badman" character is circumspect: dressed, on one hand, in a masculine suit while sporting, on the other, a bright red, as if lipsticked, mouth. As a result, scholars have registered its gender differently, with Kinnahan describing in the print a "pin-striped male" with Black features,[43] and Tyrone Williams describing a "suave black woman in a fedora."[44] Though Williams's reading is perhaps the more persuasive in the context of *Arcade*, both he and Kinnahan broadly agree that the figure's indecipherability is precisely its point. Saar's prints, Kinnahan remarks, "Resis[t] an identity politics of essence . . . insisting *not* on a fully present, knowable body but on how the body is *read* through sociohistorical and visual orders."[45] The print's ambiguity signals not just the artists' understanding of the mutually constitutive relationship between the visual and linguistic codes that naturalize gender and race and the capitalist, heteropatriarchal, white supremacist system that maintains them—what Hunt calls "The codes and mediations that sustain the status quo [and] abbreviate the human in order to fit us into the structures of production"[46]—but their intent to intervene in this harmful feedback loop and to expose the audience's complicity in it too.

In our hermeneutic impulse to settle the body in Saar's print or to decipher Hunt's elusive lyric "I," *Arcade*'s reader-viewers perpetuate the apparatus of subjugation that the collaborative artist's book itself repudiates, replicating the "dominant modes of discourse" or, in Saar's case, the visual regime of "moral management, of the science of the state, the hectoring threats of the press and media [which] use convention and label to bind and organize [marginalized peoples]."[47] As in Hunt's "Madame Narcissist," reader-viewers fall into the artist's book's carefully laid trap. For while Hunt's speaker may, in that poem, decry "I seek legibility"—seeking to be read and known—she also intimates the impossibility of her desire under the normative codes of both social

life and art that "sentence" her and her reader to operate within the confines of a "radical detachment, where 'I's' [eyes] lock" (39): a paradigm in which merely seeing each other is mistaken for knowing each other, precluding real visibility. *Arcade* reveals not just how abstract, dominant social structures work to oppress and constrain, but how people themselves, through their allegedly "natural" (internalized) and therefore unexamined seeing and reading habits "'make' / the people around them," as Hunt writes in "Science of the Concrete" (31):

> the unseen part
> is a controlling force
> over bodies written off
> as repetition of the already seen
> degrees of sex
> and color
> to be held against
> backed
> against
> the wall
> and halved
> unrecognizably
> halved. (31)

For those marked "by degrees of sex / and color," to be seen is to be made "unrecognizabl[e]": to have one's subjectivity reduced ("halved"), disparaged ("held against"), cornered ("backed / against"), or "written off" as a stereotype: "as repetition of the already seen." In "Science of the Concrete," Hunt renders obsolete whatever commitment to objectivity her title purports; after all, as *Arcade*'s Black women creators surely understand better than most, neither science nor observation has ever been neutral.

Asking their reader-viewers to confront this truth of non-neutrality in poem and print, Hunt and Saar challenge them to reexamine their seeing and (lyric) reading habits and to reconcile themselves to the discomfort, and the opportunity, of *not* knowing. "You don't know / what you are seeing / whether it is the object / you see or the shadow / you see," "Science of the Concrete" counsels (31). In the same vein, Saar's

ambivalent fourth print, like the gender-neutral figure in the fifth, un-settles what readers "see," troubling an easy conflation between vi-suality and identity. Depicting a Black figure looking in a mirror that reflects to the viewer (both figure and audience) a white face, the image defies racial categorization. The image perhaps confirms that, for Saar, art is always "a blend of the personal and political and . . . stems from a personal catalyst," reflecting her own struggle, as a biracial woman, to fully resolve her identity.[48] In its identity struggle—as if Saar's figure cries out, "I seek legibility"—the image conjures a poignant "search-ing" that, bell hooks notes, is "ever-present in Saar's work: the con-stant yearning for clarity or vision that may or may not come."[49] More crucial, however, the print "re-frames seeing as a powerful social act, where assumptions of race and gender complicate simple perception," as Hunt once observed in the artist Kara Walker's cutouts.[50] "Perhaps a trick of the woodcut," whose technology "necessitates the contrast of the white face within the blackened mirror,"[51] as Linda Kinnahan suggests—or, more affirmatively, an exploitation of it—Saar's de-sign stymies viewers' reflexive capacity for "simple perception." Un-able to be "written off / as repetition of the already seen," in Hunt's terms, as an essentialized subject or stereotype, Saar's figure demands more complete legibility. The image thus works in two ways, both re-fracting the figure's own sense of being "unrecognizably halved"—Othered, unknowable—and inviting viewers to look again, and per-haps glimpse a small reflection of themselves in it. Saar's equivocal prints and Hunt's complex poems work not just to challenge reader-viewers but to reconstruct their relation to the works. If the artist's book clarifies how the "powerful social act[s]" of seeing (and reading) can harm and divide, then it also suggests their potential to recreate and connect. Turning "Science of the Concrete" on its head, Hunt equally considers this alternative:

to write
the reader
out of retreat,
out of distant austerity
concealing this same

fragile activity
people make
each other
part by part
then whole
into *whole*. (32)

Writing to coax the reader "out of retreat" and into the "whole," Hunt reconceives the "fragile activity" of looking and of making (poesis) as an act of mutuality or intersubjective repair.

"I am drawn to writing as a form of address," Hunt has said, "the cycle of writerly production and readerly co-creation" most evident in "films texts" or "cinematic poetry" in which "looking is a labor of love" and the text "complete[s] its mission in reception."[52] What Hunt describes—writing "Not just [as] address, then, but [as] composition"—is what "Science of the Concrete" espouses: a mode not just of address but of composition, both of text and of image, that frames looking as "a labor of love" and reinscribes the reader-viewer in the work, "nestlin[g]" creators and audience "in the same body, the social body with barely acknowledged sinews."[53] Not that such inscription is uncomplicated, especially if "looking" is only as rewarding as it is grueling ("a labor of love") and if the "social body" that *Arcade* registers is an inevitably scarred one. The vellum paper on which Saar's woodcut prints appear is especially revealing in this regard. Of Mei-mei Berssenbrugge's artists' books, Joseph Jonghyun Jeon notes that "medieval manuscripts were written on vellum, a treated animal skin," reminding us not just that "Books have always been associated with bodies"[54] but that vellum itself bears a specific corporeality—perhaps the "uncanny corporeality" that Christina Sharpe registers in Saar's works.[55] Indexing the woodcut's original etchings, the prints that appear on Saar's vellum pages quite literally catalogue past cuts, like old injuries carved into skin (a particularly unsettling effect in a book that often recalls slavery's long shadow). As Henrietta Cosentino and Carine Fabius describe in Saar's sculpture works, so do her vellum pages "evok[e] scarification and memory," sharing in the "concept of the body as memory board."[56] Her prints, in other words, memorialize bodily wound. When Hunt and

Saar's collaborative artist's book consequently inscribes reader-viewers into its "social body," it is a social body that is indelibly marked: one whose "sinews" must be acknowledged—whose past harms cannot be forgotten, even if they can be partly salved.

Saar's vellum pages reveal both bodily palimpsest and a visual-verbal one. Inasmuch as the vellum pages memorialize past injury to the skin, they also reveal a stunning image, tattoo-like. Replicating the effect her textured sculpture work, Saar's vellum pages alternately signify, in Sharpe's terms, as "shield and accretion, as armament, ornament, and scar."[57] The body of the artist's book is, in this way, continually rewritten or written over. Furthermore, the vellum pages, because they are translucent, overlay word and image, creating a porous boundary between them. In form as in theme, Saar and Hunt imagine new modes of visibility and legibility, fashioning the pages themselves "like a window you can see *through*." "Allow[ing] the words of the poem[s] that follo[w] them on the next page to seep through in partial visibility," as Kinnahan describes, the vellum pages, "dissuad[e] a customary reading of the visuals as subsidiary illustrations of the (more important) verbal texts or as separate entities."[58] The prints and poems instead build up to what Saar calls in her works an "accumulated surface."[59] Like layers of skin, the pages of text and image remain discretely functional but comprise one dense, inextricable body. And the body of the book finally meets that of the reader-viewer who, turning the pages, comes into profound contact with the work: skin to skin. The collaborative form's accretive "social body" once again inscribes its audience, "completing its mission," to echo Hunt, "in reception."

Throughout the work, Hunt's poems, Saar's prints, and the collaborative book form itself work to rearchitect the arcade, restructuring its formative patterns of authority and intersubjective relation. It comes as no surprise, then, that Hunt performs a significant act of re-creationism in the volume's concluding moments. Bookending a volume whose initial poem, "First Words," "retells Genesis,"[60] its final, fittingly titled poem "Variation," animates a new world order:

> the sun (a marble spinning on a plate)
> the sky (black plane of n dimensions)

consciousness (a room in which every detail fits,
 though can't necessarily be found) (50)

Throughout *Arcade,* Hunt and Saar indeed strive to reconfigure "consciousness," engaging in both individual and collective acts of emotional, spiritual, and material repossession that are at once deeply painful and deeply restorative:
 words (worlds)
 fury (gushes, an open wound)
 joy (unwinds, changes shape)
 each raising bodies from the text.

 The apostrophe *behind* the noun. (50)

With equal parts "fury" and "joy" Hunt and Saar unravel the conventional grammar of language and visuality as well as of the body and its categories of analysis (race, gender, sexuality)—the "'master narratives . . . threaded into text'" and image[61]—and reassert their rights to them, shifting and redistributing conventional claims to ownership: "the apostrophe *behind* the noun." Finally, Hunt and Saar invite reader-viewers to help collaboratively create the new "words (worlds)" that they envision throughout their collaborative artist's book. Leaving them to further pursue the paths its artists have forged ahead, *Arcade* reveals to reader-viewers at its close the "shortcuts (straight lines for visibility) [. . .] to everything that awaits a name" (51).

CODA

Connective Devices

Collaborative Artists' Books

in the Twenty-First Century

"Artists' books," artist, printer, teacher, and Primrose Press founder Tia Blassingame contends, "have an uncanny way of combining pretty well any topic and artistic discipline — printmaking, photography, sculpture, papermaking, etc. — and becoming something else entirely. Part of my job as the viewer/ reader is to go on the journey the artist has created, but also to untangle the what, why, how."[1] The preceding chapters have endeavored to do just this: to go on the journey that the ten central poets and visual artists have laid out before us in their collaborative artists' books and to untangle the many questions they pose and resolve along the way. Offering close readings of five disparate works created by experimental American poets and painters in the twentieth and twenty-first centuries, I have traced how collaborative artists' books and their creators' engagement with received ideas about artistic subjectivity and lyric poetry evolved in the same period, spanning historically from O'Hara and Goldberg's late 1950s confrontation with the sense of heroic selfhood found in both Abstract Expressionism and the Romantic lyric in *Odes* to Mei-mei Berssenbrugge and Kiki Smith's reckoning with the contingencies of intersubjective relation in *Concordance*. As each

subsequent work deepened our understanding of the poets' and visual artists' particular attempts to reimagine the relationship between the individual subject and the collective—reincorporating the one within the many (Robert Creeley and Robert Indiana's 1968 *Numbers*), positioning the individual as an instrument of community-building (Anne Waldman and George Schneeman's 1997 *Homage to Allen G.*) and, more radically, rewriting social relations anew (Erica Hunt and Alison Saar's 1996 *Arcade*)—they together revealed the collaborative artist's book as a powerful site for reimagining collectivity and collective reimagining.

This study of collaborative artists' books has also sought to develop a clearer sense of the form's particularly salient features: intersubjectivity, intermediality, and interactivity. Founded on these essential senses of betweenness, collaborative artists' books resist aesthetic, institutional, and economic assimilation. Their idiosyncrasies notwithstanding, all five collaborative artists' books examined here, and the many others they index, resist the neat efficiency of traditional literary or art-historical canons, as they test the limits of medium specificity and of artistic and academic disciplinarity, continually reconfiguring the connection between poetry and visual art—word and image. They are, furthermore, economically resistant forms. Published as editioned works, whether in smaller runs of 145 (*Homage to Allen G.*) or 200 (*Odes*) copies or in larger runs of 2,000 (*Concordance, Arcade*) or 2,500 (*Numbers*) copies, the books' broader availability vis-à-vis non-editioned artworks allows them to resist the exorbitant price tags commanded by unique canvas or sculptural works in the fine art economy, but it also allows them to resist integration into the regular consumer economy. While cheaper than other art forms, these books are not cheap by normal standards; the oldest, *Odes* and *Numbers*, currently sell for several thousand dollars each, while *Homage* is priced in the mid-hundreds. *Concordance* and *Arcade*, printed in trade editions, are closer in price to "ordinary" books, though fine copies sometimes sell in the low hundreds and may appreciate with time.[2] Sold primarily by rare booksellers to the private collectors and institutions who can afford them, collaborative artists' books command a small market, a destiny compounded by their limited recognition to begin with. Even after these works are eventually purchased by and entrenched within

institutions, primarily museum archives and special collections libraries, they resist many typical collection and curation practices. Created to be read, held, and touched—interacted with not once but multiple times—artists' books resist both the norms of the museum gallery, where art is viewed at a respectful distance, and, to lesser extent, those of the reading room, where access to works is often restricted.

Of course, for many collaborative artist's book creators, including the ones central this study, such structural resistances were largely intentional; assimilation was perhaps never the point. For O'Hara, Creeley, Waldman, Berssenbrugge, and Hunt and the many other twenty- and twenty-first-century poets who have used the form to reimagine lyric subjectivity and resist academic New Critical reading practices; for contemporary artists like Goldberg, Indiana, Schneeman, Smith, and Saar, whose book works have contested dominant aesthetic norms; and for those artists, including several studied here, whom the mainstream artworld has uneasily accommodated by virtue of their gender, race, or sexuality, collaborative artists' books no doubt provided, and continue to provide, a welcome vehicle for formally and conceptually daring work. Moreover, because these creators produced their collaborative artists' books under the auspices of smaller, independent presses and/ or conceived of the works themselves in "do-it-yourself" fashion, they could be insulated from both the art world's and the literary world's more elitist and classist pretensions and from mass-market leanings. Finally, these artists likely took some pleasure in the resistances that their collaborative efforts afforded and the creative control that it engendered, reveling in the chance to turn away from dominant aesthetic, institutional, and economic mores and to address themselves and their work, instead, to each other and their audiences.

Yet if collaborative artists' books' resistance to aesthetic norms, market prerogatives, and institutional incorporation remains one of their most favorable ideological qualities, these resistances have also, less favorably, precipitated their continued exclusion from many academic realms (syllabi, publications, poetic anthologies), and their broader inaccessibility in the present, leaving them little seen or studied, as the introduction has laid out. Though this discrepancy is not one that collaborative artist's book creators could have foreseen, it nonetheless

elicits several pertinent questions worthy of our further consideration now: What does the form's resistant nature portend today? Do artists' books, for instance, resist contemporary technological norms or assimilate to them? What intermedial, intersubjective, and interactive opportunities do they continue to propose or preclude? What, in short, is the artist's book's fate in the twenty-first century? It is to these and related questions that this coda turns, teasing out a few provisional answers to them.

Like so many issues surrounding artists' books, from the substantial (definitions) to the tedious (apostrophe placement), the question of the form's place in today's technological world yields various, competing interpretations. One popular refrain is that artists' books act as a vital antidote to the digital age, resisting its by-now familiar norms. Making a case for this view, Karen Eliot has, for instance, called the artist's book "A refuge from the flat digital world of screens, blurs, and projections" and "the reverse vortex of the digital world."[3] For Eliot and others, the allure of the artist's book and other paper- and print-based artforms in a time of ever-advancing technology resides in their tactile nature. "In an artists' book," Eliot continues, "the arts, humanities, and sciences converge to provide a tactile and intimate experience for the reader that offers an alternative to technological spectacle."[4] Transporting us from the digital world back to the analog one, artists' books might also serve a "nostalgic function," both because, in combining works and images, they are like "children's books for adults"[5] and because they prioritize the antiquated "manual arts of letter press printing, paper marbling, and bookbinding"[6] that have been of growing interest today, leading to a recent increase in specialized print and art-making courses within colleges and universities and without. Perhaps dovetailing the "grand-millennial" trend that has reinvigorated activities like needlepoint, breadmaking, and gardening among twenty- and thirty-something tech denizens, artists' books allow their makers to disconnect from digital technology and access an ostensibly simpler time before its ascent.[7] All of this has bolstered the contemporary impression that artists' books are precious, even wistful forms, functioning as "agents of cultural memory."[8]

It is difficult to deny that artists' books can be both precious objects

and important "agents of cultural memory," and exhilarating ones besides, as the preceding chapters have ideally shown. Nevertheless, continuing to frame artists' books in this way also perpetuates the notion that they, unlike many of our current technologies, are too esoteric or fussy to be wielded and comprehended by wide audiences, further enabling their neglect.[9] Regarding the artist's book as a precious form exacerbates the perception already established by the "non-browsing, non-circulation advance-request" trappings of "rare books and special collections models" in which they, as Eva Athanasiu notes, "belong to the category of isolated art object, subjected to rarity and fetishism."[10] While the artist's book might offer a refuge from digital technology, in other words, access to that refuge can, in the context of these circulation models, prove restrictive or inequitable—available only to those who can afford to and/or have the "insider" know-how required to gain admission to special collections. Rather than demystify artists' books as accessible, user-friendly, socially inflected forms, their autonomous and fetishistic treatment within the "rare books and special collections model" may inadvertently reify classist, and perhaps it is not a leap to say sexist and racist, assumptions about who can participate in their study and appreciation. For whom, then, are artists' books nostalgic? To whose "cultural memory" do they belong?

Given the exclusionary answers such questions might elicit, an alternative narrative seems expedient, framing artists' books less as an iconoclastic outlier to the digital deluge than as its natural complement. Others have indeed made this case. While acknowledging that "The cultural icon of a book remains a potent sign, even in this new era of technology," Johanna Drucker underscores how the artist's book's personal, interactive qualities deftly parallel those of the digital sphere, as both afford us an experience that is at once private and shared.[11] In collaborative artists' books, as in the virtual world, she suggests, the reader-viewer acts as individual participant within a larger, collaborative public sphere. Offering a slightly different rationale, Hertha D. Wong locates parity between collaborative artists' books and the internet age because of their shared investment in intermediality. "More than ever before," she maintains, "it is technically easier to combine image and text. From memes—concise image-text communications—

to Facebook, with its more elaborated prospects for writing and image sharing, the tools of image-text self-expression are readily available."[12] As Wong points out, the word-image interplay found in collaborative artists' books and other print forms, which once may have confounded viewers, hardly appears avant-garde today. She echoes Drucker in noting that texts that prioritize the marriage of words and images assimilate well into our technological age insofar as they, like many of our contemporary technologies and social media platforms "demand a high degree of *interactive* engagement between producer (of image and text) and reader-viewer."[13]

Such accounts are not without their own limitations. While fetishizing artists' books as rare, precious, and indeed resistant objects risks inflating their importance and singularity (and potentially rehearsing exclusionary praxes in the process), insisting that artists' books are perfectly analogous to contemporary technologies risks too easily glossing over distinct media histories and denying the more generative resistances and intricacies they incorporate. Both attempts to situate the artist's book within the current technological climate therefore entail important shortcomings. More than that, the debate surrounding artists' books' resistance or assimilation to the digital age raises the equally vexed, adjacent question of their compatibility with or divergence from the contemporary reading practices that current technologies have occasioned or hastened. While accounts like Wong's might winningly suggest that the digital age, including our social media usage, has helped acclimate contemporary readers to the kind of intermedial thinking that collaborative artists' books require, it is equally plausible to argue that artists' books, and then any poetry or visual art found in them, require a mode of reading and viewing antithetical to that prioritized in our everyday digital lives. Because, Alexa Hazel argues, artists' books "institutional frames—including the market price, bookfair prizes, and the ritual of the reading room" conspire both to "ensure a sense of singularity essential to the experience of the object," and to "produce and guard the value of these texts," the works "act on their viewer, disrupting the unconscious ways in which she typically reads, and train her to see in a different way."[14] As Hazel suggests, these frameworks signal that artists' books are emphatically not

"ordinary" books. Rather, collaborative artists' books, and by extension the poetry and art that they contain, exhort us to be methodical in and conscientious about what we read, observe, and feel: the sequence of information we take in, the placement of words or colors on a page, textile detail (paper weight and quality, binding methods, typesetting). Demanding, in Kyle Schlesinger's terms, a "*sustained* attention" distinct from and incompatible with the "*constant* attention and minimal, spastic interaction [of] the keyboard, screen, and global network," artists' books resist the digital age's user norms.[15] As technology maximizes the amount of information we take in and the speed at which we process it and psychologically rewards us for constantly "refreshing" to get the latest news or social media post, it has only made our attention spans and reading habits shorter and quicker. As internet-speak goes: TL; DR (too long; didn't read). In this light, only the most assiduous or bored among us might allocate time to seek out and contemplate collaborative artists' books.

More optimistically, collaborative artists' books' resistance to our increasingly digital lives stand to make them incredibly valuable, even *extra*-ordinary spaces where our contemporary thinking and seeing habits might be revisited and (re)formed. In the face of a twenty-four-hour news cycle and of algorithmic programming that daily brings new tragedies and joys to our collective attention and just as quickly forsakes them, artists' books invite their audiences to slow down and tune in more carefully—to pause and to ponder. In addition, in the face of a digital age where so much of what we take in (and put out) is susceptible to our individual curation and control via filters, mute buttons, and follows, collaborative artists' books, can encourage a certain sense of submission, or even, Hazel notes, a "kind of humility" that attends the recognition that a "book in our reading of it . . . is not entirely in our grasp."[16] Hazel even goes so far as to suggest, without evident skepticism, that the "humility" these works require "may be desirable for a society faced with an impending climate disaster, and one with predominantly market-based systems of value"—a claim to which I'm broadly sympathetic.

Even so, my own cynicism persists. It may well be that collaborative artists' books, like other forms of poetry and visual art writ large, stand

to humble or rehabilitate us in a twenty-first-century age not just of technology, but of late-stage capitalism and its endlessly interchangeable commodities, and of swelling social and political crises; yet what happens if too many of us are ourselves resistant to engaging them in the first place? Or if those who are interested in doing so cannot? As invigorating as the promise of the collaborative artist's book is in theory, it seems ever more untenable in practice amid a highly polarized political and online "echo chamber" climate in which a willingness to think and see differently, as artists' books encourage, feels increasingly scarce, and a troubled higher educational climate in which adjunctification means greater employment instability and more frequent turnover among both the librarians and curators charged with stewarding institutions' artist's book collections and the precarious scholars interested in researching and teaching them. Under these conditions, the very "humbling" modes of readerly engagement that collaborative artists' books demand—slow deliberation, an appreciation for nuance and detail, the aspiration and/or ability to devote considerable time and space (and often money) to them—can seem outdated or incongruous, at best, and frivolous, at worst.

Still, our reflexive inclination to reconcile the artist's book to the current climate is not confounding. It is not only a powerful inclination but a tactical one: to ensure the form's futurity, highlighting how the artist's book contests and/or complements our technological habits, contemporary reading practices, and even urgent sociopolitical concerns amplifies the stakes of our continued engagement with them. Nonetheless, if the questions of technological resistance or assimilation and of contemporary readership are themselves interesting to explore, then no answers to them reveal an especially persuasive way forward, especially if to accept that collaborative artists' books are technologically anomalous forms risks alienating potential audiences and to accept that they are habituated forms risks denying their important provocations. Why, then, might we otherwise pursue them as objects worthy of engagement today and in the future? Several other compelling reasons emerge.

To start, artists' books are excellent teaching tools. Whether they are presented to future generations of students as akin or hostile to the

norms of the technological world, "the introduction of artists' books into a liberal arts curriculum," librarian Louise Kulp suggests, "can effectively teach critical thinking, encourage discovery of interdisciplinary connections, and prompt consideration of relationships between text and image and form."[17] In a lucid reflection-turned–field guide to teaching with artists' books across disciplines and course levels, Kulp concludes that while her "success with incorporating artists' publications [in curricula]" to date "lies primarily in humanities disciplines, . . . it is in social sciences (such as public policy, women and gender studies, sociology, and area studies) that she thinks lies the greatest potential for teaching with them,"[18] likely because of their critical resistances to normative social ideals, including who can access and participate in artistic and institutional spaces. Given the vast range of topics they cover and the many disparate forms they take, artists' books can be valuable, even unexpected, additions to humanities courses as much as to social science, life science, and mathematics ones, especially as universities promote an integrated STEAM ideal. While a work like this study's *Numbers* might, for instance, be a surprising asset to a mathematics class, works like *Arcade* and *Concordance* fit seamlessly into art history and literature syllabi as much as ethnic and gender and sexuality studies ones. Though, as Kulp notes, it is mostly non-tenure track and visiting faculty, rather than "senior faculty with established practices," who are more willing to utilize artists' books as pedagogical tools, they can and should be exciting to a broad swath of educators eager for "ideas about how to engage the current generation of students in learning beyond research papers and exams," since they "provide new ways to engage."[19] To this end, greater faculty commitment, across ranks, to incorporating these works and their institutions' collections of them in their teaching would not only acculturate students to campus libraries' vast offerings and special collection praxes, but it would further enrich students' understanding, in Suzy Taraba's terms, of "how research and creativity, form and content, beauty and rigor intersect."[20]

Amplifying their status as worthwhile pedagogical tools, artists' books offer reader-viewers inimitable insight into specific historical moments, such that each time these books are opened they not only reveal the intersection between "beauty and rigor, form and content," but

between the past and present. As the previous chapters began to clarify, collaborative artists' books offer gateways to their creators' worlds, cataloguing the embodied perspectives and the material contours, including the available technologies, the cultural attitudes, and the aesthetic trends, of the moments in which they were made. As the late Italian artist and bookmaker Germano Celant avers: an artist's book "is a collection of [images], writing, and ideas, it is a product of the activities of thought and imagination. It is a result of concrete activities and serves to document and to offer information as the means and as material."[21] Artists' books are profoundly material forms in their reception. Though neither artists' books' completed forms nor the constellation of technological, social, and aesthetic factors that shaped their production in the past can shift, the world in which new audiences continually meet these works in the present moment does. "As the world changes, as wars are fought, babies born, and species go extinct, the context [of the artist's book] is altered," bookmaker Kurt Allerslev affirms.[22] Consider, then, Tia Blassingame's assessment of her 2015 artist's book *Settled: African American Sediment or Constant Middle Passage*, a work that memorializes an eighteenth-century slaving ship passage through original poems and prints. The book, she offers,

> is designed to be held or cradled by the reader/viewer. They should give over to an impulse to protect it and its contents. The lush leather covers that are not covered boards but are loose force this. Then what is the experience of cradling close a work memorializing and mourning the real connections in life and death of participants of a slaving ship insurrection or with individuals like Tamir Rice or Trayvon Martin?[23]

Just as Blassingame's *Settled* takes on heightened resonance in the contemporary #BlackLivesMatter and #SayHerName landscape, at times evoking this milieu explicitly in its pages, all artists' books implicitly entreat their audiences to hold two worlds—that of the book and their own—in their minds, eyes, and hands, leading them not just to forge deep, even intersubjective connections between those worlds but to dwell upon the essential relationship between texts and contexts. Offering passage back to the past while simultaneously encouraging

greater reflection on the audiences' present, artists' books, as Johanna Drucker maintains, function as a vital "space for communication and exchange across vast spaces of time and geography."[24]

As such, collaborative artists' books—and their closely related cousins like 'zines, offset works, and graphic books—can serve as rich participatory and communal forms. If, as Drucker points out, artists' books are "space[s] for communication and exchange," then they are fundamentally shared spaces; they testify to the importance of collaboration not just as an aesthetic exercise but as a social and interpersonal one. Collaborative artists' books are spaces of conversation and interaction between their immediate creators (artists, printers, editors) as much as between their creators and audiences, a category which, at its most capacious, includes the curators, archivists, librarians, researchers, teachers, and students who eventually encounter and preserve them. Indeed, as all ten poets and artists in this study must have recognized, "collaborative making and publication [is a] social practice," but so too, as Bridget Elmer notes, is "curating, installing, experiencing [artist's book exhibits], and organizing the programming."[25]

Beyond the academic or institutional settings in which they continually furnish opportunities for collaboration, artists' books might also have an important civic function, enabling public and communal outreach initiatives and even inspiring modest social change. Take, for example, the work of Mobile Print Power (MPP), a Queens-based program founded by Patrick Rowe in 2013. What began "as a weekly printmaking and political education workshop at Immigrant Movement International in Corona, Queens,"[26] quickly blossomed into a full-fledged grassroots printmaking collective whose mission is to provide "participatory design in public space" by bringing "portable silkscreen printmaking carts to engage communities and explore social and cultural situations" and collaborating with artists, presses, and local community members, including young children, to "make books, prints, and public sculptures" that "reflec[t] [their] commitment to social justice and [their] belief in the value of shared artistic production."[27] After happening upon MPP in my research, I sat in on a virtual meeting with some of its members in October 2020, in the midst of the COVID-19 pandemic, as they were planning a cross-country collaboration with

the Southwest-based Navaja Press that sought to answer two inter-twined questions: "What does care for a community look like in a cri-sis?" and "How has community changed in a crisis; where is it and who makes it up?"[28] Pinpointing the research questions central to their collaborative undertaking, as they do any time they begin a new proj-ect, MPP decided to develop a series of print-based postcards to send out to members of both Navaja Press's and MPP's local communities that could function at once as beautiful graphic objects, as critical tools for disseminating resources and other essential information, and as shared artmaking spaces through which to process and heal during a global crisis. Animated by a commitment to investing time and energy into making print artforms like artists' books accessible to those who have traditionally been excluded from their reception and production, including their community's many Black, Latine, and low-income res-idents, MPP's postcard and other projects realize what founder Patrick Rowe calls "a vernacular artform that emerges out of the community."[29] In effect, MPP's desire and willingness to undertake such public-facing initiatives, even without significant monetary and other support, has created a culture and community around print forms where none existed.

If community-oriented projects like MPP's are excellent means of expanding public art initiatives and using art to disseminate critical information locally, then they are also crucial for expanding repre-sentation and interest in the book arts field more broadly. The latter outcome is not only exigent given the "many gaps in the Book Arts record in terms of Black artists, artists of color, social justice and social practice book/print work," as Blassingame relays, but it is also intensely gratifying since, "Having an opportunity to put students, practitioners, and curators in conversation gives me tremendous joy."[30] Not least, the print works that materialize through MPP's initiatives, and artists' books, more generally, can play an important role in our collective consciousness by acting as physical forms of social memory and re-sistance, much as Blassingame's *Settled* does. For many women, queer, and BIPOC bookmakers, in particular, and for "other artists for whom art is a tool of social change," as Florencia San Martín suggests in her study of Latin American works, artists' books have historically served

to "resis[t] [. . .] colonialist forgetfulness, omission, and obliteration, and will continue to do so as modernity continues."[31] Along these same lines, Suzy Taraba adds, "Acquiring and sharing" queer works has becomes "a new way of creating community through [artists'] books. It's a social activity, no longer something that has to be done secretly for fear of being found out."[32] Artists' books can function both to bring (marginalized) communities together and to bring them more fully and permanently into view.

Collaborative artists' books will not save us. But if they cannot, in themselves, stave off climate change or mitigate social injustice, if they cannot solve pressing political crises or rectify systemic inequality, then they might, at least, stand as enduring testaments to the issues and oversights, as well as to the triumphs, that past and future generations have endured. They might, at least, generate interest not just in other, less visible intermedial artforms but in all manner of tactile print works "high" and "low" (broadsides, magazines, newspapers, pamphlets, postcards) and, in doing so, remind us of some essential part of our humanity—"the human need," as Riva Castleman writes, "to embrace objects worthy of attention, admiration, and affection" and perhaps to make them too.[33] They might, at least, help some of us feel less alone, absorbing us into social collectives via the classrooms, libraries, museums, and reading rooms where we encounter them. They might inspire others of us—and, with expanded initiatives like MPP, more of us—to connect with other people in mutual exploration and collaboration.

Much as *Odes, Numbers, Homage to Allen G., Concordance, Arcade,* and so many other works in this vein have done, the collaborative artists' books created today will commemorate the technological, social, and aesthetic currents of our times. They will offer subsequent generations passage back to it. What precisely that passage will entail remains to be seen. If we are lucky, this juncture will bequeath future audiences with a wide variety of collaborative artists' books that expose, probe, and even incite us to act upon today's burning social issues, as the most politically inclined ones have always done. If we are lucky, this period will continue bring a welcome influx of collaborative artists' books by Black, Indigenous, People of Color, women, and queer creators to the

fore and stimulate our interest in the many books by these creators that languish, often unacknowledged, in standing collections as a result. And if we are lucky, this period may encourage us to sustain some of the technological practices we've been forced to adopt out of pandemic necessity—like virtual artist talks and events or online exhibitions—that can reimagine how we provide access to museum and library spaces, to rare book and special collections, and to artists' books writ large, making the technological age an undeniable boon to the book arts field, however well they fit within it. No matter what forms they take—whether they are, as Drucker has put it, "rare, affordable, unique, or banal," or whether they are personal, political, national, or global—contemporary artists' books, like the countless works sequestered in museums and libraries worldwide before them, will remain a "major staple of the art world."[34] In this regard, the necessity of our current pursuit comes more sharply into focus. If the twentieth and early twenty-first centuries have bestowed on us a wealth of artists' books that remain "as yet uncanonized and marginal, but omnipresent,"[35] then our charge moving forward is to dedicate ourselves to actively changing their fate, bringing them not just out from obscurity and into the canon but, more urgently, out from the dusty archive and library shelves and into reader-viewers' hands, where they await renewed discovery.

NOTES

Introduction

1. Johanna Drucker, *The Century of Artists' Books*, 2nd ed. (New York: Granary Books, 2004), 1.

2. Constance Lewallen, "Some Thoughts on the Types and Display of Collaborative and Artists' Books in the San Francisco Area," in *The Art of Collaboration: Poets, Artists, Books*, ed. Anca Cristofovici and Barbara Montefalcone (Victoria, TX: Cuneiform Press, 2015), 174.

3. Krystyna Wasserman, "The Brightest Heaven of Invention," in *The Book as Art: Artists' Books from the National Museum of Women in the Arts*, ed. Krystyna Wasserman (Princeton, NJ: Princeton Architectural Press, 2007), 13.

4. Of course, collaborative artists' books have not been entirely neglected in scholarly discourse, but they do appear less frequently in both literary and art-historical accounts than other types of work. Moreover, when scholars do offer close readings of works, it is often in the form of a one-off article or a single book chapter, rather than in a sustained study.

5. Kurt Allerslev, "A Closed Book Is a Treasure Trove of Wild Possibility," in *Freedom of the Presses: Artists' Books in the Twenty-First Century*, ed. Marshall Weber (New York: Booklyn, 2018), 3.

6. See especially, Kathryn Brown, *Matisse's Poets: Critical Performance in the Artists' Book* (New York: Bloomsbury, 2017); Nancy Perloff, *Explodity: Sound, Image, and Word in Russian Futurist Book Art* (Los Angeles: Getty Publications, 2017); Anca Cristofovici and Barbara Montefalcone, eds., *The Art of Collaboration: Poets, Artists, Books* (Victoria, TX: Cuneiform Press, 2015); Marshall Weber, ed., *Freedom of the Presses: Artists' Books in the Twenty-First Century* (New York: Booklyn, 2018); Kyle Schlesinger, ed., *A Poetics of the Press: Interviews with Poets, Printers, & Publishers* (New York: Ugly Duckling Press, 2021). See also, earlier works like Drucker's *The Century of Artists' Books* and Riva Castleman's *A Century of Artists' Books* (New York: Museum of Modern Art, 1994). Despite taking a slightly different approach, I am also indebted to work on collaboration within particular "schools"; see, for example, Mary Harris, *The Arts at Black Mountain College* (Cambridge, MA: MIT Press, 1987); Mark Silverberg, ed., *New York School Collaborations: The*

Color of Vowels (New York: Palgrave Macmillan, 2013); Yasmine Shamma, ed., *Joe Brainard's Art* (Edinburgh: Edinburgh University Press, 2019).

7. Though most of the books are ordered chronologically, *Arcade* was published before both *Homage to Allen G.* and *Concordance*. I have, however, chosen to engage it last both because Erica Hunt and Alison Saar are this study's youngest artists (situating Hunt in a sort of third- or fourth-generation New American Poet/Language lineage) and because this trajectory highlights artists' books' increasing investments in issues of gender and race. In each successive book (*Homage, Concordance, Arcade*), the artists' engagement with these ideas gains complexity and centrality, reflecting not only larger trends in the art world but also a broader feminist historiography, which has moved toward more robust engagement with intersectionality.

8. Daniel Kane has, for instance, written about the role of technology, especially the mimeograph and its resulting little magazines, for the crystallization of the so-called Second-Generation New York School in *All Poets Welcome: The Lower East Side Poetry Scene in the 1960s* (Berkeley: University of California Press, 2003). Along these lines, Ross Hair also offers a transatlantic account of the small press phenomenon at midcentury in *Avant-Folk: Small Press Poetry Networks from 1950 to the Present* (Liverpool: Liverpool University Press, 2017).

9. Anne Dewey and Libbie Rifkin, "Introduction," in *Among Friends: Engendering the Social Site of Poetry* (Iowa City: University of Iowa Press, 2013), 10. See also Andrew Epstein *Beautiful Enemies: Friendship and Postwar American Poetry* (New York: Oxford University Press, 2006).

10. Cristofovici, "Unfolding Possibilities: Artists' Books, Cultural Patterns, Forms of Experience," in *The Art of Collaboration*, 18.

11. Tony White, "The (r)Evolutionary Artist's Book," *Book 2.0* 3, no. 2 (2013): 165. The term was first used for a show that Vanderlip had curated at Philadelphia's Moore Gallery of Art.

12. For more on the democratic multiple's history, see Lucy Lippard, *Six Years: The Dematerialization of the Art Object from 1966 and 1972* (New York: Praeger, 1973); and Tony White, "From Democratic Multiple to Artist Publishing: The (r)Evolutionary Artist's Book," *Art Documentation: Journal of the Art Libraries Society of North America* 31, no. 1 (2012): 45–56.

13. Lucy Lippard, "The Artist's Book Goes Public" (1976), in *Artists' Books: A Critical Anthology and Sourcebook*, ed. Joan Lyons (Rochester, NY: Visual Studies Workshop Press, 1985), 48.

14. I have also recounted this history and these definitions at length because a rankled (anonymous) scholar who was asked to peer review this book in

its early manuscript form suggested that I had erroneously presented its central works as "artists' books" rather than "fine press" works, despite its dutiful citation of thinkers like Drucker. It is, furthermore, not uncommon to see works like those engaged here called "artists' books" in other accounts, even if they were technically published and/or commissioned by fine presses. Though some will continue to insist on keeping these distinctions prevalent, I have chosen to follow Karen Eliot's notion that "artist's book" has itself become the dominant term for a range of works that includes the examples at hand, as well as to embrace Drucker's more expansive "zone of activity" view.

15. I am not the first to detail its shortcomings. In response to the overly simplistic artist's book/livre d'artistes binary, Peter Verheyen, for example, suggests the term "fine press artist's book," which "falls somewhat between the two" in "Development of the Artist's Book," *BookArtsWeb* (1998), https://www.philobiblon.com/DevArtistsBook.shtml. Likewise, Clive Phillpot distinguishes between "artists' books, meaning books and booklets authored by artists, and 'bookworks,' meaning artworks in book form," in "Books by Artists and Books as Art," in *Artist/Author: Contemporary Artists' Books*, ed. Clive Phillpot and Cornelia Lauf (New York: Distributed Arts Publishers, 1998), 31–55. Duncan Chappell goes even further; chastising the "early grand narratives of [American] artists' books that display an inherent tendency to regard it in splendid isolation, rather than in perpetual relation to other fields of the book arts," he proposes twenty-eight terms for distinct printmaking categories, some drawn from other accounts (artist's magazine, catalogue d'artiste, photobookwork) and some of his own, in "Typologising the Artist's Book," *Art Libraries Journal* 28, no. 4 (2003): 12. Though these accounts are less circumscribed and nationalistic than equating the artist's book with the democratic multiple, such complex typologies also seem untenable, often introducing more confusion than they resolve.

16. As Johanna Drucker argues, the "democratic" nature of the multiple was "one of the founding myths of artists' books in their incarnation as mass-produced works," since the works not only proved quite costly to produce but also failed to gain the wide audience they envisioned, in *Figuring the Word: Essays on Books, Writing, and Visual Poetics* (New York: Granary Books, 1998), 175.

17. Johanna Drucker, *The Century*, 3–4.

18. Drucker, *The Century*, 11.

19. Drucker, *The Century*, 4–5.

20. Susi R. Bloch, "The Book Stripped Bare," in *Artists' Books: A Critical Anthology*

and Sourcebook, ed. Joan Lyons (Rochester, NY: Visual Studies Workshop Press, 1985), 133–42.

21. Drucker, *The Century*, 1.

22. Drucker, *The Century*, 9.

23. Tia Blassingame, interview by Alexandra J. Gold, email, August 2020.

24. Karen Eliot, "The Root of the Matter: The Artist's Book in the Twenty-First Century," in *Freedom of the Presses: Artists' Books in the Twenty-First Century*, ed. Marshall Weber (New York: Booklyn, 2018), 43.

25. Eliot, "The Root," 41.

26. Cristofovici, "Unfolding Possibilities," 13.

27. Thomas J. Hines, *Collaborative Form: Studies in the Relations of the Arts* (Kent, OH: Kent State University Press, 1991), 11.

28. While I was working with the Smithsonian Libraries' vast collection of artists' books across several libraries in 2019 as part of the Baird Resident Scholar program, two separate librarians conveyed this concern, noting that it had come up in heated debate at inter-institutional meetings.

29. Cornelia Lauf, "Cracked Spines and Slipped Disks," in *Artist/Author*, 79.

30. Eva Athanasiu, "Belonging: Artists' Books and Readers in the Library," *Art Documentation: Journal of the Art Libraries Society of North America* 34, no. 2 (2015): 335.

31. Cristofovici, "Unfolding Possibilities," 16.

32. Mark Silverberg usefully draws out this distinction between "collaborative practice" and "collaborative form" in his "Introduction," in *New York School Collaborations*, 8.

33. Rand, qtd. in Barbara Montefalcone, "'Poetry is a Team Sport': Some Considerations on Poetry, Collaboration, and the Book," in *The Art of Collaboration: Poets, Artists, Books*, 29.

34. For more on the intricacies of collaboration see, among others, Wayne Koestenbaum, *Double Talk: The Erotics of Male Literary Collaboration* (New York: Routledge, 1989); Jack Stillinger, *Multiple Authorship and the Myth of Solitary Genius* (Oxford: Oxford University Press, 1991); Whitney Chadwick and Isabelle De Courtivron, eds., *Significant Others: Creativity and Intimate Partnership* (London: Thames and Hudson, 1993).

35. Charles Green, *The Third Hand: Collaboration in Art from Conceptualism to Postmodernism* (Minneapolis: University of Minnesota Press, 2001), x.

36. David Shapiro, "Art as Collaboration: Toward a Theory of Pluralist Aesthetics 1950–1980," in *Artistic Collaboration in the Twentieth Century*, ed. Cynthia Jaffee McCabe (Washington, DC: Smithsonian Institution, 1984), 49.

37. Alexa Hazel, "'You Shall Look at This or at Nothing': Gaylord Schanilec and the Value of the Fine Press Book," *Book History* 24, no. 1 (2021): 157–58.

38. Brian Reed, "Visual Experiment and Oral Performance," in *The Sound of Poetry, The Poetry of Sound*, ed. Marjorie Perloff and Craig Dworkin (Chicago: University of Chicago Press, 2009), 272.

39. William Blake's eighteenth-century "illuminated manuscripts" are, for instance, an early forerunner to the artists' books of concern here. And, of course, collaboration is not a strictly Western phenomenon, despite my own primary focus on European and American works. Here, one particularly relevant example is Aimé Césaire and Pablo Picasso's *Corps Perdu* (1950), in addition to the long tradition of collaborative work and poetry in the East, like the Japanese practice of "linked poetry."

40. Tatyana Grosman's Universal Limited Art Editions (ULAE), founded in 1957, is a storied example—a press that was not only responsible for one of the earliest important postwar American collaborations, Frank O'Hara and Larry Rivers's *Stones*, but that eventually published myriad collaborations and fine art works by celebrated contemporary artists like Jasper Johns, Robert Rauschenberg, Jim Dine, Kiki Smith, and others.

41. Charles Olson, "Projective Verse," in *The New American Poetry 1945–1960*, ed. Donald Allen (Berkeley: University of California Press, 1960), 395.

42. Kenneth Koch, "A Note on This Issue," in *Locus Solus II: A Special Issue of Collaborations* (Geneva: Atar S.A., 1961), 193.

43. Virginia Jackson, *Dickinson's Misery: A Theory of Lyric Reading* (Princeton, NJ: Princeton University Press, 2005), 90.

44. Donald Allen, "Preface," in *The New American Poetry*, xi.

45. Charles Altieri, "What Is Living and What Is Dead in American Postmodernism: Establishing the Contemporaneity of Some American Poetry," *Critical Inquiry* 22, no. 4 (1997): 775.

46. Cristofovici, "Unfolding Possibilities," 13. While Cristofovici makes this claim about Creeley, adding O'Hara only seems to further consecrate it.

47. Eliot, "The Root," 48.

48. Daniel Kane, "'Angel Hair' Magazine, The Second-Generation New York School, and the Poetics of Sociability," *Contemporary Literature* 45, no. 2 (2004): 351.

49. Kane, "Angel Hair," 333.

50. Brian Wallis, "The Artist's Book and Postmodernism," in *Artist/Author*, 97–101.

51. See Juliana Spahr and Claudia Rankine, "Introduction," in *American Women Poets in the 21st Century: Where Lyric Meets Language* (Middletown, CT: Wesleyan University Press, 2002), 2.

52. Kamran Javadizadeh offers a cogent account of this figuration in "The Atlantic Ocean Breaking on Our Heads: Claudia Rankine, Robert Lowell, and the

Whiteness of the Lyric Subject," *PMLA* 134, no. 3 (2019): 475–90. See also Andrea Brady, *Poetry and Bondage: A History and Theory of Lyric Constraint* (Cambridge: Cambridge University Press, 2021).

53. Lippard, "The Artist's Book Goes Public," 46.

54. Gillian C. White, *Lyric Shame: The 'Lyric' Subject of Contemporary American Poetry* (Cambridge, MA: Harvard University Press, 2014), 12.

55. Brian Reed, "Idea Eater: The Conceptualist Lyric as an Emergent Literary Form," *Mosaic* 49, no. 2 (2016): 12.

56. Reed, "Idea Eater," 14.

57. Reed, "Idea Eater," 9.

58. White, *Lyric Shame*, 6.

59. White, *Lyric Shame*, 6.

60. Jonathan Culler, *Theory of the Lyric* (Cambridge, MA: Harvard University Press, 2015), 243.

61. Culler, *Theory of the Lyric*, 35–37.

62. Culler, *Theory of the Lyric*, 38.

63. Keith A. Smith, *Structure of the Visual Book* (Rochester, NY: Keith Smith, 1984), 9.

64. Dick Higgins, "A Preface," in *Artists' Books: A Critical Anthology*, 12.

65. Gervais Jassaud, "Global Books: New Aspects in the Making of Artists' Books," trans. Pascal Poyet and Lorie-Anne Deuch Rainville, in *The Art of Collaboration: Poets, Artists, Books*, ed. Anca Cristofovici and Barbara Montefalcone, (Victoria, TX: Cuneiform Press, 2015), 123–28.

66. Wallis, "The Artist's Book and Postmodernism," 97.

67. Culler, *Theory of the Lyric*, 8.

68. Culler, *Theory of the Lyric*, 16.

69. Lynn Lester Hershman, "Slices of Silence, Parcels of Time: The Book as Portable Sculpture," in *Artists' Books: Moore College of Art*, ed. Dianne Perry Vanderlip (Philadelphia: Falcon Press, 1973), 13.

70. Culler, *Theory of the Lyric*, 187.

71. For more on address and apostrophe in post-1945 lyric poetry, see Ann Keniston, *Overheard Voices: Address and Subjectivity in Postmodern American Poetry* (New York: Routledge, 2006). While my account complements Keniston's sense that garnering a response to poetic address, "is antithetical to lyric," giving lie to its "solitary voice" (8), I suggest that in collaborative artists' books, it is the immediate *presence* of a respondent, rather than, as Keniston argues, their exaggerated *absence* that allows postmodern poets to challenge conventional lyric structures.

72. Culler, *Theory of the Lyric*, 190.

73. Culler, *Theory of the Lyric*, 37.

74. John Perrault, "Some Thoughts on Book Art," in *Artists' Books: Moore College of Art*, ed. Dianne Perry Vanderlip (Philadelphia: Falcon Press, 1973), 18.

75. Anton Würth, "The Use of Type in Artists' Books," in *Freedom of the Presses*, 142.

76. Bill Berkson, "Hands On/Hands Off," in *The Art of Collaboration*, 87.

77. In addition to previously cited work by Jackson, Perloff, and Reed, see also Virginia Jackson and Yopie Prins, eds., *The Lyric Theory Reader: A Critical Anthology* (Baltimore, MD: Johns Hopkins University Press, 2014); Seth Perlow, *The Poem Electric: Technology and the American Lyric* (Minneapolis: University of Minnesota Press, 2018). See also "The New Lyric Studies" cluster in *PMLA* 123, no. 1 (2008): 181–234, which features work by Jackson, Hayes, and others.

78. Jackson, *Dickinson's Misery,* 10.

79. Jackson, *Dickinson's Misery*, 117.

80. Marjorie Perloff and Craig Dworkin, "Introduction," in *The Sound of Poetry, The Poetry of Sound*, 4.

81. Hines, *Collaborative Form,* 12.

82. Shelley Rice, "Words and Images: Artists' Books as Visual Literature," in *Artists' Books: A Critical Anthology*, 59.

83. Rice, "Words and Images," 59.

84. Stephen Fredman, *American Poetry as Transactional Art* (Tuscaloosa: University of Alabama Press, 2020), 5.

85. Stephen Dupont, "Lost Dogs," in *Freedom of the Presses: Artists' Books in the Twenty-First Century*, ed. Marshall Weber (New York: Booklyn, 2018), 98.

Chapter One

1. Rivers, qtd. in Brad Gooch, *City Poet: The Life and Times of Frank O'Hara* (New York: Harper Perennial, 1993), 270.

2. Frank O'Hara, "Larry Rivers: A Memoir," in *Standing Still and Walking in New York*, 2nd ed., ed. Donald Allen (San Francisco: Grey Fox Press), 1983, 169.

3. Frank O'Hara, "Why I Am Not a Painter," in *The Collected Poems of Frank O'Hara*, ed. Donald Allen (Berkeley: University of California Press, 1995), 261. *The Collected Poems* are cited hereafter in text as *CP*. For extended discussions of "Why I Am Not a Painter," see Monika Gehlawat, "'An Opposite Force's Breath': Medium-Boundedness, Lyric Poetry, and Painting in Frank O'Hara," in *New York School Collaborations*, 163–82; Brian Glavey, "Frank O'Hara Nude with Boots: Queer Ekphrasis and the Statuesque Poet,"

American Literature 79, no. 4 (2007): 781–806; Russell Ferguson, In Memory of My Feelings: Frank O'Hara and American Art (Los Angeles: Museum of Contemporary Art, 1999); Micah Mattix, Frank O'Hara and the Poetics of Saying 'I' (Lanham, MD: Fairleigh Dickinson University Press, 2001); Olivier Brossard, "Et Moi Je Ne Suis Pas Un Peintre: Why Frank O'Hara Is Not a Painter," in The Art of Collaboration: Poets, Artists, Books, ed. Anca Cristofovici and Barbara Montefalcone (Victoria, TX: Cuneiform Press, 2015), 45–54.

4. Tiber's inclusion of work by Mitchell and Hartigan merits particular emphasis, for though these women gained notoriety in their time, their names, along with those of Lee Krasner, Elaine de Kooning, and Helen Frankenthaler, have subsequently been omitted from many Abstract Expressionist accounts. For more, see Mary Gabriel's recent corrective history, Ninth Street Women (New York: Little, Brown, 2018).

5. Terence Diggory, Encyclopedia of the New York School Poets (New York: Facts on File, 2009), 268.

6. Riva Castleman, "Floriano Vecchi and the Tiber Press," Print Quarterly 2, no. 21 (2004): 132.

7. Diggory, Encyclopedia, 269.

8. Donna Stein, "When a Book Is More Than a Book," in Artists' Books in the Modern Era 1870–2000, 2nd ed., ed. Robert Flynn Johnson (San Francisco: Fine Arts Museum, 2002), 38.

9. Frank O'Hara, "Art Chronicle I," in Standing Still and Walking, 127.

10. For more on this phenomenon and its centrality to midcentury poetry and art, see Andrew Epstein, Attention Equals Life: The Pursuit of the Everyday in Contemporary Poetry and Culture. (New York: Oxford University Press, 2016).

11. Qtd. in Bill Berkson, "Hands On/Hands Off," in The Art of Collaboration: Poets, Artists, Books, 81. Originally qtd. in Harold Rosenberg, "The American Action Painters," in The Tradition of the New (New York: Ayer Publishing, 1959).

12. Jill Neimark, "Interview with Michael Goldberg," Columbia Review 58, no. 2 (1979), 1. The issue in which the interview appeared replicates Goldberg and O'Hara's "Ode to Necrophilia" on its cover.

13. Andrew Epstein, "'The Volley Maintained Near Orgasm,'" in Among Friends: Engendering the Social Site of Poetry, ed. Anne Dewey and Libbie Rifkin (Iowa City: University of Iowa Press, 2013), 174.

14. For scholarly convenience and reference, all citations are from The Collected Poems of Frank O'Hara. Unless otherwise indicated, the poetic text and its layout in CP duplicate that found in the original 1960 Odes.

15. Paul Schimmel, "The Lost Generation," in Action/Precision: The New Direction

in New York, 1955–60, ed. Paul Schimmel (Newport Beach, CA: Newport Harbor Art Museum, 1984), 22.

16. John Wilkinson, "'Where Air Is Flesh': The Odes of Frank O'Hara," in *Frank O'Hara Now: New Essays on the New York Poet*, ed. Robert Hampson and Will Montgomery (Liverpool: Liverpool University Press, 2010), 110.

17. Marjorie Perloff, *Frank O'Hara: Poet Among Painters*, 2nd ed. (Chicago: University of Chicago Press, 1997), 156.

18. *Bird in Flight* might also be an allusion to or play on Constantin Brancusi's 1928 bronze *Bird in Space*, held in MoMA's collection (with which O'Hara surely would have been familiar).

19. The allusion to King Lear in "Ode on Causality" also resonates with a comment O'Hara makes in a conversation with Goldberg, Joan Mitchell, Elaine de Kooning, and Norman Bluhm on the topic of influence and novelty: "Anyone who chose Goneril and Regan deserved what Lear got. Even a dog would know that. What do you think a great artist is, somebody who buries his dung? No. Somebody in whom it *floats*," in Frank O'Hara, "5 Participants in a Hearsay Panel," in *Art Chronicles, 1954–1966* (New York: George Braziller, 1990), 155.

20. David Sweet, "Parodic Nostalgia for Aesthetic Machismo: Frank O'Hara and Jackson Pollock," *Journal of Modern Literature* 24, no. 3/4 (2000): 383.

21. Sweet, "Parodic Nostalgia," 383.

22. Sweet, "Parodic Nostalgia," 383.

23. Frank O'Hara, *Jackson Pollock* (New York: George Braziller, 1959), 22.

24. Wilkinson, "Where Air Is Flesh," 112.

25. Allan Kaprow, "The Legacy of Jackson Pollock," *Art News* (1958), reposted on *ArtNews.com*, February 9, 2018, https://www.artnews.com/art-news/retrospective/archives-allan-kaprow-legacy-jackson-pollock-1958-9768/.

26. Neimark, "Interview with Michael Goldberg," 4.

27. Frank O'Hara, "Art Chronicle III," in *Standing Still and Walking in New York*, 142.

28. A handwritten copy of the poem, with the word "geste" underlined, appears in the Richard Miller Archive at the Houghton Library at Harvard University. Donald Allen dates the letter to May 14, 1958, in *The Collected Poems*, though it is undated in the Tiber Press archives.

29. Saul Ostrow, "Michael Goldberg by Saul Ostrow," *BOMB*, April 1, 2001, https://bombmagazine.org/articles/michael-goldberg/.

30. O'Hara, "5 Participants in a Hearsay Panel," 152–54.

31. Irving Sandler, "I Remember Michael Goldberg," in *Abstraction Over Time: The Paintings of Michael Goldberg*, ed. Marcelle Polednik (Jacksonville, FL: Museum of Contemporary Art, 2013), 16.

32. Robert Rosenblum, "Excavating the Fifties," in *Action/Precision*, 19.

33. Thomas Hess, "Younger Artists and the Unforgivable Crime," *Art News* (April 1957): 48–49.

34. Hess, "Younger Artists," 49

35. Andrew Epstein, "Frank O'Hara and Willem De Kooning: 'Hewing a clearing in the crowded abyss of the west,'" *Decals of Desire* 2, January 31, 2017, http://decalsofdesire.blogspot.com/.

36. Lytle Shaw, *Frank O'Hara: The Poetics of Coterie* (Iowa City: University of Iowa Press, 2006), 180.

37. Wilkinson, "Where Air Is Flesh," 114.

38. Daniel Kane, *All Poets Welcome: The Lower East Side Poetry Scene in the 1960s* (Berkeley: University of California Press, 2003), 17.

39. Hess, "Younger Artists," 49. Though "Ode to Willem De Kooning" is dated to 1957 (and likely to fall of that year, per Donald Allen's timeline in *The Collected Poems*), it's hard to know for certain which came first, although O'Hara likely would have seen the review if it indeed preceded the poem, given his own ties to *ArtNews* and the artists featured in the piece.

40. Edward Lucie-Smith, "An Interview with Frank O'Hara," in *Standing Still and Walking in New York*, 9.

41. O'Hara, "5 Participants in a Hearsay Panel," 152.

42. Mutlu K. Blasing, *Politics and Form in Postmodern Poetry: O'Hara, Bishop, Ashbery, and Merrill* (Cambridge: Cambridge University Press, 2009), 49.

43. James Schuyler, "A Blue Shadow Painting," in *Other Flowers: Uncollected Poems,* ed. James Meetze and Simon Pettet (New York: Farrar, Straus, and Giroux, 2010), 4.

44. Michael Goldberg, "The Canvas Plane or Onwards and Upwards," *It Is: A Magazine for Abstract Art* 1 (Spring 1958), 18.

45. Brian Glavey, "Having a Coke with You Is Even More Fun Than Ideology Critique," *PMLA* 134, no. 5 (2019): 1003.

46. Schimmel, "The Lost Generation," 20.

47. Glavey, "Having a Coke," 1005.

48. David Shapiro, "Art as Collaboration: Toward a Theory of Pluralist Aesthetics, 1950–1980," in *Artistic Collaboration in the Twentieth Century*, ed. Cynthia Jaffee McCabe (Washington, DC: Smithsonian Institution, 1984), 52. Glavey draws a similar conclusion in his own essay, noting that "Marvelous experiences are . . . by definition, relatable ones," insofar as "art and experience must be communicated so as not to be lost" ("Having a Coke," 998).

49. Perloff, *Poet Among Painters*, 139.

50. Wilkinson, "Where Air Is Flesh," 104.

51. For more on the idea of home and the wanderer figure in O'Hara's work, including in "Ode to Michael Goldberg," see Matthew Holman, "'Je suis las de vivre au pays natal': At Home and at Sea with Frank O'Hara," *Dandelion: Postgraduate Arts Journal and Research Network* 7, no. 1 (2016): 1–9.

52. I have written at greater length about "Ode: Salute to the French Negro Poets" elsewhere. See Alexandra J. Gold, "Frank O'Hara: Salute to the French Negro Poet, Aimé Césaire," *The Comparatist* 41 (2017): 257–72. The complex and often troubling treatment of race in O'Hara's oeuvre merits more space than this chapter allows, though it has been ably taken up by others; see, for example, Aldon Lynn Nielsen, *Reading Race: White American Poets and the Racial Discourse in the Twentieth Century* (Athens: University of Georgia Press, 1988), 155–57; Benjamin Friedlander, "Strange Fruit: O'Hara, Race, and the Color of Time," in *The Scene of My Selves: New Work on New York School Poets*, ed. Terence Diggory and Stephen Paul Miller (Orono, ME: National Poetry Foundation, 2001), 123–41; and Peter Stoneley, "O'Hara, Blackness, and the Primitive," *Twentieth Century Literature* 58, no. 3 (2012): 495–514.

53. Andrew Epstein, *Beautiful Enemies: Friendship and Postwar American Poetry* (New York: Oxford University Press, 2006), 125–26.

54. Blasing, *Politics and Form*, 36.

55. Glavey, "Having a Coke," 1004. Glavey even suggests that this sensibility was one O'Hara likely modeled on his understanding of Abstract Expressionism itself, inspired by how the "seriousness of these serious men is born not from rugged individualism" but from their interdependence" as well as on the Russian experimental artists whom *Odes* invokes ("Having a Coke," 1004).

56. Frank O'Hara to Richard Miller, October 13, 1958, MS Am 2694, box 1, folder 3, Richard Miller Archive for the Tiber Press Poetry Series.

57. Frank O'Hara, "About Zhivago and His Poems," in *The Collected Poems*, 505–6.

58. Jonathan Culler, *Theory of the Lyric* (Cambridge, MA: Harvard University Press, 2015), 237.

59. Culler, *Theory of the Lyric*, 237. Culler offers as an example O'Hara's 1958 "A True Account of Talking to the Sun at Fire Island," notably written the day after "Ode: Salute to the French Negro Poets," according to Donald Allen's timeline in O'Hara's *Collected Poems*.

60. O'Hara, "Personism: A Manifesto," in *The Collected Poems*, 499.

61. Frank O'Hara to Richard Miller, October 13, 1958, MS Am 2694, box 1, folder 3, Richard Miller Archive for the Tiber Press Poetry Series.

62. In *The Collected Poems*, "Ode on Necrophilia" appears, sans print with the added epigraph, "Isn't there any body you want back from the grave? We

were less generous in our time. —Palinurus (not Cyril Connolly)," 280. Donald Allen dates the poem to November 13, 1957, indicating that the collaborative print was created about a year after the poem was first written.

63. Jason Lagapa, "Parading the Undead: Camp, Horror and Reincarnation in the Poetry of Frank O'Hara and John Yau," *Journal of Modern Literature* 33, no. 2 (2010): 99.

64. Shapiro, "Art as Collaboration," 45.

65. Shapiro, "Art as Collaboration," 53. Shapiro in fact credits Kenneth Koch and the New York School with helping spearhead this innovation. "In the best [midcentury] collaborations," he elaborates, "O'Hara and Larry Rivers, Jasper Johns and O'Hara, Frank Gehry and Richard Serra, for example, the individuals maintain their own peculiar flavors and resonances but struck by the new alliance into odd forms that could never have been discovered by any of the 'players' singly" (54)—a logic that no doubt applies to *Odes*.

66. Shapiro, "Art as Collaboration," 47.

67. O'Hara, "Personism: A Manifesto," in *The Collected Poems*, 499.

Chapter Two

1. For more on these two exhibits, see Roberta Smith's review, "'Nine Artists/ Coenties Slip,' 'Frank O'Hara: Poet Among Painters,'" in *ArtForum*, April 1974, https://www.artforum.com/print/reviews/197404/nine-artists -coenties-slip-frank-o-hara-poet-among-the-painters-70122.

2. Susan Elizabeth Ryan, *Robert Indiana: Figures of Speech* (New Haven, CT: Yale University Press, 2000), 25.

3. Ryan, *Robert Indiana*, 25.

4. Thomas Crow, *The Long March of Pop: Art, Music, and Design 1930–1955* (New Haven, CT: Yale University Press, 2014), 138.

5. Susan Elizabeth Ryan, "On Indiana," unpublished interview with William Katz, February 12, 1990. Katz's claim that he "had known Creeley from school" is somewhat ambiguous; it is unclear whether he means that he had studied Creeley while in college at Johns Hopkins, whether he had seen Creeley lecture at school, or whether he had another pedagogical connection to him, since Creeley taught at several institutions. The first possibility, however, seems likeliest.

6. Robert Creeley, interview with John Sinclair and Robin Eichele, in *Tales Out of School: Selected Interviews* (Ann Arbor: University of Michigan Press, 1993), 8.

7. Barbara Montefalcone, "'Poetry Is a Team Sport': Some Considerations on Poetry, Collaboration, and the Book," in *The Art of Collaboration: Poets,*

Artists, Books, ed. Anca Cristofovici and Barbara Montefalcone (Victoria, TX: Cuneiform Press, 2015), 33.

8. Stephen Fredman, "Introduction," *Presences: A Text for Marisol, A Critical Edition*, ed. Robert Creeley, Marisol Escobar, and Stephen Fredman (Albuquerque: University of New Mexico Press, 2018), xxiv.

9. Montefalcone, "'Poetry Is a Team Sport,'" 34.

10. William Spanos, ed., "Robert Creeley: A Gathering," *Boundary 2* 6, no. 7 (1978); Amy Cappellazzo and Elizabeth Licata, eds., *In Company: Robert Creeley's Collaborations* (Chapel Hill: University of North Carolina Press, 1999). See also Stephen Fredman and Steve McCaffery, eds., *Form, Power, and Person in Robert Creeley's Life and Work* (Iowa City: University of Iowa Press, 2010), a book that was not only occasioned by a literal gathering held in Creeley's honor shortly after his 2005 death but devotes attention to the poet's sociality in chapters like Libbie Rifkin, "Reconsidering the Company of Love: Creeley between Olsen and Levertov," 143–58, and Fredman's "Contextual Practice: Interviews, Conversations, and Collaborations," 181–202.

11. Lynne Lester Hershman, "Slices of Silence, Parcels of Time: The Book as Portable Sculpture," *Artists Books: Moore College of Art* (Philadelphia: Falcon Press, 1973), 12–13.

12. This switch met resistance, much to the shock of Bell executives, who, as a 1962 *Time* article put it, "presupposed the blind acceptance of a benumbed and be-numbered public," "Give Me Liberty," July 13, 1962, Time Magazine Online Archive, https://content.time.com/time/magazine/article /0,9171,827416,00.html.

13. Oren Izenberg, *Being Numerous: Poetry and the Ground of Social Life* (Princeton, NJ: Princeton University Press, 2011), 35.

14. Ryan, *Robert Indiana*, 159.

15. Robert Creeley, "Interview with Linda Wagner," in *Tales Out of School*, 47.

16. Robert Creeley and Bobbie Creeley, "Robert and Bobbie Creeley: Placitas Phone Log (late September/early October, 1968)," *Penn Sound*, http://writing .upenn.edu/pennsound/x/Creeley.php. Transcription mine.

17. "Robert and Bobbie Creeley: Placitas Phone Log."

18. "Robert and Bobbie Creeley: Placitas Phone Log."

19. "Robert and Bobbie Creeley: Placitas Phone Log."

20. Robert Creeley, "An Intensely Singular Art," in *The Collected Essays of Robert Creeley* (Berkeley: University of California Press, 1989), 158. "Poetry for the American," Creeley writes in full, "has been an intensely singular art. It is the me and you which have concerned us—the interstices of human relationships brought home, so to speak. It is there that we have most constantly

begun," 158. Far from a poetic relic, he continues, this intense singularity "continues in contemporary verse. Sometimes the sound is belligerently self-assertive, revelatory, and painful. The I is worn as a merit in itself; all forms break to it, and what hope of relationships to others there may have been, is lost. This is of course the isolation which the American so often carries like a sore, marking him as lonely, lost, and a little pathetic," 158.

21. For scholarly convenience and reference, all citations come from *The Collected Poems of Robert Creeley, 1945–1975* (Berkeley: University of California Press, 2006), hereafter cited in text as *TCP*. Except for "The Fool," the text and layout found in *The Collected Poems* duplicates that found in the original 1968 *Numbers*. My lineation of "The Fool" here reflects that found in the collaborative volume rather than in *The Collected Poems*.

22. Robert Creeley, qtd. in Tom Clark, *Robert Creeley and the Genius of the American Common Place* (New York: New Directions, 1993), 112.

23. Robert Creeley, "Was That a Real Poem or Did You Just Make It Up Yourself?," in *The Collected Essays*, 574–75.

24. Virginia Jackson, *Dickinson's Misery: A Theory of Lyric Reading* (Princeton, NJ: Princeton University Press, 2005), 90.

25. Jackson, *Dickinson's Misery*, 133.

26. Miriam Nichols, *Radical Affections: Essays on the Poetics of Outside* (Tuscaloosa: University of Alabama Press, 2010), 71.

27. Indiana, qtd. in Carol Vogel, "Inside Art: Running Numbers," *New York Times*, December 27, 2002, https://www.nytimes.com/2002/12/27/arts /inside-art.html.

28. Robert Creeley, "Interview with Michael André," in *Tales Out of School*, 111.

29. Charles Altieri, "The Unsure Egoist: Robert Creeley and the Theme of Nothingness," *Contemporary Literature* 13, no. 2 (1972): 183.

30. Alan Badiou, *Being and Event*, trans. Oliver Feltham (London: Continuum, 2005), 4.

31. Badiou, *Being and Event*, 24.

32. Ryan, "On Indiana," unpublished interview with William Katz.

33. Bill Katz to Robert Creeley, January 26, 1968, M662 Robert Creeley Papers 1950–1997, Correspondence 1950–1990, series 1, box 85, folder 45, Robert Creeley Archive, Department of Special Collections, Stanford University, Stanford, CA.

34. Creeley, qtd. in Elizabeth Licata, "Robert Creeley's Collaborations: A History," in *In Company*, 13.

35. Mel Bochner, "The Serial Attitude" (1967), reprinted in *Conceptual Art: A Critical Anthology*, ed. Alexander Alberro and Blake Stimson (Cambridge, MA: MIT Press, 1999), 22–27.

36. Craig Dworkin, "The Fate of Echo," in *Against Expression: An Anthology of Conceptual Writing*, ed. Kenneth Goldsmith and Craig Dworkin (Evanston, IL: Northwestern University Press, 2011), xxxi–xxxii.

37. John J. Curley, "Pure Art, Pure Science: The Politics of Serial Drawings in the 1960s," in *Infinite Possibilities: Serial Imagery in 20th-Century Drawings,* ed. Anja Chávez (Wellesley, MA: Davis Museum and Cultural Center, 2004), 27.

38. Prudence Peiffer, "One Day After Another: Seriality and the Stuttering Word," in *Infinite Possibilities*, 15.

39. William V. Spanos, "Talking with Robert Creeley," *boundary 2* 6, no. 7 (1978): 27.

40. William Wordsworth, "We Are Seven," in *The Collected Poetry of William Wordsworth* (Ware, UK: Wordsworth Editions, 1994), 96.

41. Ekbert Faas, *Robert Creeley: A Biography* (Hanover, NH: University Press of New England, 2001), 74.

42. Jonathan Culler, *Theory of the Lyric* (Cambridge, MA: Harvard University Press, 2015), 226.

43. Culler, *Theory of the Lyric*, 227.

44. John Steen, "Mourning the Elegy: Robert Creeley's 'Mother's Photograph,'" *Textual Practice* 31, no. 1 (2017): 167.

45. Creeley, qtd. in Clark, *Robert Creeley,* 32.

46. Robert Creeley, interview with Michael André, in *Tales Out of School*, 111.

47. Joseph M. Conte, *Unending Design: The Forms of Postmodern Poetry* (Ithaca, NY: Cornell University Press, 1991), 130. The metonymic logic of serial poetry, Conte argues, directly opposes the "metaphoric" logic of lyric poetry, which makes the individual the center of the circle rather than one point on its periphery. Conte discusses how this works, for instance, in George Oppen's *Discrete Series*, which he compares to Creeley's *Pieces*.

48. "Robert and Bobbie Creeley: Placitas Phone Log."

49. Alan Golding, "Revisiting Seriality in Creeley's Poetry," in *Form, Power, and Person*, 50.

50. Jonathan Katz, "Two-Faced Truths: Robert Indiana's Queer Semiotic," in *Robert Indiana: New Perspectives,* ed. Allison Unruh (Ostfildern, Germany: Hatje Cantz, 2012), 225.

51. Fredman, "Introduction," xiii.

52. Ryan, *Robert Indiana*, 159.

53. Creeley, qtd. in Ryan, *Robert Indiana*, 159.

54. Adrian Dannatt, "Robert Indiana 66: Paintings and Sculpture," Price Tower Art Center, 2004, http://www.tfaoi.com/aa/4aa/4aa417.htm.

55. Ryan, *Robert Indiana*, 182. For more on the role of mothers and fathers in Indiana's work, as well as Indiana's connections to Demuth and Gertrude

Stein, see Allison Unruh, "Robert Indiana and the Politics of Family," in *Robert Indiana: New Perspectives*, 151–216.

56. Indiana, qtd. in Aprile Gallant "An American's Dream," in *Love and the American Dream: The Art of Robert Indiana*, ed. Fronia W. Simpson (Seattle: University of Washington Press, 1999), 53. *Numbers* itself undoubtedly owes a broader debt to an early visual-verbal exchange like that of Demuth and Williams, especially given the centrality of Demuth to Indiana's artistic practice and Williams to Creeley's own. Though space here does not allow for a full discussion of this influence, the cubist-inflected nature of Creeley's number poems, offering an array of perspectives on each numeric digit, echoes that which we find in Williams's "The Great Figure."

57. Daniel R. Schwarz, "Painting Williams, Reading Demuth: 'The Great Figure' and *I Saw the Figure 5 in Gold*," *William Carlos Williams Review* 32, nos. 1–2 (2015): 27.

58. Richard Brilliant, *Portraiture* (Cambridge, MA: Harvard University Press, 1991), 14.

59. Creeley, "An Intensely Singular Art," 158.

60. Altieri, "The Unsure Egoist," 181.

61. Montefalcone, "Poetry Is a Team Sport," 28.

62. Bill Katz to Robert Creeley, October 2, 1968, M662 Robert Creeley Papers, 1950–1997, Correspondence 1950–1990, series 1, box 85, folder 47, Robert Creeley Archive, Department of Special Collections, Stanford University, Stanford, CA.

63. Jackson, *Dickinson's Misery*, 97.

64. Qtd. in Artworks (Two, 1960–1962), robertindiana.com, accessed June 18, 2022, https://www.robertindiana.com/artworks/artworks-items/two3.

Chapter Three

1. For more on the so-called Second-Generation New York School and their little magazines, see Daniel Kane, *All Poets Welcome: The Lower East Side Poetry Scene in the 1960s* (Berkeley: University of California Press, 2003); Yasmine Shamma, *Spatial Poetics: Second Generation New York School Poetry* (New York: Oxford University Press, 2018); and Yasmine Shamma, ed., *Joe Brainard's Art* (Edinburgh: Edinburgh University Press, 2019). Nick Sturm has also written extensively on the younger poets associated with the New York School, especially Alice Notley and Ted Berrigan, and he has been an active curator of their works. See, for instance, Sturm, "Unceasing Museums: Alice Notley's 'Modern Americans' in Their Place at Chicago Art," *ASAP/J*,

March 12, 2019, https://asapjournal.com/unceasing-museums-alice-notleys
-modern-americans-in-their-place-at-chicago-art-institute-nick-sturm/. For
the full breadth of his past and forthcoming archival and scholarly work, see
https://www.nicksturm.com/work#/scholarship/.

2. Anne Waldman, "My Life a List," in *Vow to Poetry: Essays, Interviews & Manifestos* (Minneapolis: Coffee House Press, 2001), 28.

3. Of Waldman's first encounter with O'Hara, shortly before he died, she writes: "Meeting Frank O'Hara in 1966 provoked a strong commitment. I loved the exuberance in his work. The consciousness of his poetic persona was alive, infectious, multidimensional. He was so matter-of-fact about my wanting to be a poet, *Welcome to the club*, he said. He invited me to come work at the Museum of Modern Art as a volunteer, said that was something a poet should do. But I needed money, I protested! There's interesting history in those 'mentor' friendships. But I always felt equal to their challenge," in *Vow to Poetry*, 108.

4. Anne Waldman, "Surprise Each Other: The Art of Collaboration," in *Vow to Poetry*, 319–20.

5. Ron Padgett, ed., *Painter Among Poets: The Collaborative Art of George Schneeman* (New York: Granary Books, 2004).

6. Waldman, "Surprise Each Other," 321.

7. Waldman, "Surprise Each Other," 321.

8. Padgett, "Collaborating with Poets: A Conversation with George Schneeman," in *Painter Among Poets*, 47.

9. Padgett, "Collaborating with Poets," 56.

10. Padgett, "Collaborating with Poets," 56.

11. Anne Waldman, "By the Time of Plato No More Cakes and Ale," in *Painter Among Poets*, 77.

12. Waldman, "Surprise Each Other," 322.

13. Peter Puchek, "From Revolution to Creation: Beat Desire and Body Poetics in Anne Waldman's Poetry," in *Girls Who Wore Black: Women Writing the Beat Generation*, ed. Ronna C. Johnson and Nancy M. Grace (New Brunswick, NJ: Rutgers University Press, 2002), 244.

14. Alice Notley, "The Art of George Schneeman (Interview)," *Brilliant Corners: A Magazine of the Arts* 8 (1978): 36.

15. Kane, *All Poets Welcome*, 10.

16. Jenni Quilter, "Life Without Malice: The Minor Arts of Collaboration," in *New York School Collaborations: The Color of Vowels*, ed. Mark Silverberg (New York: Palgrave Macmillan, 2013), 148.

17. Puchek, "From Revolution to Creation," 234.

18. Oliver Harris, "Minute Particulars of the Counter-Culture: Time, Life, and the Photo-Poetics of Allen Ginsberg," *Comparative American Studies* 10, no. 1 (2012): 3–29. Harris argues that this was born of Ginsberg's conscious effort to establish the idea of the "Beats" on their own terms in opposition to their hipster "Beatnik" portrayal in Henry Luce's *Life* and *Time* magazines throughout the 1950s. Morris offers a different rationale, viewing Ginsberg's "fastidious[s]" captioning as "part of [a] documentary projec[t] that . . . align[s] to a prominent discourse concerning Jewish representation and its relation to history and communal memory," 18.

19. Allen Ginsberg, "A Comment," in *Allen Ginsberg: Photographs* (Altadena, CA: Twelvetree Press, 1990).

20. Jason Arthur, "Allen Ginsberg's Biographical Gestures," *Texas Studies in Literature and Language* 52, no. 2 (2010): 227.

21. Arthur, "Biographical Gestures," 227.

22. Daniel Kane, "'Angel Hair' Magazine, the Second-Generation New York School, and the Poetics of Sociability," *Contemporary Literature* 45, no. 2 (2004): 336.

23. Notley, "The Art of George Schneeman," 72.

24. Notley, "The Art of George Schneeman," 72.

25. I had a unique opportunity to present on this work at a 2018 New York School symposium at which Alice Notley was present. Though the people depicted in Ginsberg's photos should have been recognizable to her, as a formative member of the scene, she could not determine some of the figures, illuminating how deftly the traces have functioned to obscure them.

26. A relatively unknown Beat generation poet, Bremser had struck up correspondence with Ginsberg while he was in jail and Ginsberg, upon Bremser's release, introduced him to the Beat scene. Bremser was first published in Amiri Baraka's *Yūgen* magazine and eventually published six books of poetry between 1965 and 1998. For more on Bremser, see https://allenginsberg.org /2012/02/ray-bremser-1934-1998/.

27. One important strain of Beat criticism has restored women's central role in the movement. See Ronna C. Johnson and Nancy M. Grace, eds., *Girls Who Wore Black: Women Writing in the Beat Generation* (New Brunswick, NJ: Rutgers University Press, 2002); Mary Paniccia Carden and Justin D. Neuman, eds., *Women Writers of the Beat Era: Autobiographic and Intertextuality* (Charlottesville: University of Virginia Press, 2018); Amy L. Friedman, "'Being Here as Hard as I Could': The Beat Generation Women Writers," *Discourse* 20, no. 1/2 (1998): 229–44; Brenda Knight, *Women of the Beat Generation: The Writers, Artists, and Muses at the Heart of a Revolution*, 2nd ed. (Berkeley, CA: Conari Press, 1996). For more on the erasure of Black artists

from the movement, see H. William Rice, "Bob Kaufman and the Limits of Jazz," *African American Review* 47, nos. 2–3 (2014): 402–15; Jennie Skerl, ed., *Reconstructing the Beats* (New York: Palgrave Macmillan, 2004).

28. See Anne Conover, *Olga Rudge and Ezra Pound: 'what thou lovest well . . .'* (New Haven, CT: Yale University Press, 2011).

29. Anne Waldman, "Iovis II," in *The Iovis Trilogy: Colors in the Mechanism of Concealment* (Minneapolis: Coffee House Press, 1997), 134–35.

30. Rachel Blau DuPlessis, "Anne Waldman: Standing Corporeally in One's Time," in *Don't Ever Get Famous: Essays on New York Writing After the New York School*, ed. Daniel Kane (London: Dalkey Archive Press, 2006), 179–80.

31. DuPlessis, "Standing Corporeally," 187. For the Buddhist origins of this formulation, see Laura Bardwell, "Anne Waldman's Buddhist 'Both Both,'" *Jacket2* 27 (2005), http://jacketmagazine.com/27/w-bard.html.

32. DuPlessis, "Standing Corporeally," 227.

33. Heather Thomas elaborates on a similar conflict in "'Eyes in All Heads': Anne Waldman's Performance of Bigendered Imagination in Iovis 1," in *We Who Love to Be Astonished: Experimental Women's Writing and Performance*, eds. Laura Hinton and Cynthia Hogue (Tuscaloosa: University of Alabama Press, 2002), 203–12.

34. Francis Richard, interview with Anne Waldman, *BOMB*, March 6, 2012, https://bombmagazine.org/articles/frances-richard-and-anne-waldman/.

35. Mary Paniccia Carden, "Introduction: Writing from Nowhere," in *Women Writers of the Beat Era*, 5.

36. Carden, "Introduction," 3.

37. Richard, interview with Anne Waldman.

38. Erik Mortenson, *Capturing the Beat Moment: Cultural Politics and the Poetics of Presence* (Carbondale: Southern Illinois University Press, 2011), 122.

39. Mortenson, *Capturing the Beat Moment*, 140.

40. Jonathan Culler, *Theory of the Lyric* (Cambridge, MA: Harvard University Press, 2015), 2.

41. Charles Bernstein, "Artifice of Absorption," via *EPC* Digital Library, 2019, http://writing.upenn.edu/epc/authors/bernstein/books/artifice/AA-contents.html.

42. Culler, *Theory of the Lyric*, 213.

43. Laura Hinton, "Two Conversations with Mei-mei Berssenbrugge," in *Innovative Women Poets: An Anthology of Contemporary Poetry and Interviews*, ed. Elisabeth A. Frost and Cynthia Hogue (Iowa City: University of Iowa Press, 2006), 52.

44. Harris, "Minute Particulars," 21.

45. Sarah Greenough, cur., *Beat Memories: The Photographs of Allen Ginsberg*, reprint (Munich: Prestel, 2013), 16.

46. Qtd. in Tim Keane, "'I Noticed My Friends': Allen Ginsberg's Photography," *Hyperallergic*, February 16, 2013, https://hyperallergic.com/65172/i-noticed -my-friends-allen-ginsbergs-photography/.

47. Allen Ginsberg, photograph, reprinted and accessible online at https://from -the-sky.tumblr.com/post/40596393126.

48. Daniel Morris, *After Weegee: Essays on Contemporary Jewish American Photographers* (Syracuse: Syracuse University Press, 2011), 190.

49. Quilter, "Life Without Malice," 143.

50. Tim Keane, "No Real Assurances: Late Modernist Poetics and George Schneeman's Collaborations with the New York School Poets," *Studies in Visual Arts and Communication: An International Journal* 1, no. 2 (2014): 4.

51. Keane, "No Real Assurances," 10.

52. Anne Waldman, "'I is Another': Dissipative Structures," in *Vow to Poetry*, 194–212.

53. Culler, *Theory of the Lyric*, 226.

54. Roland Barthes, *Image-Music-Text*, trans. Stephen Heath (New York: Hill and Wang), 146.

55. Barthes, *Image-Music-Text,* 146–47.

56. Ginsberg, *Allen Ginsberg: Photographs*.

57. Waldman, "My Life a List," 25.

58. Waldman, "Vow to Poetry," 108.

59. Waldman, "I is Another," 212.

60. Wallace Stevens, "The Man with the Blue Guitar," in *The Collected Poems of Wallace Stevens* (New York: Vintage Books, 1990), 171.

61. Stevens, "The Man with the Blue Guitar," 176.

62. Stevens, "The Man with the Blue Guitar," 167.

63. Mutlu K. Blasing, *Lyric Poetry: The Pain and the Pleasure of Words* (Princeton, NJ: Princeton University Press, 2009), 142.

64. Bonnie Costello, "Collecting Ourselves: 'We' in Wallace Stevens," *ELH* 85, no. 4 (2018): 1081–82.

65. Stevens, "The Man with the Blue Guitar," 166.

66. Marjorie Perloff and Craig Dworkin, "Introduction," in *The Sound of Poetry/ The Poetry of Sound,* ed. Marjorie Perloff and Craig Dworkin (Chicago: University of Chicago Press, 2009), 3.

67. Perloff and Dworkin, "Introduction," 5.

68. Kane, "'Angel Hair' Magazine," 343.

69. Waldman, "Surprise Each Other," 322.

70. For more on Waldman's Buddhism, see Elizabeth-Jane Burnett, *A Social*

Biography of Contemporary Innovative Poetry Communities: The Gift, The Wager, and Poethics (New York: Palgrave Macmillan, 2017), 71–97.

71. Bill Berkson, "George's House of Mozart," in *Painter Among Poets*, 90.

72. Waldman, "Surprise Each Other," 327.

73. Padgett, "Collaborating with Poets," 36.

74. Ulises Carrión, "The New Art of Making Books," in *Artists' Books: A Critical Anthology and Sourcebook*, ed. Joan Lyons (Rochester, NY: Visual Studies Workshop, 1985), 18.

75. Keane, "'I Noticed My Friends.'"

76. Ginsberg, "A Comment."

77. Ginsberg, "A Comment."

Chapter Four

1. Anne Waldman, "Femanifesto," in *Vow to Poetry: Essays, Interviews, and Manifestos* (Minneapolis: Coffee House Press, 2001), 21. The title "Femanifesto" perhaps deliberately calls to mind and intervenes in the largely masculinist tradition of modernist and contemporary poetic "manifestoes," which includes Pound's "A Few Don'ts by an Imagiste," Olson's "Projective Verse," Duncan's "The Opening of the Field," and O'Hara's "Personism."

2. Waldman, "Femanifesto," 24.

3. Ranging from discussions that code Berssenbrugge's ideological invest--ments in a language of "intimacy" or "Sensitive Empiricism" to more overt discussions about the role of mothers and mothering in her work, the gendered/feminist stakes of the poet's verse have become resoundingly clear. See, for instance, Charles Altieri, "Intimacy and Experiment in Mei-mei Berssenbrugge's *Empathy*," in *We Who Love to Be Astonished: Experimental Women's Writing and Performance Poetics*, ed. Laura Hinton and Cynthia Hogue (Tuscaloosa: University of Alabama Press, 2002), 54–68; Linda Voris, "A 'Sensitive Empiricism': Berssenbrugge's Phenomenological Investigations," in *American Women Poets in the 21st Century: Where Lyric Meets Language*, ed. Claudia Rankine and Juliana Spahr (Middletown, CT: Wesleyan University Press, 2013), 68–93; Sasha Steensen, "Porous and Continuous with the World: Mei-mei Berssenbrugge's 'Four-Year-Old Girl,'" in *Quo Anima: Spirituality and Innovation in Contemporary Women's Poetry*, ed. Jennifer Phelps and Elizabeth Robinson (Akron, OH: University of Akron Press, 2019), 233–43; Megan Simpson, "Mei-mei Berssenbrugge's *Four-Year-Old Girl* and the Phenomenology of Mothering," *Women's Studies* 32, no. 4 (2003): 479–98.

4. For vital work that places the nexus of gender and race at the forefront

of Berssenbrugge's work, see Joseph Jonghyun Jeon, *Racial Things, Racial Forms: Objecthood in Avant-Garde Asian American Poetry* (Iowa City: University of Iowa Press, 2012); Yugon Kim, "An Ethics for the Erotic Avant-Garde: Feminism, Buddhism, and the Idea of Compassion in Mei-mei Berssenbrugge's Lyric Poetry," *Arizona Quarterly: A Journal of American Literature, Culture, and Theory* 72, no. 2 (2016): 83–119; Dorothy J. Wang, *Thinking Its Presence: Form, Race, and Subjectivity in Contemporary Asian American Poetry* (Palo Alto, CA: Stanford University Press, 2014); Jeannie Chiu, "Identities in Process: The Experimental Poetry of Mei-mei Berssenbrugge and Myung Mi Kim," in *Asian North American Identities Beyond the Hyphen*, ed. Eleanor T. Goellnicht and Donald C. Goellnicht (Bloomington: Indiana University Press, 2004), 84–101.

5. The two collaborated on a work titled *If I Could Say This with My Body, Would I Would*, in which Smith created a series of sculptures based on Waldman's poetic text.

6. Berssenbrugge, qtd. in Michèle Gerber Klein, "Interview with Mei-mei Berssenbrugge," *BOMB*, July 1, 2006, http://www.bombmagazine.org/article/2835/mei-mei-berssenbrugge.

7. In addition to Jeon and Kim, see Angela Hume, "Beyond the Threshold: Unlimiting Risk in Mei-mei Berssenbrugge and Kiki Smith's *Endocrinology*," *Interdisciplinary Studies in Literature and Environment* 22, no. 4 (2015): 820–45.

8. Klein, "Interview with Mei-mei Berssenbrugge."

9. Museum of Modern Art, Queens, "First New York Museum Survey of Kiki Smith's Print Art on View at MoMA QNS," press release no. 387073, Museum of Modern Art, Queens, December 2003, https://www.moma.org/documents/moma_press-release_387073.pdf.

10. Christopher Lyon, "Oral History Interview with Kiki Smith," July 20 and August 16, 2017, Archives of American Art, Smithsonian Institution, https://www.aaa.si.edu/collections/interviews/oral-history-interview-kiki-smith-17502#transcript.

11. Smith, qtd. in Chuck Close, "Interview with Kiki Smith," *BOMB*, October 1, 1994, http://bombmagazine.org/articles/kiki-smith-1/

12. Jonathan Skinner, "Boundary Work in Mei-mei Berssenbrugge's 'Pollen,'" *How2* 3, no. 2, https://www.asu.edu/pipercwcenter/how2journal/vol_3_no_2/ecopoetics/essays/skinner.html.

13. Jonathan Culler, *Theory of the Lyric* (Cambridge, MA: Harvard University Press, 2015), 8.

14. Kim, "An Ethics," 85.

15. Leonard Schwartz, "Coinciding in the Same Space: Kiki Smith and Leonard

Schwartz on Cross Cultural Politics in 2011," *Jacket2*, June 11, 2012, https://jacket2.org/interviews/coinciding-same-space.

16. Schwartz, "Coinciding in the Same Space."

17. Wang, *Thinking Its Presence*, 257.

18. Wang, *Thinking Its Presence*, 258.

19. Mei-mei Berssenbrugge, "By Correspondence," in *American Women Poets in the 21st Century*, 66.

20. Jeon, *Racial Things*, 79.

21. Jeon, *Racial Things*, 105.

22. Kamran Javadizadeh, "The Atlantic Ocean Breaking on Our Heads: Claudia Rankine, Robert Lowell, and the Whiteness of the Lyric Subject," *PMLA* 134, no. 3 (2019): 476.

23. Javadizadeh, "The Atlantic Ocean," 477.

24. Hume, "Beyond the Threshold," 839; emphasis original.

25. Altieri, "Intimacy and Experiment," 64.

26. Javadizadeh, "The Atlantic Ocean," 481.

27. Jeon, *Racial Things*, 71.

28. Laura Hinton, "Three Conversations with Mei-mei Berssenbrugge," *Jacket2*, April 2005, http://jacketmagazine.com/27/hint-bers.html.

29. Johanna Drucker, "Intimate Authority: Women, Books, and the Public-Private Paradox," in *The Book as Art: Artists' Books from the National Museum of Women in the Arts*, 2nd ed., Krystyna Wasserman (New York: Princeton Architectural Press, 2011), 16.

30. My thinking here is also indebted to Angela's Hume discussion of *Endocrinology*, in which she notes that their first artist's book clarifies how "female or feminized bodies at times experience environmental risk differently from male bodies" and thus that as the "book itself seems to suggest, to read *Endocrinology* is [both] to circulate through a *particular* marginalized body" and "to encounter the material trace of a particular embodied collaboration between a poet and visual artist," in "Beyond the Threshold," 828–30.

31. Kim, "An Ethics for the Erotic Avant-Garde," 85.

32. Hinton, "Three Conversations."

33. Hinton, "Three Conversations."

34. Smith, qtd. in Heidi Julavits, "Kiki Smith," *Interview Magazine*, July 27, 2017, https://www.interviewmagazine.com/art/kiki-smith.

35. Smith, qtd. in Adrian Dannatt, "The Body Under Scrutiny: Interview with Kiki Smith," *The Art Newspaper*, October 31, 1999, https://www.theartnewspaper.com/1999/11/01/the-body-under-scrutiny-interview-with-kiki-smith.

36. Smith, qtd. in Wendy Weitman, *Kiki Smith: Prints, Books & Things* (New York: Museum of Modern Art, 2003), 13.

37. Schwartz, "Coinciding in the Same Space."
38. Julie Joosten, "A Sensuous Field of Attention: A Review of Mei-mei Berssen-brugge's 'Concordance,'" *Jacket2*, June 22, 2011, http://www.jacket2.org/reviews/sensuous-field-attention.
39. Joosten, "A Sensuous Field."
40. Smith, qtd. in Weitman, *Kiki Smith*, 29.
41. Johanna Drucker, *The Century of Artists' Books*, 2nd ed. (New York: Granary Books, 2004), 359.
42. Vincent Katz, "Kiki Smith's Logophilia = Kiki Smith's Logophilie," *Parkett* 71 (2004): 8. Available at https://www.e-periodica.ch/cntmng?pid=ptt-001 :2004:0::936.
43. Berssenbrugge, "By Correspondence," 65.
44. Berssenbrugge, qtd. in Zhou Xioajing, "Blurring the Borders Between Formal and Social Aesthetics: An Interview with Mei-mei Berssenbrugge," *MELUS* 27, no. 1 (2002): 203.
45. Cecile Chu-chin Sun, "Mimesis and Xing, Two Modes of Viewing Reality: Comparing English and Chinese Poetry," *Comparative Literature Studies* 43, no. 3 (2006): 326.
46. Chu-chin Sun, "Mimesis and Xing," 338.
47. In his reading of both *Endocrinology* and her earlier *Hiddenness* collaboration with her husband, Richard Tuttle, Jeon elaborates on the racial implications of "color" in Berssenbrugge's artists' books. Calling Berssenbrugge a "*woman of color*" which "invokes both the phenomenological encounter with literal color in visual art and the racial sense of the term," Jeon argues that "color" becomes "a mode of seeing in addition to a mode of being," 78. As a "woman of color," he continues, "Berssenbrugge uses color to gesture toward that which is hidden and to understand it in physical, bodily terms; as an attempt to figure racial position concretely [. . .] color seems to authorize speculation about the hidden body, insisting on the physical presence of the body that remains obscured from view," *Racial Things*, 93.
48. Steensen, "Porous and Continuous," 236.
49. Skinner, "Boundary Work."
50. Skinner, "Boundary Work."
51. Berssenbrugge, "By Correspondence," 65.
52. Katz, "Kiki Smith's Logophilia," 10.
53. Smith, qtd. in Close, "Interview with Kiki Smith."
54. Weitman, *Kiki Smith*, 34.
55. Marthe Reed, "Poetics of Place in Mei-Mei Berssenbrugge's 'The Heat Bird,'" *Soundings: An Interdisciplinary Journal* 94, no. 3/4 (2011): 257.
56. Berssenbrugge, qtd. in Klein, "Interview."

Chapter Five

1. Harryette Mullen, "Poetry and Identity," in *The Cracks Between What We Are and What We Are Supposed to Be* (Tuscaloosa: University of Alabama Press, 2012), 10.

2. As Allison Cumming synthesizes: "for poets of color coming of age since the 1970s, these artistic imperatives—to write the revolution or to write the process of linguistic revolution—have often been felt as competing contradictory demands," in "Public Subjects: Race and the Critical Reception of Gwendolyn Brooks, Erica Hunt, and Harryette Mullen," *Frontiers* 26, no. 5 (2005): 4. See also Timothy Yu, *Race and the Avant-Garde: Experimental and Asian American Poetry since 1965* (Palo Alto, CA: Stanford University Press, 2009); Aldon Lynn Nielsen, *Black Chant: Languages of African-American Postmodernism* (Cambridge: Cambridge University Press, 1997); Evie Shockley, *Renegade Poetics: Black Aesthetics and Formal Innovation* (Iowa City: University of Iowa Press, 2011); and C. S. Giscombe, "Making Book: Winners, Losers, Poetry, and the Color Line," in *What I Say: Innovative Poetry by Black Writers in America,* ed. Aldon Lynn Nielsen and Lauri Ramey (Tuscaloosa: University of Alabama Press, 2015), 1–7.

3. Johanna Drucker, "Intimate Authority: Women, Books, and the Public-Private Paradox," in *The Book as Art: Artists' Books from the National Museum of Women in the Arts,* 2nd ed., ed. Krystyna Wasserman (New York: Princeton Architectural Press, 2011), 14.

4. "History," Kelsey Street Press, https://www.kelseystreetpress.org/history.

5. Erica Hunt and Alison Saar, *Arcade* (Berkeley, CA: Kelsey Street Press, 1996), 53.

6. Harryette Mullen, Review of *Arcade, Antioch Review* 56, no. 2 (1998): 245. Saar has since collaborated with both Mullen and Evie Shockley on artists' books, broadsides, and other projects.

7. Erica Hunt, "Going Off Script," *boundary 2* 42, no. 4 (2015): 122.

8. Tyrone Williams, "The Authenticity of Difference as 'Curious Thing[s]': Carl Phillips, Ed Roberson, and Erica Hunt," *boundary 2* 42, no. 4 (2015): 136.

9. For more on how temporality works in *Arcade,* and its centrality to the book, see Davy Knittle, "On Erica Hunt's 'Arcade': control/temporality/the past in the present," *Jacket2,* November 20, 2017, https://jacket2.org/commentary/erica-hunt%E2%80%99s-arcade-control-temporality-past-present.

10. Erica Hunt, "The World Is Not Precisely Round: Piecing Commotion (on writing and motherhood)," in *The Grand Permission: New Writings on Poetics and Motherhood,* ed. Patricia Dienstfrey and Brenda Hillman (Middletown, CT: Wesleyan University Press, 2003), 24.

11. Erica Hunt, "Notes for an Oppositional Poetics," in *The Politics of Poetic*

Form: Poetry and Public Policy, ed. Charles Bernstein (New York: Roof, 1990), 199–200.

12. Nicky Marsh, *Democracy in Contemporary U.S. Women's Poetry* (New York: Palgrave Macmillan, 2007), 37.

13. Linda A. Kinnahan, *Lyric Interventions: Feminism, Experimental, and Contemporary Discourse* (Iowa City: University of Iowa Press, 2004), 95.

14. Kinnahan, *Lyric Interventions,* 94.

15. Jessica Dallow, "Reclaiming Histories: Betye and Alison Saar, Feminism, and the Representation of Black Womanhood," *Feminist Studies* 30, no. 1 (2004): 96.

16. Kinnahan, *Lyric Interventions,* 94.

17. Dallow, "Reclaiming Histories," 95.

18. Dallow, "Reclaiming Histories," 95. *Arcade's* figure here recalls Saar's earlier statue "Strange Fruit" (1995). Of that piece, Christina Sharpe elaborates: "The sculpture is of a woman who has perhaps been lynched. As the figure was installed, she was hanging upside down, tied at the ankles, and suspended by a long rope . . . I think here of Saidiya Hartman's essay 'Venus in Two Acts.' Of *that* Venus, a young African girl, hung from her feet, beaten, violated, and murdered in Middle Passage, Hartman writes: 'We stumble upon her in exorbitant circumstances that yield no picture of the everyday life, no pathway to her thoughts, no glimpse of the vulnerability of her face or of what looking at such a face might demand,'" in "Alison Saar, Alchemist: 'the hand is in the making of textures,'" in *Alison Saar: Of Aether and Earthe,* ed. Rebecca McGrew and Irene Tsatsos (Claremont, CA: Benton Museum of Art at Pomona College, 2020), 92.

19. Hortense J. Spillers, "Mama's Baby, Papa's Maybe: An American Grammar," *Diacritics* 17, no. 2 (1987): 76.

20. bell hooks, "The Poetics of Soul: Art for Everyone," in *Art on My Mind: Visual Politics* (New York: New Press, 1995), 17.

21. hooks, "The Poetics of Soul," 17.

22. This second connotation is prompted by Nicky Marsh, who observes that *Arcade's* "visual images . . . shift and recombine images of fertility and of bondage, giving the frustrations of the poem a racially specific allusive context," *Democracy,* 37.

23. Hunt, "Notes for an Oppositional Poetics," 200.

24. Knittle, "On Erica Hunt's *Arcade.*"

25. Sharpe, "Alison Saar, Alchemist," 92.

26. Dallow, "Reclaiming Histories," 92–93.

27. Not long before *Arcade's* publication, Saar had debuted *Treesouls* (1994), a statue series for the Madison Square Art Program that specifically invoked

the Persephone myth. See Hadley Roach, "Thread to the Word: Alison Saar," *BOMB*, November 17, 2011, https://bombmagazine.org/articles/thread-to -the-word-alison-saar/.

28. hooks, "Facing Difference: The Black Female Body," in *Art on My Mind,* 97.
29. Rebecca McGrew, "Alison Saar's Radical Art of Sustenance," in *Alison Saar: Of Aether and Earthe,* 13.
30. Harryette Mullen, "Incessant Elusives: The Oppositional Poetics of Erica Hunt and Will Alexander," in *The Cracks Between,* 179.
31. Cummings, "Public Subjects," 17.
32. Cummings, "Public Subjects," 4.
33. Marsh, *Democracy in Contemporary U.S. Women's Poetry,* 21.
34. The subway as a metonym for these impenetrable public systems emerges with especial clarity in "Magritte's Black Flag," a poem in which the speaker describes a series of impenetrable, increasingly confusing subway delays that keep the train's passengers hopelessly (and deliberately) stuck in place:

 > Passengers are advised to take alternate routes to their destination, such as the N or R lines. The N & R lines have been switched to the LL tracks to make room for additional 5 & 6 trains making all BMT stops.
 >
 > The LL trains have been moved to the Number 1 line. The Number 1 line is On the 2 and the 2 is on the Three. (*Arcade* 18)

35. Mullen, "Incessant Elusives," 175.
36. Chris Chen, "Rereading Race and Commodity Form in Eric Hunt's *Piece Logic,*" in *Reading Experimental Writing,* ed. Georgina Colby (Edinburgh: Edinburgh University Press, 2020), 114.
37. Graham Seal, *Outlaw Heroes in Myth and History* (New York: Anthem Press, 2012), 7.
38. Seal, *Outlaw Heroes,* 10.
39. John W. Roberts, *From Trickster to Badman: The Black Folk Hero in Slavery and Freedom* (Philadelphia: University of Pennsylvania Press, 1989), 205.
40. Marsh, *Democracy,* 37.
41. Mich Nyawalo has suggested that the contemporary hip hop "gangsta" has origins in the "badman" character in "From 'Badman' to 'Gangsta': Double Consciousness and Authenticity from African-American Folklore to Hip Hop," *Popular Music and Society* 36, no. 4 (2013): 460–75.
42. hooks, "The Poetics of Soul," 15.
43. Kinnahan, *Lyric Interventions,* 101.
44. Williams, "The Authenticity of Difference," 135.
45. Kinnahan, *Lyric Interventions,* 82. Williams, striking a similar chord, notes that Saar's prints routinely "confound the conflation of the visual with

gender and racial identity in a variety of ways," "The Authenticity of Difference," 135. Interestingly, in a standalone suite of *Arcade* prints, the image is given the title "Man Tipping Hat" (2000); in the Kelsey Street edition; however, the image's gender is not only left ambiguous but even seems to lean female in the context of Hunt's poems.

46. Hunt, "Notes for an Oppositional Poetics," 200.
47. Hunt, "Notes for an Oppositional Poetics," 199.
48. Saar, qtd. in Jan Castro, "A Unification of Many Cultures: Conversations with Betye and Alison Saar," *Black Renaissance/ Renaissance Noire*, 11, no. 2/3 (2012): 169.
49. hooks, "The Poetics of Soul," 18.
50. Erica Hunt, "The Anti-Heroic in a Post Racial (Art) World," *Black Renaissance / Renaissance Noire*, 9, no. 2/3 (2009): 173.
51. Kinnahan, *Lyric Interventions*, 99.
52. Hunt, "The World Is Not Precisely Round," 21.
53. Hunt, "The World Is Not Precisely Round," 21.
54. Joseph Jonghuyn Jeon, *Racial Things, Racial Forms: Objecthood in Avant-Garde Asian America Poetry* (Iowa City: University of Iowa Press, 2012), 71.
55. Sharpe, "Alison Saar, Alchemist," 91.
56. Henrietta Cosentino and Carine Fabius, "Body Talk," *African Arts* 34, no. 2 (2001): 6.
57. Sharpe, "Alison Saar, Alchemist," 92.
58. Kinnahan, *Lyric Interventions*, 91.
59. Saar, qtd. in Jan Castro, "A Unification of Many Cultures," 167.
60. Kinnahan, *Lyric Interventions*, 103.
61. Hunt, "Notes for an Oppositional Poetics," 199.

Coda

1. Tia Blassingame, interview by Alexandra J. Gold, email, August 2020.
2. The limited-edition accordion *Concordance* naturally sells higher, around $800 to $1,200.
3. Karen Eliot, "The Root of the Matter: The Artists' Book in the Twenty-First Century," in *Freedom of the Presses: Artists' Books in the Twenty-First Century*, ed. Marshall Weber (New York: Booklyn, 2018), 52.
4. Eliot, "The Root," 37.
5. Eliot, "The Root," 52.
6. Lynne S. Vieth, "The Artist's Book Challenges Academic Convention," *Art Documentation: Journal of the Art Libraries Society of North America* 25, no. 1 (2006): 14.

7. Emma Bazilian, "The Rise of 'Grandmillenial' Style," *House Beautiful*, September 5, 2019, https://www.housebeautiful.com/lifestyle/a28594040/grandmillennial-design/.

8. Anca Cristofovici, "Unfolding Possibilities: Artists' Books, Cultural Patterns, Forms of Experience," in *The Art of Collaboration: Poets, Artists, Books*, ed. Barbara Montefalcone and Anca Cristofovici (Victoria, TX: Cuneiform Press, 2015), 23.

9. This includes their treatment in many institutions. As Blassingame points out, there is still a widespread sense that artists' books are "hard to exhibit, you can only see one page spread when you show it. Many artists' books are tactile, but they must be displayed in a vitrine or handled with gloves. They are hard to understand. It takes too much to provide context. It's not really art. Most isn't very good or complex. I think this is lazy thinking, mixed with some art snobbery. . . . If you can 'exhibit' or re-create Fluxus work, you can figure out how to exhibit artists' books. You just have to have the desire or will to do it. A desire to make art accessible to all ages and socio-economic, cultural backgrounds of people," interview by Alexandra J. Gold.

10. Eva Athanasiu, "Belonging: Artists' Books and Readers in the Library," *Art Documentation: Journal of the Art Libraries Society of North America* 34, no. 2 (2015): 335.

11. Johanna Drucker, "Intimate Authority: Women, Books, and the Public-Private Paradox," in *The Book as Art: Artists' Books from the National Museum of Women in the Arts*, 2nd ed., ed. Krystyna Wasserman (New York: Princeton Architectural Press, 2011), 16.

12. Hertha D. Wong, *Picturing Identity: Contemporary American Autobiography in Image and Text* (Chapel Hill: University of North Carolina Press, 2018), 230.

13. Wong, *Picturing Identity*, 230.

14. Alexa Hazel, "'You Shall Look at This or at Nothing': Gaylord Schanilec and the Value of the Fine Press Book," *Book History* 24, no. 1 (2021): 158.

15. Kyle Schlesinger, "The Editor at Work: Artists' Books and New Technologies," in *The Art of Collaboration*, 144; emphasis original.

16. Hazel, "You Shall Look," 170.

17. Louise Kulp, "Teaching with Artists' Books: An Interdisciplinary Approach for the Liberal Arts," *Art Documentation: Journal of the Art Libraries Society of North America* 34, no. 1 (2015): 101.

18. Kulp, "Teaching with Artists' Books," 120. For more on artists' books' pedagogical potential, see Deborah Ultan, "Counterculture Publications for Engaged Learning," in *Freedom of the Presses: Artists' Books in the Twenty-First Century*, ed. Marshall Weber (New York: Booklyn, 2018), 184–97.

19. Kulp, "Teaching with Artists' Books," 120.

20. Suzy Taraba, "A Queer Community of Books," in *Freedom of the Presses,* 86.

21. Germano Celant, *Book as Artwork 1960/1972,* 2nd ed. (New York: 6 Decades Books, 2010), 16–17.

22. Kurt Allerslev, "A Closed Book Is a Treasure Trove of Wild Possibility," in *Freedom of the Presses,* 4.

23. Blassingame, interview with Alexandra J. Gold.

24. Johanna Drucker, *The Century of Artists' Books,* 2nd ed. (New York: Granary Books, 2004), 357.

25. Bridget Elmer, Janelle Rebel, and Marshall Weber, "Freedom of the Presses: Activating Library Resources through Collaborative Curating," in *Freedom of the Presses,* 125.

26. "Mobile Print Power," accessed September 16, 2020, http://mobileprintpower.com/.

27. Mobile Print Power, "Publishing Works through Public Participation," in *Freedom of the Presses,* 115.

28. Author meeting with Mobile Print Power Collective (October 8, 2020, virtual). I am grateful for MPP's generosity in allowing me to sit in on one of their organizing meetings.

29. Author meeting with MPP Collective.

30. Blassingame, interview with Alexandra J. Gold. For more on the dearth of representation in the book arts field, see Blassingame, "Dear Books Arts: African American Artists and the Book Form," in *Freedom of the Presses,* 5–13.

31. Florencia San Martìn, "To Not Forget Twice: Art and Social Change in Artists' Books from Latin America," in *Freedom of the Presses,* 72.

32. Taraba, "A Queer Community," 86.

33. Riva Castleman, *A Century of Artists Books* (New York: Museum of Modern Art, 1994), 77.

34. Drucker, *The Century,* 363.

35. Drucker, *The Century,* 363.

BIBLIOGRAPHY

Allen, Donald. "Preface." In *The New American Poetry 1945–1960*, edited by Donald Allen, xi–xiv. Berkeley: University of California Press, 1960.

———, ed. *Standing Still and Walking in New York*. 2nd ed. San Francisco: Grey Fox Press, 1983.

Allen Ginsberg Project. "Ray Bremser (1934–1998)." February 22, 2012. https://allenginsberg.org/2012/02/ray-bremser-1934-1998/.

Allerslev, Kurt. "A Closed Book Is a Treasure Trove of Wild Possibility." In *Freedom of the Presses: Artists' Books in the Twenty-First Century*, edited by Marshall Weber, 3–4. New York: Booklyn, 2018.

Altieri, Charles. "Intimacy and Experiment in Mei-Mei Berssenbrugge's Empathy." In *We Who Love to Be Astonished: Experimental Women's Writing and Performance Poetics*, edited by Laura Hinton and Cynthia Hogue, 54–68. Tuscaloosa: University of Alabama Press, 2002.

———. "The Unsure Egoist: Robert Creeley and the Theme of Nothingness." *Contemporary Literature* 13, no. 2 (1972): 162–85.

———. "What Is Living and What Is Dead in American Postmodernism: Establishing the Contemporaneity of Some American Poetry." *Critical Inquiry* 22, no. 4 (1997): 764–89.

Arthur, Jason. "Allen Ginsberg's Biographical Gestures." *Texas Studies in Literature and Language* 52, no. 2 (2010): 227–46.

Athanasiu, Eva. "Belonging: Artists' Books and Readers in the Library." *Art Documentation: Journal of the Art Libraries Society of North America* 34, no. 2 (2015): 330–38.

Badiou, Alain. *Being and Event*. Translated by Oliver Feltham. London: Continuum, 2005.

Bardwell, Laura. "Anne Waldman's Buddhist 'Both Both.'" *Jacket2*, no. 27 (2005). http://jacketmagazine.com/27/w-bard.html.

Barthes, Roland. *Image-Music-Text*. Translated by Stephen Heath. New York: Hill and Wang, 2009.

Bazilian, Emma. "The Rise of 'Grandmillenial' Style." *House Beautiful*, September 5, 2019. https://www.housebeautiful.com/lifestyle/a28594040/grandmillennial-design/.

Berkson, Bill. "George's House of Mozart." In *Painter Among Poets: The Collaborative Art of George Schneeman*, edited by Ron Padgett, 90–98. New York City: Granary Books, 2004.

———. "Hands On/Hands Off." In *The Art of Collaboration: Poets, Artists, Books*, edited by Anca Cristofovici and Barbara Montefalcone, 77–87, 2015.

Bernstein, Charles. "Artifice of Absorption." EPC Digital Library, 2019. https://writing.upenn.edu/epc/authors/bernstein/books/artifice/AA-contents.html.

Berssenbrugge, Mei-mei. "By Correspondence." In *American Women Poets in the 21st Century: Where Lyric Meets Language*, edited by Claudia Rankine and Juliana Spahr, 63–67. Middletown, CT: Wesleyan University Press, 2013.

Berssenbrugge, Mei-mei, and Kiki Smith. *Concordance*. Berkeley, CA: Kelsey Street Press, 2006.

Blasing, Mutlu K. *Lyric Poetry: The Pain and the Pleasure of Words*. Princeton, NJ: Princeton University Press, 2009.

———. *Politics and Form in Postmodern Poetry: O'Hara, Bishop, Ashbery, and Merrill*. Cambridge: Cambridge University Press, 2009.

Blassingame, Tia. "Dear Book Arts: African American Artists and the Book Form." In *Freedom of the Presses: Artists' Books in the Twenty-First Century*, edited by Marshall Weber, 5–13. New York: Booklyn, 2018.

Bloch, Susi. "The Book Stripped Bare." In *Artists' Books: A Critical Anthology and Sourcebook*, edited by Joan Lyons, 133–42. Rochester, NY: Visual Studies Workshop Press, 1985.

Bochner, Mel. "The Serial Attitude (1967)." In *Conceptual Art: A Critical Anthology*, edited by Alexander Alberro and Blake Stimson, 22–27. Cambridge, MA: MIT Press, 1999.

Brady, Andrea. *Poetry and Bondage: A History and Theory of Lyric Constraint*. Cambridge: Cambridge University Press, 2021. https://doi.org/10.1017/9781108990684.

Brilliant, Richard. *Portraiture*. Cambridge, MA: Harvard University Press, 1991.

Brossard, Olivier. "Et Moi Je Ne Suis Pas Un Peintre: Why Frank O'Hara Is Not a Painter." In *The Art of Collaboration: Poets, Artists, Books*, edited by Anca Cristofovici and Barbara Montefalcone, 45–54. Victoria, TX: Cuneiform Press, 2015.

Brown, Kathryn. *Matisse's Poets: Critical Performance in the Artist's Book*. New York: Bloomsbury, 2017.

Cappellazzo, Amy, and Elizabeth Licata, eds. *In Company: Robert Creeley's Collaborations*. Chapel Hill: University of North Carolina Press, 1999.

Carden, Mary Paniccia. "Introduction: Writing from Nowhere." In *Women Writers of the Beat Era: Autobiography and Intertextuality*, 1–13. Charlottesville: University of Virginia Press, 2018.

Carden, Mary Paniccia, and Justin D. Neuman, eds. *Women Writers of the Beat Era: Autobiography and Intertextuality.* Charlottesville: University of Virginia Press, 2018.

Carrión, Ulisses. "The New Art of Making Books." In *Artists' Books: A Critical Anthology and Sourcebook,* edited by Joan Lyons, 31–35. Rochester, NY: Visual Studies Workshop Press, 1985.

Castleman, Riva. *A Century of Artists Books.* New York: Museum of Modern Art, 1994.

———. "Floriano Vecchi and the Tiber Press." *Print Quarterly* 21, no. 2 (2004): 127–45.

Castro, Jan. "A Unification of Many Cultures: Conversations with Betye and Alison Saar." *Black Renaissance/Renaissance Noire* 11, no. 2/3 (2012): 166–222.

Celant, Germano. *Book as Artwork 1960/1972.* 2nd ed. New York: 6 Decades Books, 2010.

Chadwick, Whitney, and Isabelle De Courtivron, eds. *Significant Others: Creativity & Intimate Partnership.* London: Thames and Hudson, 1993.

Chappell, Duncan. "Typologising the Artist's Book." *Art Libraries Journal* 28, no. 4 (2003): 12–20.

Chen, Chris. "Rereading Race and Commodity Form in Erica Hunt's *Piece Logic.*" In *Reading Experimental Writing,* edited by Georgina Colby, 99–123. Edinburgh: Edinburgh University Press, 2020. https://doi.org/10.3366/edinburgh/9781474440387.003.0005.

Chiu, Jeannie. "Identities in Process: The Experimental Poetry of Mei-Mei Berssenbrugge and Myung Mi Kim." In *Asian North American Identities Beyond the Hyphen,* edited by Eleanor T. Goellnicht and Donald C. Goellnicht, 84–101. Bloomington: Indiana University Press, 2004.

Clark, Tom. *Robert Creeley and the Genius of the American Common Place.* New York: New Directions, 1993.

Close, Chuck. "Interview with Kiki Smith." *BOMB,* October 1, 1994. http://bombmagazine.org/articles/kiki-smith-1/.

Conover, Anne. *Olga Rudge and Ezra Pound: "What Thou Lovest Well. . . ."* New Haven, CT: Yale University Press, 2011.

Conte, Joseph M. *Unending Design: The Forms of Postmodern Poetry.* Ithaca, NY: Cornell University Press, 1991.

Cosentino, Henrietta, and Carine Fabius. "Body Talk." *African Arts* 34, no. 2 (2001): 1–11.

Costello, Bonnie. "Collecting Ourselves: 'We' in Wallace Stevens." *ELH* 85, no. 4 (2018): 1065–92. https://doi.org/10.1353/elh.2018.0038.

Creeley, Robert. *The Collected Poems of Robert Creeley.* Berkeley: University of California Press, 2006.

————. "'An Intensely Singular Art.'" In *The Collected Essays of Robert Creeley*, 158–61. Berkeley: University of California Press, 1989.

————. "Interview with John Sinclair and Robin Eichele." In *Tales Out of School: Selected Interviews*, 1–23. Ann Arbor: University of Michigan Press, 1993.

————. "Interview with Linda Wagner." In *Tales Out of School: Selected Interviews*, 27–40. Ann Arbor: University of Michigan Press, 1993.

————. "Interview with Michael André." In *Tales Out of School: Selected Interviews*, 101–20. Ann Arbor: University of Michigan Press, 1993.

————. "Was That a Real Poem or Did You Just Make It Up Yourself?" In *The Collected Essays of Robert Creeley*, 571–78. Berkeley: University of California Press, 1989.

Creeley, Robert, and Bobbie Creeley. "Robert and Bobbie Creeley: Placitas Phone Log (late September/early October, 1968)." *Penn Sound*. Center for Programs in Contemporary Writing. Philadelphia: University of Pennsylvania, n.d. http://writing.upenn.edu/pennsound/x/Creeley.php.

Creeley, Robert, and Robert Indiana. *Numbers*. Germany: Edition Domberger, 1968.

Cristofovici, Anca. "Unfolding Possibilities: Artists' Books, Cultural Patterns, Forms of Experience." In *The Art of Collaboration: Poets, Artists, Books*, edited by Anca Cristofovici and Barbara Montefalcone, 13–24. Victoria, TX: Cuneiform Press, 2015.

Cristofovici, Anca, and Barbara Montefalcone, eds. *The Art of Collaboration: Poets, Artists, Books*. Victoria, TX: Cuneiform Press, 2015.

Crow, Thomas E. *The Long March of Pop: Art, Music, and Design, 1930–1995*. New Haven, CT: Yale University Press, 2014.

Culler, Jonathan. *Theory of the Lyric*. Cambridge, MA: Harvard University Press, 2015.

Cummings, Allison. "Public Subjects: Race and the Critical Reception of Gwendolyn Brooks, Erica Hunt, and Harryette Mullen." *Frontiers: A Journal of Women Studies* 26, no. 2 (2005): 3–36. https://doi.org/10.1353/fro.2005.0023.

Curley, John J. "Pure Art, Pure Science: The Politics of Serial Drawings in the 1960s." In *Infinite Possibilities: Serial Imagery in 20th-Century Drawings*, edited by Anja Chávez. Wellesley, MA: Davis Museum and Cultural Center, 2004.

Dallow, Jessica. "Reclaiming Histories: Betye and Alison Saar, Feminism, and the Representation of Black Womanhood." *Feminist Studies* 30, no. 1 (2004): 75–113.

Dannatt, Adrian. "The Body Under Scrutiny: Interview with Kiki Smith." *The Art Newspaper*, October 31, 1999. https://www.theartnewspaper.com/1999/11/01/the-body-under-scrutiny-interview-with-kiki-smith.

————. "Robert Indiana 66: Paintings and Sculpture." In *Robert Indiana 66: Paintings and Sculpture*. Bartlesville, OK: Price Tower Arts Center. Catalogue published in conjunction with an exhibition of the same title, organized and presented at the Price Tower Arts Center, Bartlesville, OK, April 23–July 4, 2004. https://www.tfaoi.org/aa/4aa/4aa417.htm.

Dewey, Anne Day, and Libbie Rifkin, eds. *Among Friends: Engendering the Social Site of Poetry*. Iowa City: University of Iowa Press, 2013.

————, eds. "Introduction." In *Among Friends: Engendering the Social Site of Poetry*, 1–18. Iowa City: University of Iowa Press, 2013.

Diggory, Terence, ed. *Encyclopedia of the New York School Poets*. New York: Facts on File, 2009.

Drucker, Johanna. *The Century of Artists' Books*. 2nd ed. New York: Granary Books, 2004.

————. *Figuring the Word: Essays on Books, Writing, and Visual Poetics*. New York: Granary Books, 1998.

————. "Intimate Authority: Women, Books, and the Public-Private Paradox." In *The Book as Art: Artists' Books from the National Museum of Women in the Arts*, 2nd ed., edited by Krystyna Wasserman, 14–17. New York: Princeton Architectural Press, 2011.

DuPlessis, Rachel Blau. "Anne Waldman: Standing Corporeally in One's Time." In *Don't Ever Get Famous: Essays on New York Writing After the New York School*, edited by Daniel Kane, 173–94. London: Dalkey Archive Press, 2006.

Dupont, Stephen. "Lost Dogs." In *Freedom of the Presses: Artists' Books in the Twenty-First Century*, edited by Marshall Weber, 98–114. New York: Booklyn, 2018.

Dworkin, Craig. "The Fate of Echo." In *Against Expression: An Anthology of Conceptual Writing*, edited by Craig Dworkin and Kenneth Goldsmith, xxiii–liv. Evanston, IL: Northwestern University Press, 2011.

Eliot, Karen. "The Root of the Matter: The Artists' Book in the Twenty-First Century." In *Freedom of the Presses: Artists' Books in the Twenty-First Century*, edited by Marshall Weber, 35–53. New York: Booklyn, 2018.

Elmer, Bridget, Janelle Rebel, and Marshall Weber. "Freedom of the Presses: Activating Library Resources through Collaborative Curating." In *Freedom of the Presses: Artists' Books in the Twenty-First Century*, edited by Marshall Weber, 125–35. New York: Booklyn, 2018.

Epstein, Andrew. *Attention Equals Life: The Pursuit of the Everyday in Contemporary Poetry and Culture*. New York: Oxford University Press, 2016.

————. *Beautiful Enemies: Friendship and Postwar American Poetry*. New York: Oxford University Press, 2006.

————. "Frank O'Hara and Willem De Kooning: 'Hewing a Clearing in the Crowded Abyss of the West.'" *Decals of Desire: An International Magazine of Art and Poetry*, January 31, 2017. http://decalsofdesire.blogspot.com/.

————. "'The Volley Maintained Near Orgasm': Rae Armantrout, Ron Silliman, and the Cross-Gender Collaboration." In *Among Friends: Engendering the Social Site of Poetry*, edited by Anne Dewey and Libbie Rifkin, 171–90. Iowa City: University of Iowa Press, 2013.

Faas, Ekbert, ed. *Robert Creeley: A Biography*. Hanover, NH: University Press of New England, 2001.

Ferguson, Russell, ed. *In Memory of My Feelings: Frank O'Hara and American Art*. Los Angeles: Museum of Contemporary Art, 1999.

Fredman, Stephen. *American Poetry as Transactional Art*. Tuscaloosa: University of Alabama Press, 2020.

————. "Creeley's Contextual Practice: Interviews, Conversations, and Collaborations." In *Form, Power, and Person in Robert Creeley's Life and Work*, edited by Stephen Fredman and Steve McCaffery, 181–202. Iowa City: University of Iowa Press, 2010.

————. "Introduction." In *Presences: A Text for Marisol, A Critical Edition*, edited by Robert Creeley, Marisol Escobar, and Stephen Fredman, xi–xxvii. Albuquerque: University of New Mexico Press, 2018.

Fredman, Stephen, and Steve McCaffery, eds. *Form, Power, and Person in Robert Creeley's Life and Work*. Iowa City: University of Iowa Press, 2010.

Friedlander, Benjamin. "Strange Fruit: O'Hara, Race, and the Color of Time." In *The Scene of My Selves: New Work on New York School Poets*, edited by Terence Diggory and Stephen Paul Miller, 123–41. Hanover, NH: University Press of New England, 2001.

Friedman, Amy L. "'Being Here as Hard as I Could': The Beat Generation Women Writers." *Discourse* 20, no. 1/2 (1998): 229–44.

Gabriel, Mary. *Ninth Street Women*. New York: Little, Brown, 2018.

Gehlawat, Monika. "'An Opposite Force's Breath': Medium-Boundedness, Lyric Poetry, and Painting in Frank O'Hara." In *New York School Collaborations: The Color of Vowels*, edited by Mark Silverberg, 163–82. New York: Palgrave Macmillan, 2013.

Ginsberg, Allen, ed. *Allen Ginsberg: Photographs*. Altadena, CA: Twelvetrees Press, 1991.

————. Photograph. Accessed May 19, 2022. https://from-the-sky.tumblr.com /post/40596393126.

Giscombe, C. S. "Making Book: Winners, Losers, Poetry, Anthologies, and the Color Line." In *What I Say: Innovative Poetry by Black Writers in America*,

edited by Aldon Lynn Nielsen and Lauri Ramey. Tuscaloosa: University of Alabama Press, 2015.

"Give Me Liberty." *Time Magazine,* July 13, 1962. http://content.time.com/time /magazine/article/0,9171,827416,00.html.

Glavey, Brian. "Frank O'Hara Nude with Boots: Queer Ekphrasis and the Statuesque Poet." *American Literature* 79, no. 4 (2007): 781–806.

———. "Having a Coke with You Is Even More Fun Than Ideology Critique." *PMLA* 134, no. 5 (2019): 996–1011.

———. *The Wallflower Avant-Garde: Modernism, Sexuality, and Queer Ekphrasis.* New York: Oxford University Press, 2015.

Gold, Alexandra J. "Frank O'Hara: Salute to the French Negro Poet, Aimé Césaire." *Comparatist* 41 (2017): 257–72.

Goldberg, Michael. "The Canvas Plane or Onwards and Upwards." *It Is: A Magazine for Abstract Art* 1 (Spring 1958).

Golding, Alan. "Revisiting Seriality in Creeley's Poetry." In *Form, Power, and Person in Robert Creeley's Life and Work,* edited by Stephen Fredman and Steve McCaffery, 50–65. Iowa City: University of Iowa Press, 2010.

Gooch, Brad. *City Poet: The Life and Times of Frank O'Hara.* New York: Harper Perennial, 1993.

Green, Charles. *The Third Hand: Collaboration in Art from Conceptualism to Postmodernism.* Minneapolis: University of Minnesota Press, 2001.

Greenough, Sarah. *Beat Memories: The Photographs of Allen Ginsberg.* Reprint ed. Munich: Prestel, 2013.

Hair, Ross. *Avant-Folk: Small Press Poetry Networks from 1950 to the Present.* Liverpool: Liverpool University Press, 2017.

Harris, Mary, ed. *The Arts at Black Mountain College.* Cambridge, MA: MIT Press, 1987.

Harris, Oliver. "Minute Particulars of the Counter-Culture: Time, Life, and the Photo-Poetics of Allen Ginsberg." *Comparative American Studies* 10, no. 1 (2012): 3–29.

Hazel, Alexa. "'You Shall Look at This or at Nothing': Gaylord Schanilec and the Value of the Fine Press Book." *Book History* 24, no. 1 (2021): 146–76. https:// doi.org/10.1353/bh.2021.0005.

Hershman, Lynne Lester. "Slices of Silence, Parcels of Time: The Book as Portable Sculpture." In *Artists Books: Moore College of Art,* edited by Dianne Vanderlip, 8–14. Philadelphia: Falcon Press, 1973.

Hines, Thomas J. *Collaborative Form: Studies in the Relations of the Arts.* Kent, OH: Kent State University Press, 1991.

Hinton, Laura. "Three Conversations with Mei-Mei Berssenbrugge." *Jacket2,* April 2005. http://jacketmagazine.com/27/hint-bers.html.

————. "Two Conversations with Mei-Mei Berssenbrugge." In *Innovative Women Poets: An Anthology of Contemporary Poetry and Interviews*, edited by Elisabeth A. Frost and Cynthia Hogue, 45–56. Iowa City: University of Iowa Press, 2006.

Holman, Matthew. "'Je Suis Las de Vivre Au Pays Natal': At Home and at Sea with Frank O'Hara." *Dandelion: Postgraduate Arts Journal and Research Network* 7, no. 1 (2016). https://doi.org/10.16995/ddl.339.

hooks, bell. "Facing Difference: The Black Female Body." In *Art on My Mind: Visual Politics*, 94–100. New York: New Press, 1995.

————. "The Poetics of Soul: Art for Everyone." In *Art on My Mind: Visual Politics*, 10–21. New York: New Press, 1995.

Hume, Angela. "Beyond the Threshold: Unlimiting Risk in Mei-Mei Berssenbrugge and Kiki Smith's Endocrinology." *Interdisciplinary Studies in Literature and Environment* 22, no. 4 (2015): 820–45.

Hunt, Erica. "The Anti-Heroic in a Post Racial (Art) World." *Black Renaissance/Renaissance Noire* 9, nos. 2–3 (2009): 170–74.

————. "Going Off Script." *boundary 2* 42, no. 4 (2015): 121–22. https://doi.org/10.1215/01903659-3155806.

————. "Notes for an Oppositional Poetics." In *The Politics of Poetic Form: Poetry and Public Policy*, edited by Charles Bernstein, 197–212. New York: Roof, 1990.

————. "The World Is Not Precisely Round." In *The Grand Permission: New Writings on Poetics and Motherhood*, edited by Patricia Dienstfrey and Brenda Hillman, 17–24. Middletown, CT: Wesleyan University Press, 2003.

Hunt, Erica, and Alison Saar. *Arcade*. Berkeley, CA: Kelsey Street Press, 1996.

Izenberg, Oren. *Being Numerous: Poetry and the Ground of Social Life*. Princeton, NJ: Princeton University Press, 2011.

Jackson, Virginia. *Dickinson's Misery: A Theory of Lyric Reading*. Princeton, NJ: Princeton University Press, 2005.

Jackson, Virginia, and Yopie Prins, eds. *The Lyric Theory Reader: A Critical Anthology*. Baltimore, MD: Johns Hopkins University Press, 2014.

Jassaud, Gervais. "Global Books: New Aspects in the Making of Artists' Books." In *The Art of Collaboration: Poets, Artists, Books*, edited by Anca Cristofovici and Barbara Montefalcone, 119–28. Victoria, TX: Cuneiform Press, 2015.

Javadizadeh, Kamran. "The Atlantic Ocean Breaking on Our Heads: Claudia Rankine, Robert Lowell, and the Whiteness of the Lyric Subject." *PMLA* 134, no. 3 (2019): 475–90.

Jeon, Joseph Jonghyun. *Racial Things, Racial Forms: Objecthood in Avant-Garde Asian American Poetry*. Iowa City: University of Iowa Press, 2012.

Johnson, Ronna C., and Nancy M. Grace, eds. *Girls Who Wore Black: Women Writing the Beat Generation.* New Brunswick, NJ: Rutgers University Press, 2002.

Joosten, Julie. "A Sensuous Field of Attention: A Review of Mei-Mei Berssenbrugge's 'Concordance.'" *Jacket2,* June 22, 2011. http://www.jacket2.org/reviews/sensuous-field-attention.

Julavits, Heidi. "Kiki Smith." *Interview Magazine,* July 17, 2017. https://www.interviewmagazine.com/art/kiki-smith.

Kane, Daniel. *All Poets Welcome: The Lower East Side Poetry Scene in the 1960s.* Berkeley: University of California Press, 2003.

———. "'Angel Hair' Magazine, the Second-Generation New York School, and the Poetics of Sociability." *Contemporary Literature* 45, no. 2 (2004): 331–67.

Kaprow, Allan. "The Legacy of Jackson Pollock." *ARTnews.Com,* February 9, 2018. https://www.artnews.com/art-news/retrospective/archives-allan-kaprow-legacy-jackson-pollock-1958-9768/.

Katz, Jonathan. "Two-Faced Truths: Robert Indiana's Queer Semiotic." In *Robert Indiana: New Perspectives,* edited by Allison Unruh, 217–65. Ostfildern, Germany: Hatje Cantz, 2012.

Katz, Vincent. "Kiki Smith's Logophilia = Kiki Smiths Logophilie." *Parkett,* no. 71 (2004): 6–16.

Katz, William. "On Indiana." Interview by Susan Elizabeth Ryan, February 12, 1990.

Keane, Tim. "'I Noticed My Friends': Allen Ginsberg's Photography." *Hyperallergic,* February 16, 2013. https://hyperallergic.com/65172/i-noticed-my-friends-allen-ginsbergs-photography/.

———. "No Real Assurances: Late Modernist Poetics and George Schneeman's Collaborations with the New York School Poets." *Studies in Visual Arts and Communication: An International Journal* 1, no. 2 (2014): 1–18.

Kelsey Street Press. "History." Accessed May 19, 2022. https://www.kelseystreetpress.org/history.

Keniston, Ann. *Overheard Voices: Address and Subjectivity in Postmodern American Poetry.* New York: Routledge, 2006.

Kim, Yugon. "An Ethics for the Erotic Avant-Garde: Feminism, Buddhism, and the Idea of Compassion in Mei-Mei Berssenbrugge's Lyric Poetry." *Arizona Quarterly: A Journal of American Literature, Culture, and Theory* 72, no. 2 (2016): 83–119.

Kinnahan, Linda A. *Lyric Interventions: Feminism, Experimental Poetry, and Contemporary Discourse.* Iowa City: University of Iowa Press, 2004.

Klein, Michèle Gerber. "Interview with Mei-Mei Berssenbrugge." *BOMB,* July 1, 2006. https://bombmagazine.org/articles/mei-mei-berssenbrugge/.

Knight, Brenda, ed. *Women of the Beat Generation: The Writers, Artists, and Muses at the Heart of a Revolution*. Berkeley, CA: Conari Press, 1996.

Knittle, Davy. "On Erica Hunt's 'Arcade': Control / Temporality / the Past in the Present." *Jacket2*, November 20, 2017. https://jacket2.org/commentary /erica-hunt%E2%80%99s-arcade-control-temporality-past-present.

Koch, Kenneth. "A Note on This Issue." In *Locus Solus II: A Special Issue of Collaborations* II, 193–97. Geneva: Atar S.A., 1961.

Koestenbaum, Wayne. *Double Talk: The Erotics of Male Literary Collaboration*. New York: Routledge, 1989.

Kulp, Louise A. "Teaching with Artists' Books: An Interdisciplinary Approach for the Liberal Arts." *Art Documentation: Journal of the Art Libraries Society of North America* 34, no. 1 (2015): 101–23.

Lagapa, Jason. "Parading the Undead: Camp, Horror and Reincarnation in the Poetry of Frank O'Hara and John Yau." *Journal of Modern Literature* 33, no. 2 (2010): 92. https://doi.org/10.2979/jml.2010.33.2.92.

Lauf, Cornelia. "Cracked Spines and Slipped Disks." In *Artist/Author: Contemporary Artists' Books*, edited by Cornelia Lauf and Clive Phillpot, 67–79. New York: Distributed Art Publishers, 1998.

Lewallen, Constance. "Some Thoughts on the Types and Display of Collaborative and Artists' Books in the San Francisco Area." In *The Art of Collaboration: Poets, Artists, Books*, edited by Anca Cristofovici and Barbara Montefalcone, 171–77. Victoria, TX: Cuneiform Press, 2015.

Licata, Elizabeth. "Robert Creeley's Collaborations: A History." In *In Company: Robert Creeley's Collaborations*, edited by Amy Cappellazzo and Elizabeth Licata, 11–21. Chapel Hill: University of North Carolina Press, 1999.

Lippard, Lucy. "The Artist's Book Goes Public." In *Artists' Books: A Critical Anthology and Sourcebook*, edited by Joan Lyons, 46–48. Rochester, NY: Visual Studies Workshop Press, 1985.

———. *Six Years: The Dematerialization of the Art Object from 1966 to 1972*. New York: Praegaer, 1973.

Loizeaux, Elizabeth Bergmann. *Twentieth-Century Poetry and the Visual Arts*. New York: Cambridge University Press, 2008.

Lucie-Smith, Edward. "An Interview with Frank O'Hara." In *Standing Still and Walking in New York*, 2nd ed., edited by Donald Allen, 3–26. San Francisco, CA: Grey Fox Press, 1983.

Lyon, Christopher. "Oral History Interview with Kiki Smith." Archives of America Art, Smithsonian Institution, Washington, DC, August 20, 2017. https.// www.aaa.si.edu/collections/interviews/oral-history-interview-kiki-smith-17502.

Marsh, Nicky. *Democracy in Contemporary U.S. Women's Poetry*. New York: Palgrave Macmillan, 2007.

Mattix, Micah. *Frank O'Hara and The Poetics of Saying "I."* Lanham, MD: Fairleigh Dickinson University Press, 2011.

McGrew, Rebecca. "Alison Saar's Radical Art of Sustenance." In *Alison Saar: Of Aether and Earthe*, edited by Rebecca McGrew and Irene Tsatsos, 13–25. Claremont, CA: Benton Museum of Art at Pomona College, 2020.

"Michael Goldberg Papers, 1942–1981," n.d. Archives of American Art, Smithsonian Institution, Washington, DC.

Mitchell, W. J. T. *Picture Theory: Essays on Verbal and Visual Representation.* Chicago: University of Chicago Press, 1994.

Mobile Print Power. "Publishing Works through Public Participation." In *Freedom of the Presses: Artists' Books in the Twenty-First Century*, edited by Marshall Weber, 115–24. New York: Booklyn, 2018.

Montefalcone, Barbara. "'Poetry Is a Team Sport': Some Considerations on Poetry, Collaboration, and the Book." In *The Art of Collaboration: Poets, Artists, Books*, edited by Anca Cristofovici and Barbara Montefalcone, 27–36. Victoria, TX: Cuneiform Press, 2015.

Moore, Lisa L. *Sister Arts: The Erotics of Lesbian Landscapes.* Minneapolis: University of Minnesota Press, 2011.

Morris, Daniel. *After Weegee: Essays on Contemporary Jewish American Photographers.* Syracuse, NY: Syracuse University Press, 2011.

Mortenson, Erik. *Capturing the Beat Moment: Cultural Politics and the Poetics of Presence.* Carbondale: Southern Illinois University Press, 2011.

Mullen, Harryette. "Incessant Elusives: The Oppositional Poetics of Erica Hunt and Will Alexander." In *The Cracks Between What We Are and What We Are Supposed to Be: Essays and Interviews*, 173–81. Tuscaloosa: University of Alabama Press, 2012.

———. "Poetry and Identity." In *The Cracks Between What We Are and What We Are Supposed to Be: Essays and Interviews*, 9–12. Tuscaloosa: University of Alabama Press, 2012.

———. "Review of Arcade." *Antioch Review* 56, no. 2 (1998): 244. https://doi .org/10.2307/4613694.

Neimark, Jill. "Interview with Michael Goldberg." *Columbia Review* 58, no. 2 (1979): 1–4.

"The New Lyric Studies." *PMLA* 123, no. 1 (2008): 181–234.

Nichols, Miriam. *Radical Affections: Essays on the Poetics of Outside.* Tuscaloosa: University of Alabama Press, 2010.

Nielsen, Aldon Lynn. *Black Chant: Languages of African-American Postmodernism.* Cambridge: Cambridge University Press, 1997.

———. *Reading Race: White American Poets and the Racial Discourse in the Twentieth Century.* Athens: University of Georgia Press, 1990.

Notley, Alice. "The Art of George Schneeman (Interview)." *Brilliant Corners: A Magazine of the Arts* 8 (1978): 34–76.

Nyawalo, Mich. "From 'Badman' to 'Gangsta': Double Consciousness and Authenticity, from African-American Folklore to Hip Hop." *Popular Music and Society* 36, no. 4 (October 2013): 460–75. https://doi.org/10.1080/03007766 .2012.671098.

O'Hara, Frank. "About Zhivago and His Poems." In *The Collected Poems of Frank O'Hara*, edited by Donald Allen, 501–9. Berkeley: University of California Press, 1995.

———. "Art Chronicle I." In *Standing Still and Walking in New York*, 2nd ed., edited by Donald Allen, 126–32. San Francisco: Grey Fox Press, 1983.

———. "Art Chronicle III." In *Standing Still and Walking in New York*, 2nd ed., edited by Donald Allen, 140–51. San Francisco: Grey Fox Press, 1983.

———. *The Collected Poems of Frank O'Hara*. Edited by Donald Allen. Berkeley: University of California Press, 1995.

———. "5 Participants in a Hearsay Panel." In *Art Chronicles, 1954–1966*, 149–56. New York: George Braziller, 1990.

———. *Jackson Pollock*. New York: George Braziller, 1959.

———. "Larry Rivers: A Memoir." In *Standing Still and Walking in New York*, 2nd ed., edited by Donald Allen, 169–73. San Francisco, Calif: Grey Fox Press, 1983.

———. "Personism: A Manifesto." In *The Collected Poems of Frank O'Hara*, edited by Donald Allen, 498–99. Berkeley: University of California Press, 1995.

O'Hara, Frank, and Michael Goldberg. *Odes*. New York: Tiber Press, 1960.

Olson, Charles. "Projective Verse." In *The New American Poetry 1945–1960*, edited by Donald Allen. Berkeley: University of California Press, 1960.

Ostrow, Saul. "Michael Goldberg by Saul Ostrow." *BOMB*, April 1, 2001. https:// bombmagazine.org/articles/michael-goldberg/.

Padgett, Ron. "Collaborating with Poets: A Conversation with George Schneeman." In *Painter Among Poets: The Collaborative Art of George Schneeman*, edited by Ron Padgett, 35–62. New York: Granary Books, 2004.

Peiffer, Prudence. "One Day After Another: Seriality and the Stuttering Word." In *Infinite Possibilities: Serial Imagery in 20th-Century Drawings*, edited by Anja Chávez, 15–24. Wellesley, MA: Davis Museum and Cultural Center, 2004.

Perloff, Marjorie. *Frank O'Hara: Poet Among Painters*. 2nd ed. Chicago: University of Chicago Press, 1997.

Perloff, Marjorie, and Craig Dworkin. "Introduction." In *The Sound of Poetry / The Poetry of Sound*, edited by Marjorie Perloff and Craig Dworkin, 1–17. Chicago: University of Chicago Press, 2009.

Perloff, Nancy. *Explodity: Sound, Image, and Word in Russian Futurist Book Art*. Los Angeles: Getty Publications, 2017.

Perlow, Seth. *The Poem Electric: Technology and the American Lyric*. Minneapolis: University of Minnesota Press, 2018.

Perrault, John. "Some Thoughts on Book Art." In *Artists Books: Moore College of Art*, edited by Dianne Vanderlip, 15–21. Philadelphia: Falcon Press, 1973.

Phillpot, Clive. "Books by Artists and Books as Art." In *Artist/Author: Contemporary Artists' Books*, edited by Cornelia Lauf and Clive Phillpot, 31–55. New York: Distributed Art Publishers, 1998.

Puchek, Peter. "From Revolution to Creation: Beat Desire and Body Poetics in Anne Waldman's Poetry." In *Girls Who Wore Black: Women Writing the Beat Generation*, edited by Ronna C. Johnson and Nancy McCampbell Grace, 227–50. New Brunswick, NJ: Rutgers University Press, 2002.

Quilter, Jenni. "Life without Malice: The Minor Arts of Collaboration." In *New York School Collaborations: The Color of Vowels*, edited by Mark Silverberg, 141–61. New York: Palgrave Macmillan, 2013.

Reed, Brian M. "Idea Eater: The Conceptual Lyric as an Emergent Literary Form." *Mosaic* 49, no. 2 (2016): 1–18.

———. "Visual Experiment and Oral Performance." In *The Sound of Poetry, the Poetry of Sound*, edited by Marjorie Perloff and Craig Dworkin, 270–84. Chicago: University of Chicago Press, 2009.

Reed, Marthe. "Poetics of Place in Mei-Mei Berssenbrugge's 'The Heat Bird.'" *Soundings: An Interdisciplinary Journal* 94, no. 3/4 (2011): 257–78.

Rice, H. William. "Bob Kaufman and the Limits of Jazz." *African American Review* 47, no. 2–3 (2014): 403–15. https://doi.org/10.1353/afa.2014.0031.

Rice, Shelley. "Words and Images: Artists' Books as Visual Literature." In *Artists' Books: A Critical Anthology and Sourcebook*, edited by Joan Lyons, 59–69. Rochester, NY: Visual Studies Workshop Press, 1985.

Richard, Frances. "Frances Richard and Anne Waldman." *BOMB*, March 6, 2012. https://bombmagazine.org/articles/frances-richard-and-anne-waldman/.

Richard Miller Archive for the Tiber Press Poetry Series by Ashbery, Koch, O'Hara, and Schuyler, circa 1955–1975. Houghton Library, Harvard University, Cambridge, MA.

Rifkin, Libbie. "Reconsidering the Company of Love: Creeley Between Olsen and Levertov." In *Form, Power, and Person in Robert Creeley's Life and Work*, edited by Stephen Fredman and Steve McCaffery, 143–58. Iowa City: University of Iowa Press, 2010.

Roach, Hadley. "Thread to the Word: Alison Saar." *BOMB*, November 17, 2011. https://bombmagazine.org/articles/thread-to-the-word-alison-saar/.

Robert Creeley Papers 1950–1997, Robert Creeley Archives. N.d. Department of Special Collections, Stanford University, Stanford, CA.

Roberts, John W. *From Trickster to Badman: The Black Folk Hero in Slavery and Freedom*. Philadelphia: University of Pennsylvania Press, 1989.

Rosenblum, Robert. "Excavating the Fifties." In *Action/Precision: The New Direction in New York, 1955–1960*, edited by Paul Schimmel, 13–18. Newport Beach, CA: Newport Harbor Art Museum, 1984.

Ryan, Susan Elizabeth. *Robert Indiana: Figures of Speech*. New Haven, CT: Yale University Press, 2000.

San Martín, Florencia. "To Not Forget Twice: Art and Social Change in Artists' Books from Latin America." In *Freedom of the Presses: Artists' Books in the Twenty-First Century*, edited by Marshall Weber, 59–75. New York: Booklyn, 2018.

Sandler, Irving. "I Remember Michael Goldberg." In *Abstraction over Time: The Paintings of Michael Goldberg*, edited by Marcelle Polednik. Jacksonville, FL: Museum of Contemporary Art, 2013.

Schimmel, Paul. "The Lost Generation." In *Action/Precision: The New Direction in New York, 1955–60*, edited by Paul Schimmel, 19–41. Newport Beach, CA: Newport Harbor Art Museum, 1984.

Schlesinger, Kyle. "The Editor at Work: Artists' Books and New Technologies." In *The Art of Collaboration: Poets, Artists, Books*, edited by Anca Cristofovici and Barbara Montefalcone, 141–54. Victoria, TX: Cuneiform Press, 2015.

———. *A Poetics of the Press: Interviews with Poets, Printers, & Publishers*. New York: Ugly Duckling Presse, 2021.

Schuyler, James. "A Blue Shadow Painting." In *Other Flowers: Uncollected Poems*, edited by James Meetze and Simon Pettet, 76. New York: Farrar, Straus and Giroux, 2010.

Schwartz, Leonard. "Coinciding in the Same Space: Kiki Smith and Leonard Schwartz on Cross Cultural Politics in 2011." *Jacket2*, June 11, 2012. https://jacket2.org/interviews/coinciding-same-space.

Seal, Graham. *Outlaw Heroes in Myth and History*. London: Anthem Press, 2012. https://doi.org/10.7135/UPO9780857284211.

Shamma, Yasmine, ed. *Joe Brainard's Art*. Edinburgh: Edinburgh University Press, 2019.

———. *Spatial Poetics: Second Generation New York School Poetry*. New York: Oxford University Press, 2018.

Shapiro, David. "Art as Collaboration: Toward a Theory of Pluralist Aesthetics 1950–1980." In *Artistic Collaboration in the Twentieth Century*, edited by Cynthia Jaffee McCabe and Robert Carleton Hobbs, 45–61. Washington, DC: Smithsonian Institution, 1984.

Sharpe, Christina. "Alison Saar, Alchemist: 'The Hand Is in the Making of Textures.'" In *Alison Saar: Of Aether and Earthe*, edited by Rebecca McGrew and Irene Tsatsos, 91–97. Claremont, CA: Benton Museum of Art at Pomona College, 2020.

Shaw, Lytle. *Frank O'Hara: The Poetics of Coterie*. Iowa City: University of Iowa Press, 2006.

Shockley, Evie. *Renegade Poetics: Black Aesthetics and Formal Innovation in African American Poetry*. Iowa City: University of Iowa Press, 2011.

Silverberg, Mark. "Introduction." In *New York School Collaborations: The Color of Vowels*, edited by Silverberg, Mark, 1–16. New York: Palgrave Macmillan, 2013.

———, ed. *New York School Collaborations: The Color of Vowels*. New York: Palgrave Macmillan, 2013.

Simpson, Megan. "Mei-Mei Berssenbrugge's Four-Year-Old Girl and the Phenomenology of Mothering." *Women's Studies* 32, no. 4 (2003): 479–98.

Skerl, Jennie, ed. *Reconstructing the Beats*. New York: Palgrave Macmillan, 2004.

Skinner, Jonathan. "Boundary Work in Mei-Mei Berssenbrugge's 'Pollen.'" *How2* 3, no. 2 (n.d.). https://www.asu.edu/pipercwcenter/how2journal/vol_3_no_2/ecopoetics/essays/skinner.html.

Smith, Keith A. *Structure of the Visual Book*. Rochester, NY: Keith Smith, 1984.

Smith, Roberta. "'Nine Artists / Coenties Slip,' 'Frank O'Hara: Poet Among the Painters.'" *ArtForum*, April 1974. https://www.artforum.com/print/reviews/197404/nine-artists-coenties-slip-frank-o-hara-poet-among-the-painters-70122.

Spanos, William V. "Talking with Robert Creeley." In special issue, "Robert Creeley: A Gathering," edited by William V. Spanos, *boundary 2* 6–7 (1978): 11–76.

Spillers, Hortense J. "Mama's Baby, Papa's Maybe: An American Grammar Book." *Diacritics* 17, no. 2 (1987): 64. https://doi.org/10.2307/464747.

Steen, John. "Mourning the Elegy: Robert Creeley's 'Mother's Photograph.'" *Textual Practice* 31, no. 1 (2017): 159–77.

Steensen, Sasha. "Porous and Continuous with the World: Mei-Mei Berssenbrugge's 'Four-Year-Old Girl.'" In *Quo Anima: Spirituality and Innovation in Contemporary Women's Poetry*, edited by Jennifer Phelps and Elizabeth Robinson, 233–43. Akron, OH: University of Akron Press, 2019.

Stein, Donna. "When a Book Is More Than a Book." In *Artists' Books in the Modern Era 1870–2000: The Reva and David Logan Collection of Illustrated Books*, 2nd ed., edited by Robert Flynn Johnson, 17–44. San Francisco: Fine Arts Museum, 2001.

Steiner, Wendy. *The Colors of Rhetoric: Problems in the Relation Between Modern Literature and Painting.* Chicago: University of Chicago Press, 1982.

Stevens, Wallace. "The Man with the Blue Guitar." In *The Collected Poems of Wallace Stevens,* 165–84. New York: Vintage Books, 1990.

Stillinger, Jack. *Multiple Authorship and the Myth of Solitary Genius.* Oxford: Oxford University Press, 1991.

Stoneley, Peter. "O'Hara, Blackness, and the Primitive." *Twentieth Century Literature* 58, no. 3 (2012): 495–514.

Sturm, Nick. "Unceasing Museums: Alice Notley's 'Modern Americans in Their Place at Chicago Art Institute.' *ASAP/J,* March 12, 2019. https://asapjournal .com/unceasing-museums-alice-notleys-modern-americans-in-their-place-at -chicago-art-institute-nick-sturm/.

———. "Work." Accessed May 19, 2022. https://www.nicksturm.com/work.

Sweet, David L. "Parodic Nostalgia for Aesthetic Machismo: Frank O'Hara and Jackson Pollock." *Journal of Modern Literature* 23, no. 3/4 (2000): 375–91.

Taraba, Suzy. "A Queer Community of Books." In *Freedom of the Presses: Artists' Books in the Twenty-First Century,* edited by Marshall Weber, 85–97. New York: Booklyn, 2018.

Thomas, Heather. "'Eyes in All Heads': Anne Waldman's Performance of Bi-gendered Imagination in Iovis I." In *We Who Love to Be Astonished: Experimental Women's Writing and Performance Poetics,* edited by Laura Hinton and Cynthia Hogue, 203–12. Tuscaloosa: University of Alabama Press, 2005.

Ultan, Deborah. "Counterculture Publications for Engaged Learning." In *Freedom of the Presses: Artists' Books in the Twenty-First Century,* edited by Marshall Weber, 184–97. New York: Booklyn, 2018.

Unruh, Allison. "Robert Indiana and the Politics of Family." In *Robert Indiana: New Perspectives,* edited by Allison Unruh, 151–216. Ostfildern, Germany: Hatje Cantz, 2012.

Verheyen, Peter. "Development of the Artist's Book." *BookArtsWeb,* 1998. https:// www.philobiblon.com/DevArtistsBook.shtml.

Vieth, Lynne S. "The Artist's Book Challenges Academic Convention." *Art Documentation: Journal of the Art Libraries Society of North America* 25, no. 1 (2006): 14–19.

Vogel, Carol. "Inside Art: Running Numbers." *New York Times,* December 27, 2002. https://www.nytimes.com/2002/12/27/arts/inside-art.html.

Voris, Linda. "A 'Sensitive Empiricism': Berssenbrugge's Phenomenological Investigations." In *American Women Poets in the 21st Century: Where Lyric Meets Language,* edited by Claudia Rankine and Juliana Spahr, 68–93. Middletown, CT: Wesleyan University Press, 2013.

Waldman, Anne. "By the Time of Plato No More Cakes and Ale." In *Painter Among Poets: The Collaborative Art of George Schneeman*, edited by Ron Padgett, 76–82. New York City: Granary Books, 2004.

———. "Femanifesto." In *Vow to Poetry: Essays, Interviews & Manifestos*, 21–24. Minneapolis: Coffee House Press, 2001.

———. "'I Is Another': Dissipative Structures." In *Vow to Poetry: Essays, Interviews & Manifestos*, 193–214. Minneapolis: Coffee House Press, 2001.

———. "Iovis II." In *The Iovis Trilogy: Colors in the Mechanism of Concealment*. Minneapolis: Coffee House Press, 1997.

———. "My Life a List." In *Vow to Poetry: Essays, Interviews & Manifestos*, 25–50. Minneapolis: Coffee House Press, 2001.

———. "'Surprise Each Other': The Art of Collaboration." In *Vow to Poetry: Essays, Interviews & Manifestos*, 1st ed., 319–28. Minneapolis: Coffee House Press, 2001.

———. "Vow to Poetry." In *Vow to Poetry: Essays, Interviews & Manifestos*, 107–36. Minneapolis: Coffee House Press, 2001.

Waldman, Anne, and George Schneeman. *Homage to Allen G*. New York: Granary Books, 1997.

Wallis, Brian. "The Artist's Book and Postmodernism." In *Artist/Author: Contemporary Artists' Books*, edited by Cornelia Lauf and Clive Phillpot, 93–101. New York: Distributed Art Publishers, 1998.

Wang, Dorothy J. *Thinking Its Presence: Form, Race, and Subjectivity in Contemporary Asian American Poetry*. Palo Alto, CA: Stanford University Press, 2014.

Wasserman, Krystyna. "The Brightest Heaven of Invention." In *The Book as Art: Artists' Books from the National Museum of Women in the Arts*, edited by Krystyna Wasserman, 18–25. Princeton, NJ: Princeton Architectural Press, 2007.

Weber, Marshall, ed. *Freedom of the Presses: Artists' Books in the Twenty-First Century*. New York: Booklyn, 2018.

Weitman, Wendy. *Kiki Smith: Prints, Books & Things*. New York: Museum of Modern Art, 2003.

White, Gillian C. *Lyric Shame: The "Lyric" Subject of Contemporary American Poetry*. Cambridge, MA: Harvard University Press, 2014.

White, Tony. "From Democratic Multiple to Artist Publishing: The (r)Evolutionary Artist's Book." *Art Documentation: Journal of the Art Libraries Society of North America* 31, no. 1 (2012): 45–56.

———. "The (r)Evolutionary Artist Book." *Book 2.0* 3, no. 2 (2013): 163–83.

Wilkinson, John. "'Where Air Is Flesh': The Odes of Frank O'Hara." In *Frank O'Hara Now: New Essays on the New York Poet*, edited by Robert Hampson and Will Montgomery, 103–18. Liverpool: Liverpool University Press, 2010.

Williams, Tyrone. "The Authenticity of Difference as 'Curious Thing[s]': Carl Phillips, Ed Roberson, and Erica Hunt." *boundary 2* 42, no. 4 (2015): 123–38. https://doi.org/10.1215/01903659-3155818.

Wong, Hertha D. *Picturing Identity: Contemporary American Autobiography in Image and Text*. Chapel Hill: University of North Carolina Press, 2018.

Wordsworth, William. "We Are Seven." In *The Collected Poetry of William Wordsworth*, 96. Ware, UK: Wordsworth Editions, 1994.

Würth, Anton. "The Use of Type in Artists' Books." In *Freedom of the Presses: Artists' Books in the Twenty-First Century*, edited by Marshall Weber, 136–70. New York: Booklyn, 2018.

Xiaojing, Zhou. "Blurring the Borders Between Formal and Social Aesthetics: An Interview with Mei-Mei Berssenbrugge." *MELUS* 27, no. 1 (2002): 199–212.

Yu, Timothy. *Race and the Avant-Garde: Experimental and Asian American Poetry since 1965*. Palo Alto, CA: Stanford University Press.

INDEX

berg, 27; meets Waldman, 199n3; "Ode," 47, 50, 193n52, 193n59; "Ode (to Joseph LeSueur)," 50; "Ode on Causality," 32, 34–36, 49, 191n19; "Ode on the Grave of Jackson Pollock," 34; "Ode on Lust," 47; *Ode on Necrophilia,* 51–52, 53; "Ode on Necrophilia," 30, 34, 55, 193–94n62; "Ode to Michael Goldberg," 36, 43–44, 46–49, 193n51; "Ode to Willem de Kooning," 39, 41, 43, 192n39; *Odes,* 15, 20, 23, 28, 194n65; *Oranges,* 41; *Poem-Paintings,* 30; and race, 193n52; and Rivers, 194n65; *Stones,* 30, 187n40; "To Richard Miller," 37–38, 191n28; "True Account of Talking to the Sun at Fire Island, A," 193n59; "Two Russian Exiles," 49–50; "Why I Am Not a Painter," 27–28, 38, 41, 189–90n3

Olson, Charles, 12, 95

"One" (Creeley), 62–63

One (R. Indiana), 64

one-to-one semblance, 23

Oppen, George: *Discrete Series,* 70, 197n47

"Oppositional Poetics" (Hunt), 152

orange, 41

Oranges (O'Hara & Hartigan), 41

Orlovsky, Julian, 96

Orlovsky, Peter, 96

Overheard Voices (Keniston), 188n71

Padgett, Ron, 11, 86

parataxis, 75–76

parentheses, 152, 153, 154

Parra, Nicanor, 97

Pasternak, Boris: discussed, 50; *Doctor Zhivago,* 49–50

Perloff, Marjorie, 22, 34, 46, 108

Permanently (Koch & Leslie), 28

Persephone, 154–55, 158, 208–9n27

Personism, 50, 54–55

Phillips 66, 79

Phillpot, Clive: "Books by Artists and Books as Art," 185n15

Picasso, Pablo: *Corps Perdu,* 187n39; discussed, 28

Pictorial Key to the Tarot, A (Waite), 66

Piece Logic (Hunt), 140, 159

Pieces (Creeley), 68, 77, 197n47

Plath, Sylvia: "Lady Lazarus," 147

Poem-Paintings (O'Hara & Bluhm), 30

Poems, The (Ashbery & Mitchell), 28

poetics of community, 4

poetics of human relationships, 4–5

poetics of place, 138

Pollock, Jackson: discussed, 31, 32, 34–36, 49; Kaprow on, 37; on nature, 13; O'Hara on, 37

"Porous and Continuous with the World" (Steensen), 203n3

postcards, 180

Pound, Ezra, 94, 101

Presences (Creeley & Escobar), 59

Prevallet, Kristin, 94

prices, 170, 210n2

Primrose Press, 8, 169

prisons, 128

Pucheck, Peter, 89, 95

Quilter, Jenni, 89, 102

race, 193n52, 206n47

Rachmaninoff, Sergey, 49, 50

Racial Things, Racial Forms (Jeon), 203–4n4

Rand, Archie, 10

Rauschenberg, Robert, 187n40

Reaganism, 15

CONTEMPORARY NORTH AMERICAN POETRY SERIES